Donnybrook

A HISTORY

Donnybrook

A HISTORY

BEATRICE M. DORAN

The
History
Press
Ireland

In memory of

*Sr Vincenzo O.P. (Sr Meabh Ni Cleirigh),
an inspirational history teacher*

And

*Claire Baylis (née) Dowling, MA, DLIS,
lecturer in librarianship and historian*

First published 2013

The History Press Ireland
50 City Quay
Dublin 2
Ireland
www.thehistorypress.ie

British Library Cataloguing in Publication Data.
A catalogue record for this book is available from the British Library.

ISBN 978 1 84588 769 8

Typesetting and origination by The History Press

CONTENTS

The disadvantage of men not knowing the past is that they do not know the present. History is a hill or high point of vantage, from which alone men see the town in which they live or the age in which they are living.

G.K. Chesterton, *All I Survey* (1933)

Leaving town by what was formerly known as the Donnybrook Road, but which, since its accession to respectability, has become the Morehampton Road, we enter Donnybrook, now almost merged in the populous district around it, though still retaining its distinctive character as a village. Few of its old features, however, now remain, its quaint inns are gone, its thatched cottages have vanished, and the whole place has assumed a less rural appearance than it possessed in the days when the 'glories' of its Fair shed around it their halo of renown.

W. St Joyce, *The Neighbourhood of Dublin* (1912)

ACKNOWLEDGEMENTS

So many people and institutions helped me in writing this book. I am grateful in particular to the staff of the following institutions:

Ballsbridge, Donnybrook & Sandymount Historical Society, Chester Beatty Library, Dublin City Libraries – the Gilbert Library Pearse Street, Pembroke Library, Irish Architectural Archive, Irish Music Archive, National Library of Ireland, National Photographic Archive, Representative Church Body Library, Royal Dublin Society Library, RTÉ Library, Ordnance Survey of Ireland – UCD Libraries, Belfield, Blackrock, Richview, and the Department of Archives, Society of Friends, G. & T. Crampton, Fugimerrion, (Conor McCarthy) and Scott Tallon Walker.

Thank you too to the following people who provided me with information and images of Donnybrook:

Reverend Ted Ardis, Richard Ashen, Sr Barnabas OP, Julia Barrett, Ann Barry, Nick Bradshaw, Rosemary Brady, Sean Brennan, Dr Cliona Buckley, Dr Eileen Campbell, Valerie Clancy, Dr Mary Clark, Andrew Clinch, Enda Cogan, Dr Lisa Cogan, Anne Coleman, Con Collins, Mary Coolahan, Valerie Clancy, Elaine Bastable Cogavin, Nieves Roche Collins, Glenda Cimino, David Crampton, Peggy Hickey Curran, Joe Curtis, Maurice Curtis, Yvonne Davis, Anton Daltun, Professor Fergus D'Arcy, Mary Smyth Dee, Desmond Delany, Joanne Donnelly, Glynn Douglas, Elizabeth Dunne, Honora Faul, Penelope

FitzGerald, Eithne Frost, Pascal & Mary Fuller, Fr Seamus Galvin, Maire and Lisa Godfrey, David Griffin, Dr Stephen Harrison, Elizabeth Hartford, Anne Henderson, Seamus Helferty, John and Jacqueline Holohan, Dr Vivien Igoe, Frances Kavanagh, Tony Kearney, Ben Kealy, Joan and Mary Keenan, Kevin Kelleher, Mary Kelleher, Dr Donal Kelly, William Kelly, Dr Maire Kennedy, Susan Kennedy, Frances Kiely, Deirdre Ellis King, Elizabeth Kirwan, Dr Ita Kirwan, Dermot Lacey, Jean Lane, Sheila Larchet, Denis and Gillian Leonard, Alan Little, Lorna Madigan, Conor McCarthy, Kathleen McCloskey, Stephen McCormack, Patricia McKenna, Madeleine McKeown, Deirdre Mac Mahuna, Dr Ruth McManus, Prof. Ged Martin, Eithne Massey, Veronica Meenan, Christopher Moriarity, Paul Murphy, Honor O'Brolochain, Anne O'Byrne, Angela O'Connell, Tim & Ann O'Driscoll, Maeve O'Leary, Nora O'Leary, Patricia O'Loan, Hugh Oram, Dr Dagmar O Riain, Professor Padraig O Riain, Sister Patrice, Sheila O'Shea, Danny Parkinson, Madeleine Parkinson, Dr Michael Pegum, Margaret Pettigrew, Annette Sorahan Quigley, George and Jane Reddan, Dr Raymond Refusee, Sarah Jane Roe, Anne Sheppard, Brian Siggins, Joan Soraghan, Eileen Spelman, Marguerite Stapleton, John Steele, Annette Sweeney, Sean Tobin, Grace Toland, Liz Turley, Dr Elizabeth Twohig, Sally Walker, Margaret Walsh, Gerard Whelan, Gail Wolf, and the Woods family.

Many thanks are also due to Ronan Colgan, who commissioned this book, and to my editor Beth Amphlett and the staff of The History Press.

FOREWORD

From pre-Celtic times Donnybrook has featured in the annals of history, firstly as a place of hospitality on one of the four roads south from Tara of the High Kings, then as a place of worship, close to the River Dodder, not far from the sea, where a holy woman, Broc, one of the seven daughters of Dalbronach, is reputed to have had a place by a well for pilgrims – hence we have the name Domnach Broc. Later, with the coming of the Normans, we have the Charter of King John 1204, granting the City of Dublin the right to hold a fair, which, as the Donnybrook Fair, continued to 1855.

Up to the eighteenth and into the nineteenth century, Donnybrook was a tranquil village by the River Dodder to which people came to enjoy peaceful sojourns south of the city. In the eighteenth and nineteenth centuries industries developed in the area, such as the cotton and calico mills, a hat factory, and quarries. In the nineteenth century landowners like the Fitzwilliams, later the Herberts, Earls of Pembroke, the Scotts, Earls of Clonmel, Riall of Old Conna and Branston-Smith, all saw the potential to develop a suburb south of the city. They laid out roads and leased plots for house-building from the 1830s, and so we saw the transformation of a rural village into a suburban arcadia.

Accounts of the history of the area from earlier writers on Donnybrook – authors like Revd Beaver Blacker and Francis Elrington Ball, to later works by Deirdre Kelly and Dr Seamus Ó Maitiú – have opened the way for further research and so additional research on Donnybrook resulting in the present book by Dr Beatrice Doran is most welcome!

The initiative of Liz Turley, librarian at Pembroke Library, in inviting a group in the area to form a Historical Society bore fruit in 2006 when the Ballsbridge, Donnybrook & Sandymount Society was formed. The society's inaugural lecture on 'The Humours of Donnybrook, being the story of The Donnybrook Fair', was given by Dr Seamus Ó Maitiú and held at Ballsbridge College of Further Education in January 2007. The first major project undertaken by the society was the staging of a display to celebrate the centenary of the Irish International Exhibition of 1907, held on the ground now Herbert Park. The support and collaboration of the Royal Dublin Society in funding and hosting this project was of much value to the area, and greatly appreciated by the society.

Donnybrook has the unique distinction of having representation of institutions ecclesiastical, educational, social and commercial, in its midst, in the churches, schools, businesses, shops and in the many sports and leisure facilities which support the community and the leisure of its citizens. This book, encompassing the origins of Donnybrook and the development of all these facilities to the present day, is a most welcome addition to Dublin's local history.

John R. Holohan, BCL, BL
Chairman
Ballsbridge, Donnybrook & Sandymount Historical Society
April 2013

INTRODUCTION

I was born and reared in Donnybrook, educated there (Muckross Park and University College Dublin) and still live there. This book is not a comprehensive history of Donnybrook, but rather an overview and contribution to the history of my native place.

The book begins with the early history of Donnybrook and a number of sources must be acknowledged, such as Mrs Moyra Gorevan's article on Donnybrook in the *Dublin Historical Record* that provided an excellent introduction to the history of Donnybrook. The Revd H. Beaver Blacker's *Brief Sketches of the Parishes of Booterstown and Donnybrook* (1861) was another important resource, as was the Revd N. Donnelly's *History of Donnybrook Parish* (1912). Father C.P. Crean's *Parish of the Sacred Heart* proved invaluable, as did Danny Parkinson's book *Donnybrook Graveyard*. Richard Lattimore's *The Real Donnybrook* was also consulted. L.J. Lennan's 'Growing Up in Donnybrook 1910-1930', transcribed by his son, was another useful source and is available online at www.rootsweb. ancestry.com/~lennan/len003.htm. A comprehensive local history of interest is Martin Holland's book on *Clonskeagh* and Mary Daly's *Dublin: The Deposed Capital* was a wonderful resource for nineteenth- and twentieth-century Dublin. The national broadcasting centre of RTÉ is also included in this chapter and Richard Pine's comprehensive book *2RN and the Origins of Irish Radio* was a delight to read regarding RTÉ radio. John Bowman's *Window and Mirror: RTÉ Television 1961-2011* was also extremely helpful.

Chapter 2 tells the story of Donnybrook Fair. As well as descriptions of the fair in the *Freeman's Journal* and the *Dublin Penny Journal*, Seamus Ó Maitiú's book *The Humours of Donnybrook* and Professor Fergus D'Arcy's article 'The Decline and Fall of Donnybrook Fair' were excellent sources of information on the fair. Schools and colleges in Donnybrook are discussed in Chapter 3. Some of the schools very kindly provided me with histories and accounts of their schools; some were individual publications, while others had been published in school magazines over the years.

Sports and leisure facilities and activities in Donnybrook are discussed in Chapter 4. Here the local sports clubs were a valuable source of information on their history and activities. *The Record of the Irish International Exhibition of 1907*, held in Herbert Park and published two years after the event, was a detailed account of the exhibition. *The Great White Fair* by Brian Siggins together with Ken Finlay's book *The Biggest Show on Earth* were most informative. Dermot Lacy, the local Labour councillor, very kindly provided me with a transcript of the 'History of the Donnybrook Boy Scouts' that he is currently writing.

Local transport is the topic for Chapter 5 and it covers the early history of transport together with details of the trams and buses that served Donnybrook over the years. Michael Corcoran's *Through Streets Broad and Narrow* was a most interesting account of the Dublin trams, while *Dublin Tram Workers* by Bill McCamley provided an insight into the lives of the tram workers during the period 1872 to 1945.

Shops and businesses in the 1950s and 1960s are the topic of Chapter 6. Members of several of the families who had shops or businesses in Donnybrook provided me with additional information on them. *Thom's Directories* dating from the nineteenth century were another major source of information.

Historic roads and houses are discussed in Chapter 7. Again, Mary Daly's book *Dublin: The Deposed Capital* was invaluable. The history of the Pembroke Township was covered in detail by Seamus Ó Maitiú in his book *Dublin's Suburban Towns*. Constantia Maxwell's *Dublin under the Georges* is still one of the standard books on the topic as is Maurice Craig's *Dublin 1660-1860: A Social and Architectural History*. Ruth McManus has written a comprehensive account – *Dublin 1910-1940: Shaping the City and Suburbs* – and Dr McManus is also the author of *Crampton Built: A History of G & T Crampton*, about the well-known Dublin builders.

Chapter 8, the final chapter, provides an account of some of the more well-known people who have lived in Donnybrook over the years, including politicians, local councillors, writers, poets, actors, composers and artists.

The aim of this book is to provide residents and friends of Donnybrook with an overview of the history and facilities of the area.

Dr Beatrice M. Doran
April 2013

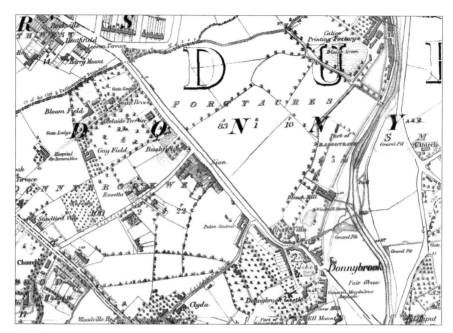

 Ordnance Survey Ireland. Ordnance Survey Map of 1837. (Ordnance Survey Ireland/ Government of Ireland, Copyright Permit No. MP003513)

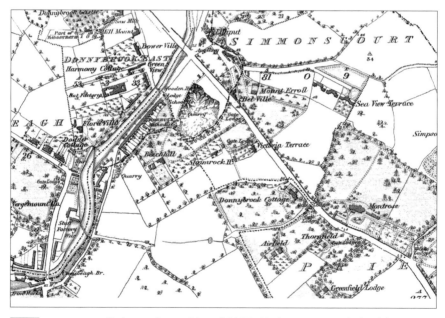

 Ordnance Survey Ireland. Ordnance Survey Map of 1837. (Ordnance Survey/Ireland/ Government of Ireland, Copyright Permit No. MP003513)

1

EARLY HISTORY
AND INSTITUTIONS

Donnybrook is one of Dublin's many suburban villages. It is situated on the southeast side of the city, two and a half miles from the General Post Office in O'Connell Street. There is historical evidence from the *Annals of the Four Masters* (1632-1636) that there were five principal highways (*slighes*) which led to and from Tara, the headquarters of the High Kings of Ireland, in early medieval Ireland. One of these roads went through Donnybrook on its way south.[1] Tradition tells us that near Donnybrook, on the Slighe Cualann, was a hostel owned by the Da Derga, where travellers along the road could obtain refreshments and a place to rest. However, not all historians agree that this was the site of the hostel as it has also been suggested that it was closer to the source of the River Dodder. The earliest archaeological evidence from Donnybrook is a Viking burial found when builders were digging the foundations for the German Ambassador's residence (Danesfield) on Seaview Terrace, off Ailesbury Road in 1877.[2]

Origin of the Name Donnybrook

There are two possible explanations for the meaning of Donnybrook in the Irish version, Domhnach Broc. The word *Domhnach* means Sunday, possibly a church founded by St Patrick on a Sunday. *Broc* is the Irish for a badger so Domhnach Broc could mean either the church of the badger, or, as according to tradition, the Church of St Broc, who was one of the seven

daughters of Dallbronach, from Deece, County Meath. She is mentioned by Aengus the Culdee (who was a monk in the monastery at Tallaght) in two manuscripts in the Book of Leacan. History suggests that she founded a convent on the banks of the River Dodder in the first half of the eighth century. A well in the grounds of Eglinton Square, formerly the site of a house called Ballinguile, is associated with St Broc. In the *Martyrology of Donegal* (which dates from the seventeenth century), Mobhi, a nun of Donnybrook, is mentioned.[3] The site of St Broc's convent is reputed to be where the old graveyard is located, in the centre of the present village of Donnybrook. When the graveyard was being restored in the 1970s, a granite base for a wooden cross dating from the eighth or ninth century was found, which may indicate that it was the site of St Broc's convent.

Viking Invasion

The Viking invasion of Ireland commenced about AD 950 and St Broc's convent (if it existed at all) probably did not survive the Viking raids.

Between 1125 and 1134 Donnybrook was part of the kingdom of Mac Gillamocholmog, who were a powerful Irish clan from County Wicklow. A member of this clan, Donell Mac Gillamocholmog, supported Dermot McMurrough in his negotiations with Henry II of England at the time of the Norman invasion. The territory of Mac Gillamocholmog appears to have been divided up at the time of this invasion and the largest part of it went, in 1174, to one of Strongbow's men, Walter de Ridelesford, Lord of Bray.[4] Included in this territory was Donnybrook, which probably covered a much larger area than the present Donnybrook. To protect his new lands from the marauding Irish of County Wicklow, de Ridelesford built a fort.

Among the knights who accompanied Henry II to Ireland in 1171 was Hugh de Lacy, and for his services he was awarded all the lands of County Meath. Among the knights of Hugh de Lacy was one William Messet, who was granted the area of Donnybrook by de Lacy. Dr Arlene Hogan, in her recent book *The Priory of Llanthony Prima and Secunda in Ireland, 1172 to 1541*, has pointed out that this Welsh monastery (which had been founded by Hugh de Lacy) benefited from a charter of William Messet *c.* 1177-91 concerning the benefices and tithes of his land of Donnybrook and others:

Let all men present and future know that I William Messet have given and
et cetera and by my present charter have confirmed to God and to St Mary
and St John of Llanthony and to the canons there serving God all of the
tithes and ecclesiastical benefices of Donnybrook and all its appurtenances
in pure and perpetual alms, moreover I have given to them one measure
of land in Donnybrook right up to the water of the Dodder to have and to
hold freely, quietly and honourably, free and quit from all secular exactions
and services, in churches, fishing rights, pastures, meadows waters, wind-
mills, in woods and plains and in all things concerning which the tithe is
accustomed to be exchanged and given. Moreover I order that the flocks
and animals of the same canons can go, and have pasture and common
issue of my pasture with my men.

William Messet also augmented the above with a house on the banks of the
Dodder. These references to the River Dodder must be some of the earliest
references to the Dodder in the medieval period. Arlene Hogan has pointed
out that Maizet, from where this family take their name, is just over a mile
from Amaye-sur-Orne, where the de Lacy's also held land.

In 1185, John, the eighteen-year-old youngest son of Henry II, was given
the territory of Ireland by his father with the title Dominus Hiberniae (Lord
of Ireland). When John succeeded his brother Richard as King of England in
1199 the Lordship of Ireland reverted to the English Crown.

In 1204, a Royal Charter of King John initiated the Donnybrook Fair,
which continued for some 600 years. It began as a fair for cattle and horse-
trading but it had expanded by the seventeenth century into a recreational
and holiday event lasting fifteen days.[5]

During the twelfth century King John sent:

A Grant to his citizens of Dublin as perambulated on oath by good men of
the City under precept of his father King Henry – namely from the eastern
part of Dublin and the southern part of the pasture which extends so far
as the gate of the Church of St Kevin, and then along the way as far as
Kilerecaregan, and so by the mere of the land of Duuenolbroc as far as the
Dother and from the Dother to the sea.

This was the beginning of the municipal tradition in Dublin of riding the
city boundaries, known as Riding the Franchise. During his reign, King John
became aware that the Anglo-Norman families were becoming too powerful so,

in 1210, he came to Ireland and stayed here for about sixty days, during which time he reduced the powers of the Anglo-Norman families.

The Donnybrook Fair received its charter from King John in 1204 and it is discussed in more detail in Chapter 2.

With the death of Walter de Ridelesford, his infant granddaughter, Christiana de Marisco, inherited his property. She became a ward of the Crown and at some stage was married to Ebulo de Geneve. This marriage was not a success and she was taken under the protection of Eleanor, widow of King Henry III. Christiana de Marisco moved to Provence with the dowager Queen Eleanor, and it is said she followed her into a convent. Her lands then went to the English Crown.[6] During the mid-thirteenth century, the lands of Donnybrook passed to the Fitzwilliam family. In the fifteenth century Richard Fitzwilliam is mentioned as living in Donnybrook and through his marriage he received some of the lands of the de Ridelford family. By the sixteenth century the Fitzwilliam family were now known as the Lords of Merrion.[7] They built a chapel beside the Church of St Mary's in Donnybrook Graveyard, and a number of the Fitzwilliam family were interred here.

In 1524, the ownership of the lands of Donnybrook fell to Alison Ussher, sister of Richard Fitzwilliam, as part of her marriage settlement. Two years after her marriage she became a widow and her son John inherited the Donnybrook Estate. John Ussher (1529-1590) was Mayor of Dublin, like his father, and he was the first person to publish a book in the Irish language, *Aibidil Gaoidheilge Caiticiosma* (*Irish Alphabet and Catechism of the Church of Ireland*), printed in 1571 by John Kearney. Sir William Ussher was John Ussher's only surviving son. Tragically, William Ussher's eldest son Arthur drowned while crossing the Dodder at Donnybrook. Many noble and distinguished people can trace their descent from the Ussher family, including the Dukes of Wellington and Leinster, and the Earls of Rosse, Egmont, Lanesborough, Enniskillen and Milltown.[8]

The Ussher family, who now owned substantial lands in Donnybrook, built an Elizabethan-style mansion in the sixteenth century in Donnybrook, known as Donnybrook Castle. In 1649 Oliver Cromwell selected Donnybrook as the rendezvous for his army after he had taken Drogheda. At the beginning of the eighteenth century, Donnybrook Castle was vested in trustees for the purpose of sale. One of the trustees was Sir Francis Stoyte, Lord Mayor of Dublin in 1705, and for a while Donnybrook Castle was occupied by some of Stoyte's relatives, including Jonathan Swift's Stella. The demesne and lands of Donnybrook were sold in 1726 to Robert Jocelyn, who subsequently became Lord Chancellor of Ireland.

In 1816 Donnybrook Castle became a boys' school known as the Castle School and it was then purchased, in 1837, by Mother Mary Aikenhead, as a home for the Irish Sisters of Charity and the Magdalene Home. Mother Mary Aikenhead died on 22 July 1858 and she is interred in the nuns' cemetery located in the gardens of Donnybrook Castle.

There are few records for Donnybrook during the seventeenth and eighteenth centuries in existence. Until the middle of the seventeenth century the City of Dublin was a small walled town. By 1603 the circuit of the municipal boundaries – called Riding of the Franchises made on horseback once every three years – had become quite an elaborate occasion.[9] Three hundred horses and a large group of the citizens of Dublin often accompanied the mayor, sheriffs and aldermen. The group rode along the shoreline of Dublin Bay as far as Blackrock. From there they turned inland and passed Merrion and went on to the southeast side of the green of Smothe's Court, to the millpond of Donnybrook on the Dodder. From there it proceeded to Clonskeagh and back to the city of Dublin.

Between 1691 and 1801 Ireland was ruled by a Protestant Ascendancy who were the descendants of the English who had settled in Ireland during the various plantations. Ireland had its own parliament but the vast majority of the population were excluded from holding power or the ownership of property under the Penal Laws because they were Catholic. Dublin City thrived in the eighteenth century under the Protestant Ascendancy until the outbreak of the Rebellion in 1798. The Act of Union of 1800 was a great blow to the country, which saw many of the Ascendency leave the city of Dublin for London. This, of course, had a great impact on the growth and development of Dublin and its suburban towns and villages.

Catholic and Protestant Churches in Donnybrook

With the Norman invasion, the English proceeded to impose Roman methods and doctrine on the native Irish Church. During the twelfth century, under the Archbishopric of St Laurence O'Toole, the parish of Donnybrook was affiliated with Dundrum. Between 1181 and 1212 Archbishop Comyn (1181-1212), Archbishop of Dublin, dedicated St Mary's Church at Donnybrook. Under Archbishop Luke (1230-1255) St Mary's had an independent existence with a parish priest called William de Romney, who was the Archbishop's chaplain. Queen Elizabeth I suppressed Catholic worship in 1559, and the old Catholic

Church of St Mary was handed over to the Church of Ireland. The church appears to have been rebuilt by Archbishop William King (1703-1729) in 1720.

St Mary's Church of Ireland continued in use until the 1820s, when a new church was built at the junction of Anglesea Road and Simmonscourt Road on land that belonged to Christ Church Cathedral.[10] It opened for worship in 1830, and was built in the Gothic revival style. The architect for this church was John Semple, a distinguished Dublin architect, and the building was completed at a cost of £4,500. The church contains a window by Edward Burne-Jones (1833-1898), the distinguished British stained-glass artist. It is a memorial to Minnie, wife of Mr Justice Madden of Nutley.

There are very few records from 1630 until the eighteenth century in relation to the development of a Catholic parish at Donnybrook. In 1615 the Catholic Church held a provincial Synod in Kilkenny where it was decided, among other things, to re-constitute the parishes in Dublin. From

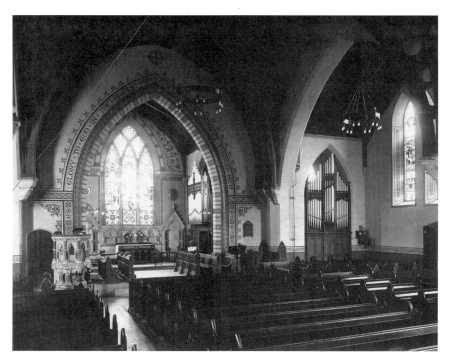

Interior of St Mary's Church at the junction of Simmonscourt and Anglesea Roads.
(Courtesy Representative Church Body Library)

1617 to 1787 Booterstown, Blackrock, Stillorgan, Kilmacud and Dundrum were all pre-Reformation sub-parishes of Donnybrook. In the eighteenth century the Archbishop of Dublin, John Troy, created a parish consisting of Booterstown-Blackrock, Stillorgan and Dundrum.[11] Donnybrook retained Ballsbridge, Ringsend and Irishtown, and a Fr Nicholson was appointed parish priest. Shortly afterwards Archbishop Troy decided a new chapel was needed in Donnybrook and he appointed Fr Peter Clinch to the parish. A new chapel for Catholics was built in 1787 beside the Protestant Church of St Mary in Donnybrook Graveyard, and it too was called St Mary's.[12] The wall of this church is the wall dividing the graveyard from the Garda Station in the village. This church remained in use until the Church of the Sacred Heart, the present Catholic Church, opened in 1866 on the site of the Donnybrook Fair, now the home of Bective and Old Wesley Rugby Football Clubs.

During the years when there was no Catholic Church in Donnybrook, the Old Catholic families like the Fitzwilliams, the Archbolds and the Wolverstons, provided sanctuary for priests who celebrated Mass in the chapels attached to their homes.

The boundaries of Donnybrook parish have changed dramatically over the centuries. It once included not only Sandymount and Ringsend, but also Haddington Road, Dundrum, Booterstown and Blackrock. According to the Census of 1831, the Catholic population of Donnybrook was about 8,000 people, most of them living in great poverty.

In the 1840s it was decided that the Catholic church in the graveyard was not sufficiently large for the growing Catholic population of Donnybrook. Monsignor Andrew O'Connell, appointed by the Archbishop of Dublin to the combined parishes of Donnybrook, Irishtown, Ringsend and Sandymount in 1849, began a building campaign to replace the old churches with new ones. Dr O'Connell acquired a new site on the right bank of the River Dodder, facing the old Fair Green, as a location for the new Catholic church for Donnybrook.

Work on the new church, which was to be dedicated to the Sacred Heart, began in 1860. The foundation stone was blessed and laid on 12 June 1863 by Archbishop Paul Cullen. (It has been said that it was built in reparation for the sins of intemperance, and the violent and righteous behaviour which was common at the Donnybrook Fair over the centuries.) The new Catholic church cost approximately £7,000 to build. The original architect was Patrick Byrne (1783-1864), but he had to resign due to ill health in

1863.[13] Pugin and Ashlin, a well-known firm of Dublin architects who were in partnership from 1860 to 1868, then took over. Edward Welby Pugin (1834-1875) was the son of Augustus Welby Pugin (1812-1852), the well-known church architect. George Coppinger Ashlin (1837-1921) had married Edward Pugin's sister, Mary Pugin (1844-1933), so there was a family connection between the two. The builder of Donnybrook church was Michael Meade, a well-known Dublin builder, who constructed a number of important buildings around Dublin, together with many houses at the Merrion Road end of Ailesbury Road.

The Church of the Sacred Heart was built of granite with Bath Stone dressings. It was highly ornamental in character and the internal dimensions are 148ft in length by 58ft in width. The aisles of the church are separated from the nave by an arcade of six arches that rest on polished Cork marble shafts, with carved Caen stone capitals. The opening ceremony took place on 26 August 1866, which was the same date that the Donnybrook Fair normally started.[14] The church contains a beautiful rose window in the west gable and there are some lovely stained-glass windows (St Malachi and St Bernard) by Harry Clarke and Michael Healy (St Patrick, St Eithne and St Feidhlim).[15] A Mrs Jury of Greenfield presented the Stations of the Cross to the church in 1887 and Mrs Catherine Dignam presented the High Altar, in memory of her husband. The Altar of Our Lady was a gift from William McDermott Fitzgibbon while John R. Corballis of Roebuck presented the windows over the Sacred Heart statue. Other benefactors were the Egan and Martin families, who presented the windows of St Rita and St Bernard.

At a meeting held in 1912 to raise funds for the completion of the Church of the Sacred Heart, it was decided to erect a tower instead of the spire that was in the original design of the church. Many might have preferred a steeple for the top of the church, but a tower was considered a much safer proposition. The tower was completed at the cost of £1,200. In 1915, Monsignor Dunne took over the parish building debt of £3,000. Through the generosity of parishioners, and with the proceeds of a bazaar, the debt was cleared. There was also money left over to be used for improvements to the church and, as a memorial to his predecessor, Cannon Gossan, Monsignor Dunne used a portion of this money to install electric light in the church. It is interesting that the Church of the Sacred Heart was not consecrated until 1923, the year when the parish debt was cleared!

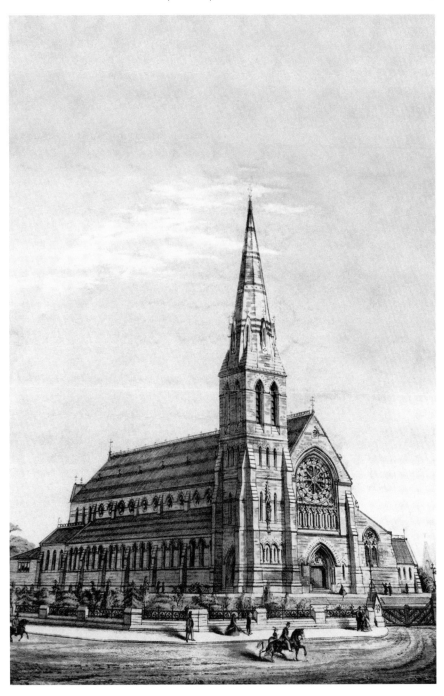

Original architectural drawing for the Church of the Sacred Heart, 1866. (Courtesy John Holohan)

Consecration and blessing by Dr Edward J. Byrne, Archbishop of Dublin of a stone cross found in the old Donnybrook Graveyard, 1923. (Author's image)

On 19 July 1923, Revd Dr Edward J. Byrne, Archbishop of Dublin, conse-crated a stone cross which had been found in the old Donnybrook Graveyard when the road was widened. This probably belonged to the earlier church, which was located in the old graveyard in the centre of the village. In 1936 the old stone cross was incorporated into a wall of the new extension to the church. The architect for the extension was W.H. Byrne & Sons and it was built by W. & J. Bolger, the well-known Dublin builders, whose family continues to live on Eglinton Road to this very day. The extension consists of two transepts, which have a capacity of 700, together with a baptistery and a mortuary chapel.

The present-day parish of the Sacred Heart extends from the south side of Ranelagh Road to the RDS Ballsbridge and from Belfield to Leeson Street Bridge.

There is also a Wesleyan Methodist church (now disused) in Donnybrook, at the back of No. 9 Beaver Row, which was built by the Wright Brothers who had a hat factory on the site of Eglinton Park.

Another religion with their church in Donnybrook are the Christian Scientists, whose church, the First Church of Christian Scientist, is on Herbert Park Road.

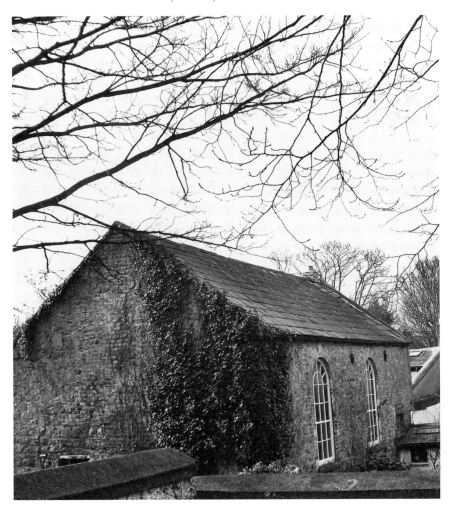

Wesleyan Methodist church (disused) at the rear of No. 9. Beaver Row. (Courtesy Glenda Cimino)

Donnybrook Village

Some of the earliest photographic images of Donnybrook village go back to the beginning of the twentieth century and show a variety of shops and their customers. In the nineteenth century, according to a number of *Thom's Directories*, Donnybrook had become home to many of the prosperous merchants in the city of Dublin and among the manufacturers it listed for Donnybrook were smiths and farriers, millwright, boot and shoe makers, coopers, and manufacturers of jaunting cars, gig carts and dray carts.

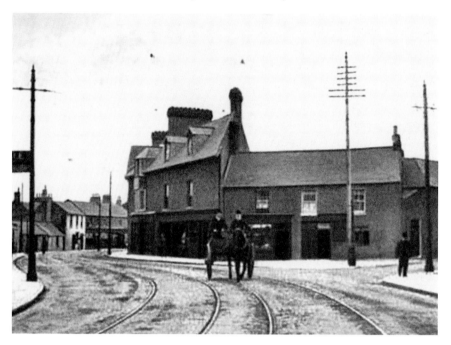

Donnybrook village, *c.* 1905. (Author's collection)

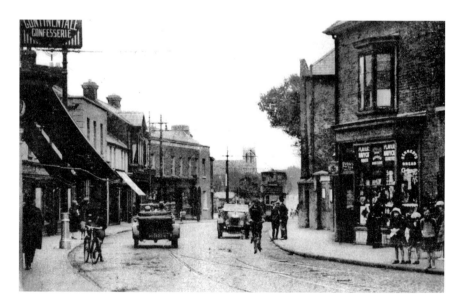

Donnybrook village, *c.* 1925. (Courtesy of Dr Donal Kelly)

Donnybrook Graveyard

In the heart of the village of Donnybrook lies Donnybrook Graveyard.[16] The earliest recorded burial in this graveyard was that of Sir Richard Fitzwilliam, who died in 1595. He was a member of the Fitzwilliam family, who were wealthy landowners in Donnybrook and its environs. For more than 400 years the Fitzwilliam family influenced life in Donnybrook from their castle, which is now the Home for the Blind in Merrion and Caritas, a convalescent home run by the Irish Sisters of Charity.

The graveyard, according to tradition, was the location of an old Celtic church founded by St Broc. In later years there were two churches on the site dedicated to St Mary. The graveyard was in use between AD 800 and 1880, with the exception of some later burial rights to 1936, when the last interment took place. It is interesting to note that the graveyard was the burial place of rich and poor.[17]

Memorials to the dead were not common until the late seventeenth century, when they became ubiquitous. From the eighteenth and nineteenth centuries there are a variety of different types of headstones in the graveyard, including box tombs and flat slabs lying on the ground. What is significant about Donnybrook Graveyard is that Catholics, Protestants, Jews and Huguenots all lie together. It was not until the middle of the nineteenth century that separate graveyards were opened for Catholics. At one time there was what was called a cholera hole just inside the gate, where people who died in the cholera epidemics during the nineteenth century were buried. The bodies from this mass grave were found when the road was widened in 1931 and were re-interred in the southern part of the cemetery.

There is evidence to suggest that the entrance to Donnybrook Graveyard was originally located to the south, where the Sisters of Charity convent now stands. Today's entrance is through an archway that was erected in 1893 in memory of Thomas Chamney Searight, who was Registrar of the Dublin Stock Exchange. He and his family are buried in this graveyard. The archway plaque states:

> This memorial has been erected by the members of the Dublin Stock Exchange to the late Thomas Chamney Searight for many years the registrar to their society. He died May 27th 1890 and his remains are buried in this churchyard.

Over the years Donnybrook Graveyard became neglected and in 1847 improvements were made to it and in the following century Dermot Lacey, a former Lord Mayor of Dublin and a city councillor, chaired a Department of Labour-funded Social Employment Scheme for the Donnybrook area which cleaned up the graveyard.[18] Cecil Harmsworth King and his wife Dame Ruth King were also involved in the project and contributed financially to it. The graveyard was re-opened by Cearbhall O Dalaigh, President of Ireland, in May 1977. In more recent times Donnybrook Graveyard became the responsibility of Dublin City Council. Today David Neary, a local historian, conducts regular tours of the graveyard during the summer months.

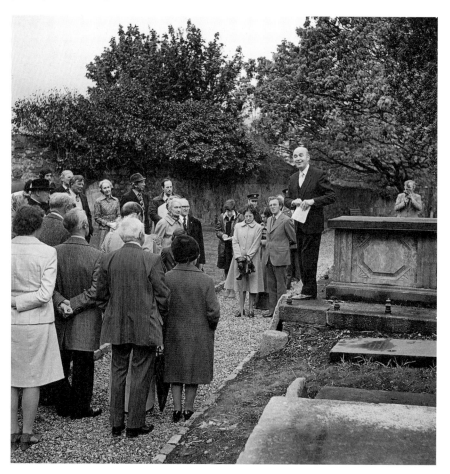

President Cearbhail Ó Dálaigh speaking at the re-opening of Donnybrook Graveyard in 1977. (Courtesy Dublin City Libraries)

The Revd Beaver Blacker, in his *History of the Parishes of Booterstown and Donnybrook*, points out that the Fitzwilliam family had a small chapel attached to the old Protestant St Mary's Church where members of their family were buried, including Sir Richard Fitzwilliam. With the move to the new Church of Ireland on Anglesea Road, the Fitzwilliam family chapel disappeared. However, there is a baptismal font and other items from the Fitzwilliam chapel in St Mary's Church on Anglesea Road. The Fitzwilliam family remained Catholic until the death of Thomas, 4th Viscount Fitzwilliam, in 1704. Richard, 5th Viscount, took the oath

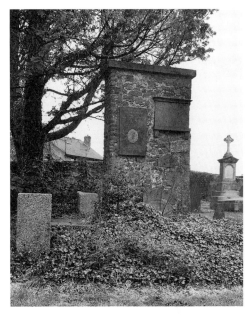

The remaining piece of the wall of old St Mary's Church in Donnybrook Graveyard and the plaque commemorating Bartholomew Mosse was designed by a member of the Mosse family in County Kilkenny. (Courtesy Dublin City Libraries)

of allegiance to the Established Church and he became a member of the House of Lords in 1704. The 7th and last Viscount Fitzwilliam did not marry, and when he died in 1816 his estate passed to his cousin, the 11th Earl of Pembroke. The history of the Pembroke Estate in Ireland therefore dates from 1816. The Revd Beaver Blacker's history contains details of about two-thirds of the inscriptions in the graveyard, together with those which no longer exist. He mainly recorded details of the well-known people who were buried there and had little interest, it appears, in the graves of the lower classes of society!

Among those that Blacker lists as being buried in the graveyard are: Archbishop William King (1650-1729), Archbishop of Dublin; Bishop Robert Clayton (d. 1758), a Church of Ireland Bishop of Cork and Ross and who is interned here with his wife Katherine (he built No. 80 St Stephen's Green, now the home of the Department of Foreign Affairs); Revd Richard Graves, DD (1763-1829), who was Dean of Ardagh and Regius Professor of Divinity at Trinity College Dublin; Bartholomew Mosse (1712-1759), who founded

the Rotunda Hospital; William Ashford (d. 1824), the distinguished landscape painter and the first president of the Royal Hibernian Academy; Robert Haig, a member of the famous Haig Scotch Whiskey family; and Leonard McNally, who betrayed Robert Emmett.

Irish doctor, writer, abolitionist and biographer of the United Irishman Dr Richard Robert Madden (1798-1886) was also buried here with other members of his family. He had a varied and interesting career which included working in the West Indies and Africa as superintendent of the abolition of slavery. Madden was also a great traveller and wrote books on Savonarola, Gallileo and Lady Blessington (an Irish novelist). Leon O'Broin (1902-1990) a civil servant, writer and playwright, spent time trying to identify the location of Madden's grave and in his article 'The Hunt for Madden's Grave', he tells us that he managed to identify it by stumps of Cypress trees.[19] Madden, it seems, had brought back a number of Cypress trees from his travels and had planted them around his family grave, where he was later interred.

The twelve-year-old son of Abraham Colles, the well-known Dublin surgeon after whom the Colles fracture is named, and former president of the Royal College of Surgeons in Ireland, who lived in Donnybrook Cottage on the Stillorgan Road, is buried in a box tomb in this graveyard, although his father is buried in Mount Jerome.

Sir Edward Lovett Pearce (1699-1733), a well-known Irish architect, is interred here, but the location of his grave has not been ascertained. A plaque to his memory was unveiled by Dr Edward McParland (Trinity College) on behalf of the Royal Institute of Irish Architects in 1990. Lovett Pearce became one of the leading proponents of Palladian architecture in Ireland. His most famous buildings are: the former Houses of Parliament, now the Bank of Ireland, in College Green; Castletown House; the Archbishop's Palace in Cashel; and Bellamont Forest in County Cavan. Drumcondra House and Gloster House near Birr in County Offaly are also attributed to him. Of local interest is the fact that he was responsible for the obelisk and grotto at Stillorgan, County Dublin, which was derived from Bernini's fountain in the Piazza Navona in Rome. Lovett Pearce's father was a first cousin of Sir John Vanbrugh, the English architect, and he appears to have trained with him. He was appointed Surveyor General of Ireland in 1730, a post that he held until his untimely death in 1733 at his home, 'The Grove', in Stillorgan. He received a knighthood the year before he died.[20] Sir Edward Lovett Pearce was MP for Ratoath. His brother, Lieutenant

General Thomas Pearce, is also buried in Donnybrook graveyard. He was a member of the Privy Council, Mayor of Limerick and also represented Limerick in Parliament.

The last two internments in Donnybrook Graveyard were the two sisters of the Revd Gore Ryder, Elizabeth (d. 1935) and Amy (d. 1936).

The Irish Genealogical Research Society set up a sub-committee in 1972 to encourage and coordinate the work of recording grave inscriptions throughout the country. Julian Walton copied the inscriptions in Donnybrook Graveyard in 1976. A complete list of 240 inscriptions is available in the sub-committee's archive in the Irish Genealogical Office. Danny Parkinson's book *Donnybrook Graveyard* is also an invaluable source of information.

Donnybrook Parish Records

Most of the Church of Ireland records were sent to the Public Records Office in the late nineteenth century and they were unfortunately destroyed in the fire of 1922 at the Custom House. However, the Donnybrook registers still survive. Records exist of baptisms, marriages and burials from 1712 to 1768 and from 1800 onwards in the Representative Church Body Library. There are also a few baptismal records for 1705-1712 and records of marriages in the parish from 1776 to 1800. The Donnybrook parish records are now available online, thanks to the Irish National Archives.

Since the Catholic church in Donnybrook has only existed as a separate parish since 1876 the registers of the larger parish were held in St Mary's Church, Haddington Road. Recently these records, containing details of baptisms and marriages from 1798, became available online.

Poor Clare's, St Damien's, Simmonscourt Road

In the late nineteenth century Simmonscourt came into the hands of the McCann family. Mary McCann was born on 11 August 1873 but she was so frail and delicate that it was thought that she might not survive into adulthood. She wanted to become a Poor Clare sister, so joined a Poor Clare convent in Carlow in 1900. The Poor Clare's decided to send her to

Poor Clare's Community, St Damien's, Simmonscourt Road. (Courtesy Mother Abbess Sr Patrice)

their monastery in Levenshulme, Manchester for her novitiate. Some years later, they wanted to set up a foundation in Dublin, and Sr Magdalene asked her parents, who were very wealthy, to give them St Mary's Lodge in Donnybrook, which they owned, for this purpose. Permission was then obtained from the Archbishop of Dublin, Dr Edward J. Walsh, for the new convent.

The new convent needed an abbess and Sr Magdalene asked if Mother Genevieve, who had trained with her in the novitiate in Manchester, could be appointed to the post. She accepted the post and the new convent opened in 1906. Mother Genevieve held the post of abbess for twenty-seven years.

Between 1908 and 1912 the congregation continued to attract postulants.[21] During the First World War, twelve sisters from Niewport in Belgium came and stayed with the Donnybrook congregation and the sisters kept in touch after they returned to Belgium.

Lack of postulants in recent years has led to a rationalisation of the Poor Clare convents and the different houses. On 16 January 2008, the Poor Clare community from Southampton joined those in St Damien's on Simmonscourt Road. The Poor Clare's continue their work of prayer at St Damien's to this very day, under the direction of their Abbess Sr M. Patrice.

Irish Sisters of Charity

In December 1816, the Irish Sisters of Charity was officially established with permission of Pope Pius VII by Mother Mary Aikenhead. Mary Aikenhead was born a Protestant, in Cork city, in 1787. She converted to Catholicism and felt the calling to the religious life.[22] Her dream was to set up a religious congregation devoted to serving the poor and the Irish Sisters of Charity have made this their mission since their foundation.

The Irish Sisters of Charity provided a number of Magdalene Asylums in Dublin, including the one in Donnybrook. These asylums were common throughout Europe and Ireland between the eighteenth and the late twentieth centuries. Prior to the move to Donnybrook, the Magdalene Home had been located in Townsend Street.

The Donnybrook Magdalene Home and convent was built on the site of Donnybrook Castle. The castle, which belonged for centuries to the Ussher family, was demolished in 1759 and a new house was built on the site in 1798. In 1837, Mother Mary Aikenhead bought this house for the Irish Sisters of Charity.

As well as running the asylum and laundry, the Irish Sisters of Charity have, over the years, done a great deal of work to help the poor of Donnybrook and surrounding areas. The political and economic policies at national and international level during the nineteenth and early twentieth centuries made life difficult for the poor, who suffered from lack of employment and squalid living conditions. They visited the sick regularly and ran a social service, including hot dinners for the unemployed and poor in Donnybrook. Today, the Donnybrook Parish Community Centre, located in St Mary Magdalene's in the parish, carries on this work.

Gayfield/Avila

Gayfield on Bloomfield Avenue in Donnybrook dates from the eighteenth century and was originally built for the Yelverton family. It was sold in 1859 to the Dioceses of Dublin as a site for a new seminary. The diocese also purchased Clonliffe and opted to make this the location for the diocesan seminary instead of Gayfield. In 1863 Gayfield became a hall of residence for Newman's Catholic University.

Gayfield changed function in 1865 when Revd Edward O'Donohue opened a school for boys there and this existed between 1866 and 1874. In the novel *Geoffrey Austin*, Canon Sheehan provides a glimpse of Gayfield as a boarding school, surrounded by orchards and green fields. In 1884 the Carmelite fathers, who had purchased the house in 1875 for the sum of £5,200, opened it as a House of Studies. Shortly afterwards there was a need for additional accommodation so an extension was completed in 1886. The well-known Dublin architect Patrick Byrne designed the new church for the community in 1902. The Carmelites made further additions to Gayfield, with extensions in 1934 and 1946. Unfortunately there is no trace today of the original Georgian house.

In more recent times the Carmelite Fathers opened a new centre called Avila and that is the name by which Gayfield is now known.[23] Avila can be used as a conference centre but the emphasis of the new centre is on the running of retreats and short courses. Accommodation is available in Avila for self-catering retreats.

The Community of St John the Evangelist (Ireland)

The Community of St John the Evangelist run St Mary's Home in Pembroke Park. This order of Protestant nuns was founded in Sandymount in 1912 by Revd Fletcher LeFanu, the rector of St John's. From the beginning, the nuns had an orphanage, a boarding school for girls, visited prisons and hospitals and then opened a home for elderly women.

This religious community had a branch house in Wales from the 1930s and this became the Mother House in 1967. In 1996, the nuns moved to the house originally taken over in 1959 from the Community of St Mary the Virgin, founded in the 1890s. The present house was formerly a school, and then a home for elderly ladies of the Church of Ireland. It is now a Registered Nursing

and Residential Home under the care of the community but run by lay people. The home is run almost entirely on voluntary donations. The remaining Sisters of the Community of St John the Evangelist continue to live in St Mary's Home, where the only very active member of the community is Sr Verity Ann.

The Royal Hospital, Donnybrook

The Royal Hospital has a long and interesting history. Located at the top of Bloomfield Avenue, the earliest surviving records of the hospital date from 1771. It was founded in 1743 at Townsend Street as a hospital for incurables, on the initiative of the Charitable Musical Society of Crow Street. The present site of the hospital in Donnybrook was originally called Buckingham Hospital, named after John Hobart, Earl of Buckinghamshire and Lord Lieutenant in Ireland (1777-1780). Buckingham House is still extant and is part of the Royal Hospital today. It was a lock hospital (a hospital for the treatment of venereal diseases) and it transferred to Townsend Street in exchange for the Donnybrook premises that became the Royal Hospital for Incurables. Between

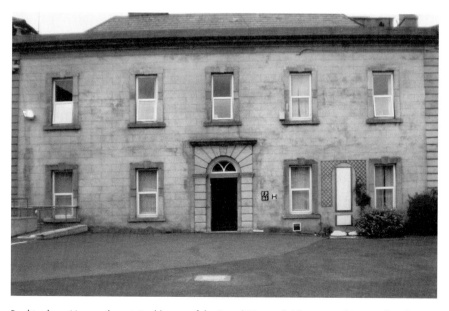

Buckingham House, the original house of the Royal Hospital. (Courtesy of Hospital Archivist Stephen McCormack)

1771 and 1799 fifty governors were elected to run the Royal Hospital and it is interesting to note that between 1800 and 1900 there were 1,233 governors, of whom 316 were female. This was a voluntary hospital which admitted patients for life. The hospital was expensive to run because its diet was generous. Patients were clothed well and the hospital also provided what they called stimulants (beer, wine, brandy and whiskey) for the patients!

Over the years the hospital relied on charitable donations, bequests and fundraising. There have always been a large number of volunteers helping out in many different ways as well as the full-time staff. The earliest building on the site dates from 1784. Located in thirteen acres of grounds, the Royal Hospital is an independent, voluntary, charitable organisation and today it is associated with St Vincent's University Hospital.

In recent times, the Royal Hospital has developed a reputation as the 'largest provider of its kind of rehabilitation, respite and continuing care.' It is also the oldest continuously operating hospital of its kind in Ireland and in the United

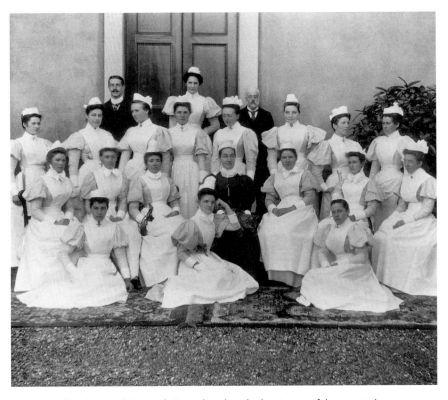

Nursing staff at the Royal Hospital, Donnybrook at the beginning of the twentieth century. (Courtesy of Hospital Archivist Stephen McCormack)

Kingdom. Today it offers particular expertise in the care of the elderly as well as those who are chronically ill and disabled. Dr Helen Burke, to celebrate the 250th anniversary of the founding of the hospital, wrote a wonderful book on the history of the Royal Hospital and its activities.[24]

The Religious Society of Friends (The Quakers)

The Religious Society of Friends has been in Ireland since 1654. The Quakers are well known for their charitable work and they are also involved in education in Ireland. Their schools included Rathgar Junior School, Newtown School in Waterford, and the Friends School in Lisburn.

There is evidence from the Quaker records that the Quakers have been in Bloomfield Avenue in Donnybrook since 1811.[25] This was the year when Bloomfield Hospital was founded to provide mental health and nursing home care for the elderly and for those suffering from dementia. It was modelled on a similar hospital run by the Quakers in York.

Bloomfield House originally belonged to William Saurin, who was a powerful figure in Dublin in the nineteenth century. He was offered the post of Solicitor General in 1798 but turned it down because he was not a supporter of the Act of Union. In the nineteenth century he became Attorney General and was very much opposed to Catholic Emancipation. In 1802 he sold Bloomfield to Dr Robert Emmet, who became physician to Swift's Hospital, St Patrick's Hospital. He was the father of Thomas Addis Emmet, and Robert Emmet and the Emmet family retained Bloomfield after Dr Emmett's death, until they sold it in 1809, for £1,520, to the Society of Friends.

The Society of Friends also owned Swanbrook House on Bloomfield Avenue. Its origins were similar to Brookfield House as it was owned in the late eighteenth century by Gustavus Hume, who owned land in Donnybrook and a good deal of property in Dublin (Hume Street is named after him). In 1786 he leased land to George Cowen, a glazier from Dublin, and he erected a house on the site that he named Swanbrook, after the river of the same name that ran through the grounds. The house was probably re-modelled, if not rebuilt, at the beginning of the nineteenth century. Other owners included Alderman Frederick Darley, a former Lord Mayor of Dublin and member of the Corporation who also served as High Sheriff and held other public offices. Thomas Steel, James Lindsay, Revd John Chute and

Swanbrook House, Bloomfield Avenue, which was formerly owned by the Society of Friends. (Courtesy Society of Friends)

his son Arthur later occupied the house in succession. In the 1860s the property came into the hands of Colonel Edward Wright, who leased the property to Bloomfield Trustees in 1863.

The Bloomfield site also contained New Lodge (nursing care) and Westfield (residential home), together with the administrative office for the Religious Society of Friends in Ireland. Bloomfield moved from its original Donnybrook site to its current location in Rathfarnham in 2005, and today much of the

site has been redeveloped for modern housing, although there is a preservation order on the two old houses.

Radió Telefís Éireann

Radió Telefís Éireann (RTÉ) was established by the government of the day in 1960, to inaugurate a national television service and to take over Radio Éireann that had been in existence since 1926.[26] The national television service began on 31 December 1961. The main architects for the RTÉ Campus at Montrose have been the firm Scott Tallon Walker. The first building to go up on the new site was in 1961, when the television studio was completed. In 1967 three more buildings were completed: the Administration Building, a building for holding scenery and the RTÉ restaurant. The new radio centre was finished in 1973 and the move from Henry Street took place the following year. RTÉ continued to expand as the decades when by and in the 1970s additional lands adjacent to Montrose were purchased, including St Andrew's College playing fields, and Mount Errol house. In the 1980s and '90s further new buildings were added, including a sound stage and a TV programming building. According to documentation from Scott Tallon Walker, the architecture of the RTÉ campus 'expresses the continuity of design philosophy practised by Scott Tallon Walker over a period of forty years'.

There are long-term plans for the redevelopment of the RTÉ site at Montrose that includes a new Radio Centre and a new Television Centre, and a gradual replacement of the 1960 and 1970 buildings. A purpose-built National Broadcasting centre is required for RTÉ to enable it to provide high-definition programmes that are the way of the future.[27]

The River Dodder and Donnybrook

The River Dodder has always played an important role in the life of Donnybrook. The Dodder rises on Kippure Mountain, in Wicklow, and flows for fourteen miles through the south side of the city until it enters the sea at Dublin bay.[28] Up to the end of the eighteenth century the river was crossed in Donnybrook by a ford. In those days the river was wider and shallower and flooding was common. Major flooding occurred with Hurricane Charley

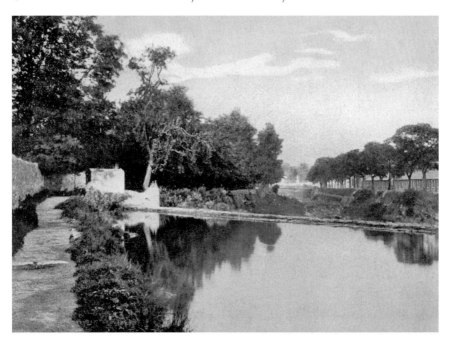

River Dodder at Donnybrook. The cottages on the right were built by the Wright Brothers for the staff of their hat factory. (Courtesy Michael Pegum)

in August 1986, when houses along the banks of the Dodder together with the RDS showgrounds were badly flooded. Also flooded were Bective Lawn Tennis Club and Merrion Cricket Club. More flooding occurred in 2011 and residents from Anglesea Road had to leave their houses for up to a year due to the damage caused.

The first bridge over the Dodder at Donnybrook was built in 1741, but unfortunately within a year it was swept away by floods. It was rebuilt a number of times during the next eighty years. The present bridge, the Anglesea Bridge, dates from 1832. It was named after Henry Richard Paget, Marquis of Anglesey, who was the Lord Lieutenant at the time.

Rivers have always been an important source of power and this was especially true during the eighteenth and nineteenth centuries, when a number of mills were built on the Dodder near Donnybrook. These included paper mills, cloth mills, iron mills, corn mills, flour mills and bleach mills. Some of the early maps even show a windmill near where Eglinton Terrace now stands.

Other industries in Donnybrook at that time included an iron works, salt works, a distillery, a hat factory and a large calico printing works. There

was also a quarry on the site of the present bus station and the stone was used in the construction of the Dublin to Kingstown railway. This was a great source of employment for the people of Donnybrook. Local people were also to be found working in the mills and factories of Donnybrook and Ballsbridge.

Tributaries of the River Dodder

There are two other rivers associated with the River Dodder: the Swan River and the Muckross Stream. The Swan River is 16km in length and runs through Rathmines, Ranelagh, Donnybrook and Ballsbridge (along Shelbourne Road) before it joins the Dodder at Lansdowne Road. Today the river mostly runs underground and acts as a storm drain. It is also part of the Pembroke/Rathmines drainage system.

The Muckross Stream is another tributary of the River Dodder and runs from Milltown to Donnybrook, where it joins the River Dodder. It begins near the Mageough Home in Rathmines and passes by Sandford School and Hollybank Avenue, Sandford Road and into the grounds of the Dominican Convent at Muckross Park. It then passes under six houses and gardens on Belmont Avenue, where it runs by the south end of Belmont Park and moves on to the present fire station, crosses the Donnybrook Road and enters Pembroke Cottages, from where it flows into the Dodder opposite Hazeldene, an apartment block on Anglesea Road.[29]

An early *Thom's Directory* describes Donnybrook as:

A large and pleasant village two miles from the Castle of Dublin, and much frequented by the citizens of Dublin on account of the good accommodation to be had there, particularly at the two principal tea-houses, one at the Sign of the Rose at the entrance of the place and the other a little further on kept by Mrs Darby.

Another nineteenth-century description from *Thom's* says:

At Donnybrook taverns and tea houses with the signs of the Dargle, the Red Cross, and the Rose, tempted the country tourist, and the quaint old church which then stood in the village repaid inspection.

There are a number of different places called Donnybrook throughout the world, including Australia, South Africa and the United States of America. There is also a Donnybrook in Cork city. There are at least two in Australia, one 210km south of Perth in Western Australia and one in Victoria, 33km north of Melbourne. In the USA there is a Donnybrook in North Dakota and one that is a suburb of Montvale, New Jersey. In South Africa there is a Donnybrook in KwaZulu-Natal and another in the Eastern Cape.

2

THE DONNYBROOK FAIR

Oh Donnybrook, jewel! Full of mirth is your quiver
Where all flock from Dublin to gape and to stare
At two elegant bridges, without e'er a river
Success to the Humours of Donnybrook Fair!

Eighteenth-century Dublin ballad

A Royal Charter of King John established the Donnybrook Fair in 1204 'to compensate Dubliners for the expense of building walls and defences around the city'. In 1215, King John extended the duration of the fair to fifteen days and a later charter chose 26 August as the date for the beginning of the fair. From that date the Donnybrook Fair took place over fifteen days from the end of August until mid-September and was held every year for over 600 years.

The site of the Donnybrook Fair is where Bective Rangers Rugby Club now stands but covered both sides of the road. Seamus Ó Maitiú, in his book *The Humours of Donnybrook*, has suggested that the site may have been where earlier gatherings took place as it was a border area and the site of an early church. Situated on the banks of the River Dodder, Donnybrook was on the edge of the jurisdiction of the City of Dublin, as granted by King John in 1172. It was probably also a site where there was a ford over the river and a major road to the south of the country passed through it. The Fair Green was also close to Donnybrook Graveyard, and popular gatherings have, for many centuries, been associated with burial places.[1]

Initially Donnybrook Fair was an important livestock and produce market, but as the centuries passed it became more like a carnival and funfair and for centuries was the largest fair in Ireland, attracting crowds of over 75,000

annually.[2] It had a wide range of stallholders not only from Ireland but also from Britain and America, trading mainly in livestock and also horses for local haulage.[3] Dealers and tradesmen would arrive in Donnybrook a week in advance of the opening of the fair. Tents had to be constructed, which were primitive in the extreme, with canvasses made of rags, sheets and scarves. Until it was abolished in 1837 by William Hodges, Lord Mayor of Dublin, Walking Sunday was held a week before the fair was due to open, when thousands of Dubliners would stroll out to Donnybrook to see the preparations for the fair in progress.

Tolls and taxes from the fair's activities were vested in the Corporation of Dublin and the following are examples of some of them:

> For every horse, mare, mule, gelding or ass sold, 6d; for every do. Swopped or exchanged, 6d each; for every cow, bullock or bull sold, 4d; for every do; one or two-year old sold, 3d; for every do; one year old sold 2d; for every sheep, pig or calf sold 1d. Hawkers paid according to the articles they were selling from 2d to 1s. Standings according to the ground they occupy from 6d to 3s.

However, during the 1690s the corporation needed to clear a debt so they transferred the right to the revenues of the fair to the Ussher family, who lived in Donnybrook and were a prominent mercantile family. In 1812 John Madden, who also lived in Donnybrook, purchased the rights to revenues from the Donnybrook Fair for £750. During the nineteenth century the Maddens received approximately £400 per annum from the fair. However, according to Professor Fergus D'Arcy in his study *The Decline and Fall of Donnybrook Fair*, the commercial importance of Donnybrook Fair had been in decline from the seventeenth century.

Food and drink were important elements of the Donnybrook Fair and, at one penny a portion or drink, was considered cheap. The following is a description of the Donnybrook Fair from the *Freeman's Journal* of 31 August 1778:

> How irksome it was to friends of the industry and well-being of Society, to hear that upwards of 50,000 persons visited the Fair on the previous Sunday, and they returned to the city like intoxicated savages.

Entertainment was also available in abundance. Sideshows, jugglers, acrobats, boxing matches, ballad singers, fiddlers and dancers all performed at

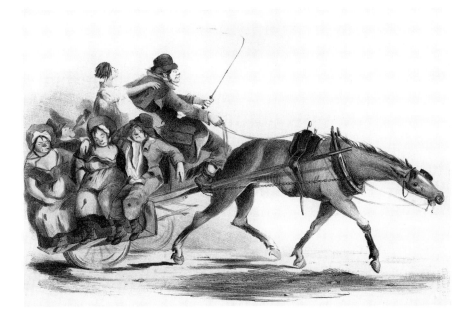

Caricature of people in a jaunting cart on the way to the Donnybrook Fair from a series of drawings, 'Sketches of Irish Characters from Life', by Captain Robert Williams. (Courtesy National Library of Ireland)

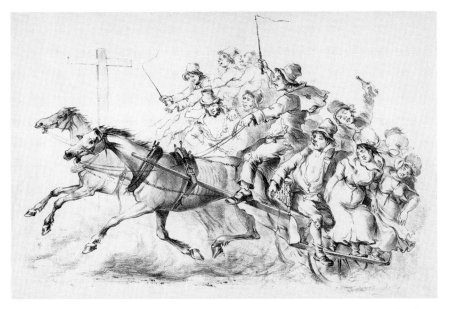

Caricature of people returning from the Donnybrook Fair from a series of drawings, 'Sketches of Irish Characters from Life', by Captain Robert Williams. (Courtesy National Library of Ireland)

Donnybrook Fair and the fair actually gave its name to an Irish jig and other Irish dances. Circuses were also a feature of the fair for many years, as well as theatrical performances.[4]

However, the most famous element of the fair was the fighting, which became notorious. In fact the term 'Donnybrook' entered the English language – according to the *Oxford English Dictionary* it means 'a scene of uproar and disorder; a riotous or uproarious meeting; a heated argument. Seamus Ó Maitiú has suggested that an Irishman is the only man in the world who fights for amusement!

Another description comes from the *Dublin Penny Journal*, vol. 2, 16 November 1833:

> Reader have you ever seen the Donnybrook Fair, that far famed spot for drollery and drunkenness, for courting and cudgeling, for gambling and gymnastics, for frolicking and fighting; a scene altogether so diversified and various, so thoroughly characteristic of the lower orders of our countrymen as to witnessed on no spot on earth besides our own dear Emerald Isle; the land of the shamrock and the shillelaghs. Here a troop of itinerant equestrians exiting the astonishment of the country clown and the well-dressed cut, they're a merry-go-round full of boys and girls getting their pennyworth of fun!

The Donnybrook Fair adversely affected the businesses in South County Dublin for its duration. An article by Laurence O'Dea in the *Dublin Historical Record* suggests that while the celebrations and fights at the Donnybrook Fair led to major problems of behaviour, a number of contemporary observers, both visiting tourists and Dublin journalists of the period, pointed out that the Donnybrook Fair frequently passed off without any major incidents.[5] An interesting description comes from Mr and Mrs S.C. Hall's book on their visit to Ireland in the nineteenth century:[6]

> Far famed 'Donnybrook' is but a shadow of its former self; we have indeed had the luck to see Donnybrook Fair ... The fair still keeps alive the memory of 'Donnybrook capers, that bother'd the vapours and drove away care' ... we were curious to see the difference between the Donnybrook of yesterday and that of today ... it was with utter astonishment, we noted the contrast and reckless 'devilry' of former times and the decent hilarity of the present.

The following poem may convey a fairly accurate description of Donnybrook Fair:

Behold what crowds at Donnybrook are seen
Some clad in yellow, others dressed in green
Boys in rags, swarthy hags,
buckish wags who ride their nags,
girls in tatters, wives in shatters,
hosiers, haters mending matters,
cheating bakers, pulpit shakers,
money stakers, mantua makers,
drunken sailors, valiant tailors,
undertakers, Sabbath breakers
God forsakes, midnight walkers
Thieves, thief takers.
Darting along as on the wings they flew
While others close the train with eyelids black and blue.
But hark! What strains inspire these jovial souls?
The piercing trumpets make its voice to soar
And now the drum its martial thunder tolls
While Prentice boys rebellow to the road.

In the nineteenth century a great deal of social and moral reforms took place, spearheaded by Church and State. It was a time of religious revival and the temperance movement. The fair, with its reputation of drunkenness and violence, became a great nuisance and embarrassment to the respectable people who lived in the village and so the Committee for the Abolition of the Donnybrook Fair was established, with the aim of raising the money required to purchase the fair license from the holder of the licence. Members of the committee included such prominent citizens as John Vernon, John Sibthorpe, William Dargan, the Lord Mayor, and the Archbishop of Dublin. The commissioners of the Dublin Metropolitan Police at the time, Colonel George Browne and John Lewis More O'Farrell, supported the committee's efforts by sending a subscription of £5 each. The army chiefs also contributed to the funds. A retailer of military footwear from Grafton Street, William Baxter, urged employers in the city to persuade their workforce to subscribe to the fund. The Baxter employees contributed a subscription of one shilling each.

A leading light in the committee was the Revd P.J. Nowlan, who regarded
the Donnybrook Fair as a major occasion of sin. He was appointed a Catholic
curate in Donnybrook in 1853 and seems to have been a reforming priest
of great zeal. It was he who managed to persuade his parishioner Eleanor
Madden, who owned the Fair's Charter, to part with it for the sum of £3,000,
which was a great deal of money in those days. The Corporation of Dublin
finally dissolved the Donnybrook Fair in 1855 and, according to Ó Maitiú,
the local police broke up the crowds attempting to assemble on the Fair Green
that year.

However, it did not quite end there as Joseph Dillon, a nephew of Eleanor
Madden, owned an inn in Donnybrook with a large garden, and continued to
hold his own version of the Donnybrook Fair in the garden, in defiance of both
Church and State. Up to 20,000 people per day continued to visit the Dillon ver-
sion of the Donnybrook Fair. This required a large number of policemen to be
in attendance every day. Inspector Peter Fitzpatrick of the Donnybrook Police
Station attributes the demise of this version of Donnybrook Fair,

> ... to the absence of music in the public houses of Donnybrook and the
> neighboring locality as there was not a sound of music to be heard in any
> public house in the whole subdivision; no doubt they all dreaded the refusal
> of their licences if they went against the police arrangements which were
> carried out effectively.

On the same day that Dillon's Donnybrook Fair ended, 26 August 1866,
the new Church of the Sacred Heart in Donnybrook was opened. This date
was chosen to symbolise the victory of virtue over vice.

3

SCHOOLS
AND COLLEGES

Over the centuries education has always been valued highly by Irish people.[1] From the beginnings of Christianity in Ireland until the end of the Middle Ages there were two educational systems in existence in this country: the Bardic schools and the monastic schools. The Bardic schools were less well known than the Irish monastic schools, but they somehow survived in remote parts of Ireland until the rebellion of 1641. Students in the Bardic schools studied history, law, language, genealogy and literature. The origin of the Bardic schools is unknown, for there was a Bardic order in existence in Ireland in prehistoric times and the position of Bards in Irish Society was well established. The Bardic profession appears to have been a hereditary profession and students took up to seven years to qualify as a bard.[2]

There were monastic schools in existence in Ireland as early as the sixth century.[3] Every large monastery had a school attached to it and they were celebrated and well known all over Europe, with students coming from far and wide to attend them. Irish monasticism seems to have come to an end with the Viking raids and invasion, which began at the close of the eighth century and lasted for over 200 years

There were parish schools in Ireland too that were established under King Henry VIII, and under Queen Elizabeth I diocesan schools were introduced to provide a grammar school education. These schools were in essence Protestant schools, as were the Royal Schools of James I and Erasmus Smith. However, some of these schools were attended by a small group of Catholic pupils.[4]

In general, formal education was denied to the Catholic people of Ireland from the seventeenth century as the English rulers were afraid that the Irish would become too powerful and rebel if they had access to education. From about 1695, the Penal Laws gave rise to a new kind of school in this country and also saw the establishment of Irish Colleges on the continent of Europe.[5] As a result, the Irish set up their own underground system of education and a network of so-called hedge schools existed throughout the country during the eighteenth and nineteenth centuries.[6] The quality of education varied considerably in these schools. Children were taught reading, writing and arithmetic and some of the schools also taught Greek and Latin. By 1824 there were approximately 11,000 schools in Ireland, most of which were hedge schools.

The National School system was established in 1831 and this led to the decline of both the hedge schools and the parish schools. At that time the government's aim was to promote harmony in Irish society through the provision of multi-denominational education. A National School Board was set up to collect the necessary money to build the schools, to develop a system of school inspections, to pay the salaries of the teachers and to establish professional training facilities for teachers.

Second level education emerged in the nineteenth century, predominantly under religious or denominational organisations. Broadly speaking these schools existed without State subvention until the early twentieth century. Second level education was standardised after the establishment of the Irish Free State through the introduction of the Intermediate and Leaving Certificate programmes.

In 1930 vocational education was introduced through the Vocational Education Act (1930), leading to the provision of vocational education and the Group Certificate examination. A government report, *Investment in Education* (1962), resulted, among other developments, in the upgrade in the status of vocational schools. Intermediate and Leaving Certificate courses were offered in vocational schools shortly after that. Currently about 25 per cent of secondary education students attend these schools. Vocational schools are entirely funded by the State and after 1967 funding was also extended to the Voluntary Secondary sector. A further development of State-subvented education came with the development of comprehensive education (1960s) and Community Schools (1970s). Today, Ireland has a well-established educational system at primary and secondary levels, as is evident from the first and second level school provision in Donnybrook.

Donnybrook Boys' National School

According to the Catholic Directory for 1831, there was a general free school for boys in Donnybrook with 100 pupils and there was also an evening school taught by the same master. It is not known where this school was located.

It was replaced by Donnybrook Boys' National School, which opened in 1870. The school building was erected and donated by John Corballis QC, who lived at Rosemount on the Roebuck Road. He wanted to provide a facility for the education of boys from Donnybrook and Clonskeagh.[7] The school was located in the townland of Belville and was built adjacent to the Catholic Church of the Sacred Heart. A plaque in the old school, which now operates as a community centre, commemorates John Corballis and the opening of the school.

In the early days it was the school manager who paid the teacher's salary of £10 per annum. When it first opened the building consisted of just one classroom. However, in 1892 the parish priest added another large classroom. In 1964 the building was reconstructed to turn it into a modern school with three classrooms, a teacher's room and central heating. The school finally closed in 1980 and was amalgamated with the Girls' National School on Belmont Avenue.

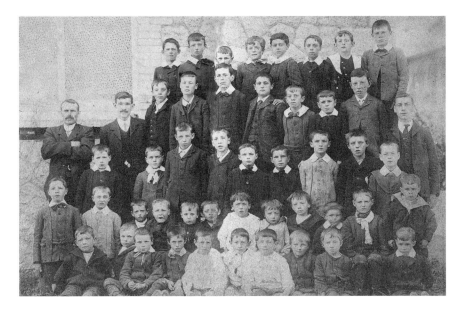

Donnybrook Boys' National School class in the early 1900s. (Author's collection)

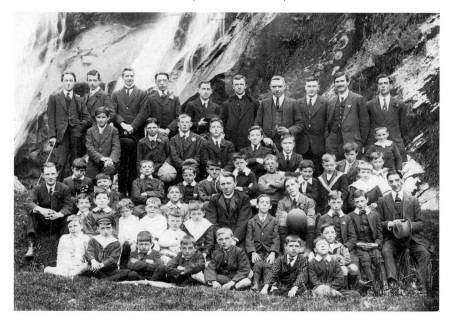

Donnybrook parish outing to Powerscourt in the 1920s. (Author's collection)

Erasmus Smith's School

D'Alton's *History of County Dublin* states that there was an Erasmus Smith's school in Donnybrook from the nineteenth century where about sixty boys and girls were educated. This presumably was the school on Beaver Row that eventually amalgamated with Sandford Parish School in Ranelagh and the building was demolished to make way for a modern development of houses in recent years.

St Mary's Girls' National School, Belmont Avenue

The earliest evidence for a girls' school in Donnybrook comes from an article by the late Joseph Redmond in *The Parish of the Sacred Heart, Donnybrook* edited by the Revd C.P. Crean, PP. Redmond records that a Mr Dillon of Roebuck paid £250 in 1835 for a house near the old chapel in Donnybrook, to be used as a school for Catholic girls. It appears that a James and Catherine Boyle, together with two sisters, A. and M. Gaffney, were involved in this school with the Misses Gaffney functioning as Lancaster Plan superinten-

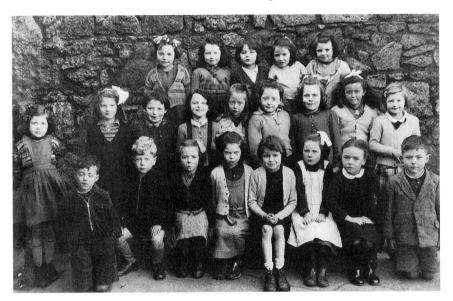

Junior infant class at St Mary's Belmont Avenue National School in the 1950s.
(Courtesy Sheila O'Shea)

dents. In 1835 there were 148 pupils in attendance, and subjects taught included reading, spelling, writing, arithmetic, and needlework.

The National Board of Education took over the school in 1879 and when Miss Gaffney retired the following year the school was taken over by the Irish Sisters of Charity, who had a fine new two-storey building constructed on Belmont Avenue. This building is still standing today and is currently in use as Donnybrook Youth Club.

The manager of the school appears to have been the parish priest of Donnybrook and when Canon Harris was the priest he added two large classrooms. Until 1912 teaching was shared between the nuns and some lay teachers; after that the nuns withdrew and only lay teachers taught.[8]

Demand for places in St Mary's Belmont Avenue National School grew over the years and finally, on 26 October 1968, a new school was opened and blessed by His Grace, Dr John Charles McQuaid, the Archbishop of Dublin. The new school, still in use today, is a two-storey building with accommodation for 270 pupils. The school has seven classrooms, a teachers' room, a principal's office, storage space and toilet facilities. Donnybrook Boys' Club now uses the old school.[9] The club dates back to 1965 and it was associated with the Conference of St Laurence O'Toole founded by the late Paul Liuzzi, who grew up on Belmont Avenue.

Dominican Convent, Muckross Park, Marlborough Road

Today Muckross Park is an entirely lay secondary school, with a Dominican ethos, having been set up and run by the Dominican nuns since 1900. It is now one of the Dominican schools in the Le Ceile Schools Trust that is made up of the schools of fourteen religious congregations.

Muckross Park was built by the nineteenth-century builder Patrick Cranny as his family home in 1865. The Cranny family owned Muckross Park until 1900, when Mrs Cranny sold it to the Dominican Sisters.

It is interesting to recall that Irish women were not permitted to attend lectures at either of the universities in Dublin during the nineteenth and very early twentieth centuries. The Old Royal University had admitted women to their examinations from 1879, but it did not provide lectures for female students. This led to the Dominican Sisters setting up St Mary's University College in 1886, which offered lectures and classes to female students, first in Eccles Street and then at 28 Merrion Square.[10] Its students obtained the highest of academic honours when they took the examinations of the old Royal University. In 1900 St Mary's University College

Junior school class, Muckross Park, 1949. (Courtesy school archivist Deirdre Mac Mahuna)

moved to Donnybrook, when the Dominican nuns purchased Muckross
Park from Mrs Maria Cranny.

On 4 August 1900 the *Freeman's Journal* reported the following:

St Mary's University College. Important Developments
The Dominican Sisters have just purchased as a permanent home for
St Mary's University College, the beautiful and spacious park known as
Muckross Park, Donnybrook with its fine residence.

The house of residence for St Mary's University College was on Mount
Eden Road, next door to the school entrance on Mount Eden Road, and it
was called Ard Eoin (now Glenwood). There was another house of residence
on the Morehampton Road. The teachers at St Mary's University College
comprised both Dominican nuns and lay staff and included: Professor
Mary Hayden, Professor Semple, Professor Arthur Clery (who went on to
hold Chairs at University College Dublin), Professor P.J. Merriman (a future
President at University College Cork), and Professor Mary Ryan (who went
on to hold the Chair of Franch at UCC). In 1910 Mary Ryan was appointed
Professor of Romance Languages at University College Cork, making her
the first female professor in Ireland and Great Britain. University College
Dublin opened its doors to female students in 1909. The major work of the
Dominican nuns in university education for women ceased with the excep-

Learning to drive – students of Muckross Park with Sr M. Barnabas OP in the 1960s.
(Courtesy school archivist Deirdre Mac Mahuna)

tion of Dominican Hall, St Stephen's Green, which continued to be run by the Dominican sisters until recent years.

In 1900 the Dominican sisters also opened a secondary school, a preparatory school and later a boarding school at Muckross Park. The Dominican Convent, Muckross Park, very soon gained an excellent reputation for the quality of its teaching and its students. By 1901 the secondary school was amongst the six leading schools of the year. That same year, twenty candidates were presented for public examinations and they won eight exhibitions, one gold medal, six compositions prizes and many others.

In 1907 a dormitory was built and a new secondary school wing was also added in 1925. Demand for places in Muckross continued and so another wing was built in 1935, consisting of science rooms, a hostel for nuns from the country attending University College Dublin, a junior school and a concert hall. The school chapel dates from 1945 and was designed by Eleanor Butler, a past pupil. Additional land was acquired in 1949 for playing fields, tennis courts and eventually an all-weather hockey pitch. It soon became necessary to add a fourth storey to the original school in the 1950s and 1960s as the numbers of pupils continued to increase.[11]

Besides receiving a high-quality academic education, drama has also played an important part in the Muckross education, and present and past pupils recall with pleasure the many plays and musicals that took place in the school's concert hall over the years. The late Sr Maebh and Mother Patrick spearheaded Ceilidhi, Feiseanna, Cumainn Gaelic debates, and visits to the Gaeltacht. As far back as 1903, Dr Douglas Hyde, presiding at a debate in Irish in the school, congratulated the Muckross staff and students on 'having the courage to be boldly and frankly Irish'.

Muckross has always been known as a great hockey-playing school and its past pupils founded Muckross Hockey Club, which is still in existence today. Over the years Muckross girls have achieved international fame playing hockey for Ireland. Joan Priestman (*née* Horne) was a distinguished hockey international as was Valerie Clancy (*née* Barry) who still lives in Donnybrook; both were inaugurated into the Irish Hockey Hall of Fame. Both Marguerite Barry (Valerie Clancy's sister) and Loraine O'Reilly were also international hockey players. Sandra O'Gorman, another past pupil, was one of the best international goalkeepers in the world and won the award for Outstanding Goalie of the 1994 World Cup. Alice Stanton, another past pupil who grew up on Anglesea Road, was a distinguished international cricketer and is now a professor at the Royal College of

Senior school class, Muckross Park in the 1950s. (Courtesy school archivist Deirdre Mac Mahuna)

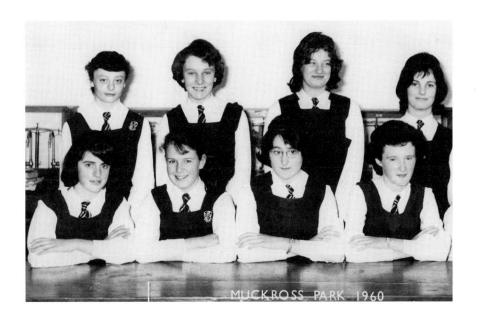

Pupils of Muckross Park, 1960. (Courtesy of Deirdre Mac Mahuna)

Surgeons in Ireland. Besides the Hockey Club, the Muckross past pupils formed their own Musical and Dramatic Society, and numerous plays and operas were produced over the years. The Past Pupils Union of Muckross is one of the oldest in the country and was founded twelve years after the foundation of the school. It celebrated its centenary in 2012 and a book of memories was published to commemorate the event, edited by past pupil Valerie Cox, the well-known RTÉ journalist.[12]

The Teresian School, Stillorgan Road

A very popular girls' school in Donnybrook today is the Teresian School, run by members of the Teresian Association who came to Ireland fifty years ago at the invitation of the then Archbishop of Dublin, Dr John Charles McQuaid.

The Teresian Association was founded by St Pedro Poveda, a Spanish priest and educationalist, in 1911.[13] The Teresians are a Lay Catholic Association who are committed to living Christian values in their family and working life. Teresian Association schools exist in many countries around the world.

When the Teresians came to Ireland they first opened a university residence for female students in 1960 at No. 12 Stillorgan Road. This residence continued in existence for four years before it closed down to make way for a school.

Today, the Teresian is a highly successful school and there are 492 pupils enrolled in either the pre-school, junior or secondary sections of the school.

Park House School

One of two private secondary schools which are no longer with us was Park House School, a Protestant school located on Morehampton Road. I am grateful to Margaret Pettigrew, whose mother was headmistress there for a number of years, for the following information.

Park House School was located at 74 and 76 Morehampton Road. It was initially owned and run by two sisters, the Misses Esther and Beryl Kennedy. When they retired the school was bought by a group of parents who operated it as a limited company.

The school was founded originally in 1930 as a preparatory school for Sandford Boys' School and it continued as such until 1934. In 1963, when

Margaret Pettigrew's mother Cecile Catt took over as headmistress, there were about 130 pupils at the school and that number soon rose to 500, with a long waiting list.

The school had an arrangement with the An Óige Hostel next door whereby the school used some of their rooms during term and An Óige used school-rooms in the holidays.

The girls at Park House wore green uniforms with blue blouses but in the sixth form, with the approval of the headmistress, they could choose from their own attire – very progressive for the period! Hockey and tennis were the main sports but the headmistress also introduced judo and fencing, the first girls' school in Ireland to do so. The headmistress also wrote and produced anthologies each Christmas in which all the children took part, with the exception of the kindergarten classes. Jennifer Johnson, the well-known Irish novelist, is an alumnus of Park House.[14]

When the Hall School in Monkstown closed Park House took it over, and the school also took over Glengara Park School in Dun Laoghaire. When Cecile Catt retired Park House amalgamated with Hillcourt School to become Rathdown School in Glenageary.

The premises on Morehampton Road have been occupied over the years by a number of different educational organisations and presently the John Scotus School is located there.

St Xavier's School

St Xavier's, which is also no longer with us, was a private Catholic boys' school located at 58 Morehampton Road, Donnybrook. Described as a school for the sons of Catholic gentlemen, St Xavier's existed from 1933 to 1961. The headmaster was Mr W.C.A. Hughes. He studied to be a Jesuit priest but never completed his studies. Before opening St Xavier's he had taught in Australia. Distinguished past pupils include Christopher Barry, Jim Buckley, Walter Beatty, John and Declan Costello, Julian Deale, Hugh Hamilton, Tiernan McBride, Oliver O'Brien, and the brothers Tom and Michael Veale. Another past pupil, Desmond Delaney, a well-known international veteran tennis player, recalled that the only sports facilities he could remember in St Xavier's was an old-fashioned gym horse in the back garden, which the boys used to exercise on!

St Andrew's College, Wellington Place

St Andrew's College was located on Wellington Place for many years. The school was founded as a secondary school for boys in 1894 at 21 St Stephen's Green. It moved twice in the next 100 years. Over the years student numbers increased, but, along with many Protestant schools, it went through a period of crisis during the early years of the Irish Free State. In the 1930s the number of registered students began to fall and the school seemed doomed. There was a determined effort by parents and past pupils to ensure its continuation and, in 1937, the school moved to new premises in Wellington Place, Clyde Road. As time went by the school needed to expand and the Board of Management bought adjoining houses in Wellington Place to cope with the increased numbers of pupils.

The college leased its playing fields on the Stillorgan Road from the Pembroke Estate, where the students helped it build an outdoor swimming pool in the 1940s. One of the headmasters, Mr Southgate, lived on Belmont Avenue in Donnybrook for many years.[15]

St Andrew's College eventually found that the site on Wellington Place could not cope with the growing numbers of students and it was not in a position to provide the sporting facilities needed by the school. Eventually a new site was acquired on Booterstown Avenue, and the present school was built there with a number of playing fields attached. The new school opened in 1973 and became a co-educational school, with the first group of female students arriving for the opening of the winter term in 1973. St Andrew's is no longer a boarding school and its students now number 1,200.

St Conleth's College, Clyde Road

St Conleth's College, a Catholic lay school, is located at the junction of Pembroke Park and Clyde Road and was founded by Mr Bernard Sheppard in 1939. He had been a teacher at St Xavier's School on the Morehampton Road prior to this.

St Conleth's began at No. 17 Clyde Road and moved to 28 Clyde Road in 1941. It is both a junior and senior school. The junior school caters for boys only, while girls are admitted to the senior school in the fifth and sixth year.

Mr Kevin Kelleher joined the school in 1944 and became headmaster in 1957, after the previous headmaster, Mr Bernard Sheppard, died suddenly

A garden party at St Conleth's College in 1944. (Courtesy A. Sheppard)

during the Christmas holidays. Teachers and pupils were devastated by this news. However, the dedication of his wife Patricia together with Mr Kelleher ensured the survival of St Conleth's to the present day.

Kevin Kelleher was headmaster of St Conleth's for many years. He was also a distinguished international referee and administrator of Schools Rugby. Sport has ways been an important part of life in St Conleth's, with cricket and fencing becoming popular with the boys in the 1960s. Past pupils of the school have represented Ireland at fencing in the Olympic Games.

A number of extensions were added to St Conleth's in the 1950s, '60s, '70s, '80s and '90s, in the form of additional classrooms, a gymnasium, a canteen, and an art and music room. All of these extensions were privately funded with no input from the State.

Today there are 330 pupils at the school. Ann Sheppard, daughter of the school's founder, Bernard Sheppard, is now the principal of St Conleth's, and is helping to develop and introduce plans to ensure the school's future.[16]

St Michael's College, Ailesbury Road

St Michael's College opened its doors to students on 8 May 1944. It was founded by the Congregation of the Holy Spirit (The Spiritans) as a Catholic

junior school for boys. In 1952–53 St Michael's saw its first students go into the first year, which became the origin of the senior school. Between 1944 and 1968 St Michael's continued to be a junior school, which had served as far as the second year, but in 1968 it was decided that the boys would stay in St Michael's until after the Intermediate Certificate. Fr Seamus Galvin was appointed the first president (1970–1976) of the fully-fledged primary and secondary school.

Under Fr Galvin's presidency, St Michael's became an independent school from Blackrock College. A building programme led by Fr Galvin began in the 1960s, when a block of ten classrooms, an assembly hall/gymnasium, swimming pool and chapel were added and 1972–73 saw the construction of a new library, classrooms and science laboratories.

First Under Tens Rugby Team (1944) at St Michael's College, Ailesbury Road. From left to right, back row: Billie Bolger, Brian Mooney, Stewart Barrett, John Cullen, Niall Coakley, John McMahon. Middle row: Garret Carton, Paddy Shaw, Ken Ryan (Capt.), Paddy Dempsey, Brian Howlett. Front row: Gerald Fogharty, John Tierney, David McGee, Des Colligan. (Courtesy Fr Seamus Galvin)

Sport has always played an important part in life at St Michael's College with rugby being the dominant sport. Over the years the school has won the Leinster Schools Junior Cup three times, in 1991, 2002 and 2012. Victory came to the Senior Cup Team in 2007 and again in 2012.

Rugby is not the only sport in which the boys of St Michael's participate. Basketball, tennis, water polo, Gaelic football, cricket and golf are other popular sports. There is also an annual play, often performed in conjunction with the Teresian School on the Stillorgan Road. The school also organises a fashion show with the pupils of Muckross Park that raises substantial sums of money for charity.

St Michael's can list a number of distinguished past pupils that include rugby international players, politicians, lawyers, doctors and actors.[17]

The original St Michael's house was built in 1860 by Michael Meade, a well-known Dublin builder, as his family home. It was modelled on Osborne House, on the Isle of Wight, the favourite home of Queen Victoria.

University College Dublin

Donnybrook is also home to the main campus of University College Dublin (UCD) that moved many of its faculties from Earlsfort Terrace and Merrion Street in the late 1960s and early 1970s. Known as Belfield, it takes its name from Belfield House and demesne, which was one of the properties acquired by UCD to form the main campus of the University. UCD dates from 1910 and the Irish Universities Act. It is interesting to note that Belfield was one of the sites originally suggested as a possible location for Dublin Airport, before a decision was made to locate it at Collinstown, the present home of Dublin Airport.

During the 1940s, the university authorities realised that it was time to plan for the future to facilitate the ever-growing student population. The aim was to acquire a site which would allow the college to develop a purpose-built campus which would unite all of the university's faculties. As far back as 1934, UCD acquired land and houses on the Stillorgan Road to form a potential new campus for the university. This included doing a swap with the government for a site on the same side as Belfield – in return the government acquired the site which now houses our national radio and television station RTÉ at Montrose.

In 1959, on the recommendation of a Commission on the Accommodation needs of the Colleges of the National University of Ireland, the government

of the day agreed, in principle subject to the approval of the Dail, that UCD could be transferred from the centre of the city to the Belfield site. The year 1947 saw the appointment of Dr Michael Tierney as UCD president, which led to firm plans being put in place to relocate. However, by 1969 most of the faculties were still in the Earlsfort Terrace building, which was chronically overcrowded. The University's Governing Body, with the approval of the government, finally made a decision to move the college to Belfield. This led to UCD's 'Gentle Revolution' of protests and sit-ins by the students over the proposed move to Belfield that took place. After many meetings with the college authorities the students grievances were eventually resolved.

The earliest new buildings in Belfield were completed in 1964, for the Faculty of Science, and, in the 1970s, the Faculties of Arts, Commerce and Law moved out to Belfield. The College Administration moved in 1972. Other faculties and facilities followed in recent years and, with the move of the Faculty of Medicine to Belfield in 2006, the College in its entirety is now on the one campus. President Michael Tierney's vision has been completed!

In the early days of the move to Belfield many of the old historic houses were reconditioned and became research departments for the college. Medical and Industrial Microbiology moved to Ardmore, Biochemistry and Pharmacology to Merville, Medicine and Surgery research were at Woodview, and Experimental Psychology and the Institute for Research into the History of Irish Families Abroad moved to Belgrove House.[18]

4

SPORTS AND LEISURE

Donnybrook is home to a number of sporting clubs, many of which have existed since the nineteenth century. For example, Beech Hill was the location of the first All Ireland Football Final, which took place in 1888 between

Plaque commemorating the first All Ireland Football Final, played at Beech Hill on 29 April 1888. (Author's Image)

the Limerick Commercials, who represented Limerick, and the Dundalk Young Irelands of Louth. Beech Hill Football Ground (or Byrne's Field as it was also known) was also the home of the Benburbs Club, which existed until the 1930s; Shelbourne Athletics, Shamrock Rovers, St James Gate and other soccer teams also used it. Byrne's Field finished its days as a rugby pitch, when it was rented to a club called Loyola, for whom Kevin Barry, the Irish patriot, played, and it was later rented to Old Belvedere Rugby Club. Other rugby clubs in the area include Bective Rangers Rugby Club, Old Wesley Rugby Club and Donnybrook is also home to the headquarters of Leinster Rugby.

Bective Rangers RFC

Bective Rugby Club began as Bective Football Club with past pupils from a school founded in 1834, called 'Bective House Seminary for Young Gentlemen'. It was a boarding and day school located at 15 Rutland Square East, now Parnell Square. One of its distinguished students was Bram Stoker, creator of *Dracula*, who went on to Trinity College, where he became involved with rugby, rowing and athletics.

Bective School closed down in 1885 and gradually membership was opened to non-Bective School past pupils and it was renamed the Bective Rangers Football Club.

James Joyce mentions Bective Rugby Club in *Ulysses*, *Finnegan's Wake* and *A Portrait of the Artist as a Young Man*. Why did Joyce choose to cite Bective in his work since there were a number of well-known rugby clubs in Dublin at the time? Bective was certainly one of the major rugby clubs and it had a number of prominent and distinguished members, including two of Joyce's schoolmates, Eugene Sheehy and W.G. Fallon. Joyce used information gleaned from these school friends in many of his writings.

Bective Rangers has produced an extraordinary number of Irish rugby international players going back to the nineteenth century and up to the present day. The club also provided a number of players for the Lions rugby teams that toured Australia, New Zealand and South Africa, they included: brothers L.M. and J. Magee, who played in South Africa for the Lions in 1896; J.L. Farrell ,who was on the Lions tour to Australia and New Zealand in 1930; G. Norton, who played for the Lions in 1950 on their Australian and New Zealand tour; and W.A. Mulcahy, who was a member of two Lions Touring Teams to Australia

and New Zealand (1959) and also the one which went to South African in 1962. Other famous men associated with Bective Rangers include Sir Charles Cameron, the distinguished public health physician who was president of the club for the decade 1898-1908, and Lorcan Sherlock, Lord Mayor of Dublin, who was a vice-president of Bective Rangers Rugby Club.

It is interesting to note that Bective Football Club was in existence before the Irish Rugby Football Union, which was founded in 1873. Bective RFC played rugby on a number of grounds around Dublin, including the Phoenix Park and the Royal Dublin Society, until it finally settled in Donnybrook in 1910. Their new home was the location of the old Donnybrook Fair, which had been abolished in 1855.[1]

Bective Rangers has always had an international and ecumenical dimension to its membership, with people from various parts of Ireland and the United Kingdom and from all creeds among its members. Cliff Morgan, the great Welsh rugby international, was a stalwart of Bective Rangers Rugby Team in the 1955/56 season. The club was dubbed the 'Morgan Rangers' as a result!

Old Belvedere Rugby Club

The origins of the Old Belvedere Rugby Club go back to 1918-1919. The club shared a ground with Old St Mary's at Beech Hill, Donnybrook at the beginning. A number of reasons, including the arrest and execution of Kevin Barry, a past pupil of the school, the internment of other rugby players including the captain, the loss of the playing field at Beech Hill, and the move to a less-than-perfect pitch in Clontarf, all contributed to the demise of the club during the 1922/23 season.

Old Belvedere Rugby Club was reformed as a junior club in 1930, and it was restricted to past pupils of the school. During the following years the club had a great run of victories that lasted until 1947. During that time the club won seven Senior Cups in succession. The club did not do so well during the latter years and in 1976 it was decided to make Old Belvedere Rugby Club an open club. One of the first non-graduates of Belvedere College to join were the current television personality Tom McGuirk, and the St Mary's Centre, Gary O'Hagan.

The acquisition of floodlights, which were installed in 1972, led to the inauguration of the Leinster Floodlit competition in 1987, which lasted

until 1999. The Anglesea Road ground lease was acquired by the club in 1944, but the first match was not played there until 1949 as the grounds had to be prepared for rugby. An old stand from Croke Park was acquired and this was in existence in the Anglesea Road grounds until it was lost in a fire in 1993. The present rugby pavilion opened in 1962 and the bar and ballroom were replaced in 1995.

The 1990s marked the modern playing era for Old Belvedere, with promotion to Division 2 of the All Ireland league, and a move to Division 1 took place in 2007. A ladies' rugby team was introduced in the 1990s and ladies' rugby continues to be popular.

Over the years Old Belvedere has won nineteen Senior trophies and sixty-five Junior trophies. Fourteen of its members have been capped for Ireland and six others were wartime internationals. In 1948 Karl Mullen, a member of Old Belvedere, captained the Irish rugby team which won the Triple Crown and, for the first time, the Grand Slam in the Five Nations Championship. Another well-known member of the club was Tony O'Reilly, who had a magnificent international rugby career. He went on to acquire twenty-nine caps

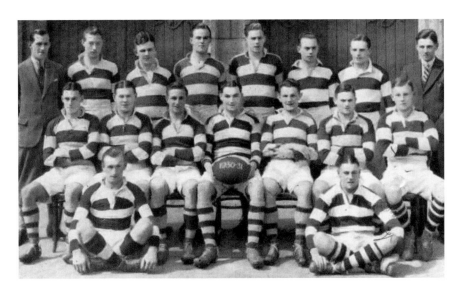

The first Old Belvedere Rugby Team (1930/31) to represent the club in Junior Rugby. From left to right, back row: H.M. MacNulty (Hon. Treas.), L. Murphy, A. Grant, J. Cummins, J. Byrne, J. Conroy, J. Nolan, F.A. Ingram (Hon. Sec.). Middle row: F. Lemass, P.J. Morgan, T.C.J. O'Connell (Capt.), T. Gleeson, R. Fox, P. Kevins, J. Brophy. Front row: T.C. Whelan, B. O'Reilly. (Courtesy Old Belvedere Rugby Club)

and took part in two of the Lions tours. Two other distinguished members of the club, Patrick Madigan and Barry Keogh, were presidents of the Irish Rugby Football Union (IRFU).[2]

Old Wesley Rugby Club

The past pupils of Wesley College, Dublin, founded a rugby club in 1891. It became one of the outstanding rugby clubs in Ireland and won the Leinster Senior Cup in 1909. The club celebrated its centenary in 1991 with a match against the Barbarians that they won with a last-minute drop goal! The club moved to Donnybrook during the 1919/20 season. A pavilion was built for the Rugby Club during the 1924/25 season and in 1946/47 improvements were made to the main Rugby Pavilion at Donnybrook.

The club's home ground is shared with Bective Rangers Rugby Club and the Leinster branch of the Irish Rugby Football Union. Old Wesley introduced a social club when the bar was installed and the pavilion extended in the 1963/64 season.

In 1981-82 work started on new dressing rooms and bar and in the 1983/84 season the new clubhouse was opened. In the 1990/91 season, Old Wesley signed a lease for ninety-nine years on the grounds at Donnybrook with the Leinster branch.

Over the years Old Wesley has had a number of international rugby players in the club, including Philip Orr, Eric Miller, Henry Hurley, Chris Pim, Dan Van Zyl, Dave Bursey, Mark Warburton, Austen Carry, George Hamlet and Eric Campbell.[3]

Merrion Cricket Club

Merrion Cricket Club was founded in 1906 by members of the old Land Commission Cricket Club, which played at Lansdowne Road Rugby Union ground between 1892 and 1900 and moved to its present grounds, at Anglesea Road, in 1908.

In 1919, the Leinster Senior League was formed, and the club was opened to members outside the Civil Service for the first time. Cricket victories in the 1924 and 1925 Intermediate Leagues led to their admission to the Leinster Senior League in 1926. In 1940 Merrion were unbeaten and they became the

first cricket club to win the League and Cup double. A twenty-year period of sustained success followed.

In 1952, Merrion Cricket Club purchased the lease on its ground at Anglesea Road, which was extended to its present size in 1958. Flooding from the River Dodder has always been a problem at the ground, due to their proximity to the river. During the period 1961-1994 Merrion endured two major floods and a fire that demolished their pavilion. At the same time the First XI struggled to compete, winning no trophies at all over a period of thirty-five years. Unfortunately, the club was demoted from the Senior League in 1994, a decision that was overturned by a vote of the other teams. Results improved immediately and four consecutive twenty-over competitions were won, along with the Senior B League in 1997 and 1999. By this time Merrion had grown to include seven men's and two ladies' teams, and its youth policy was the envy of every other club in Leinster.

The new millennium saw victory in the Senior A League in 2001 and the League Cup in 2007, another three twenty-over trophies, a triumphant Irish Senior Cup win in 2010 and a Leinster Senior Cup trophy in 2011. Merrion

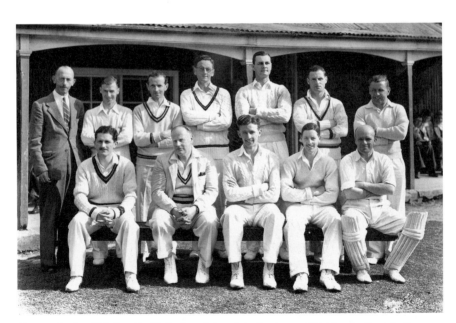

Merrion Cricket Club First XI, 1951. From left to right, back row: T.E. Murphy (President), D.J. McCourt, P.P. Waldron, C. Mara, J.P. Clifford, S.A. Curley, C.M. McAlinden. Front row: W.T. Campbell, R.H. Shortt, J.J. Burke (Captain), V.J. Holloway, W.L.C. Lindsay (wicket-keeper).

Cricket Club currently has eight men's, two ladies' and two Tavernier's teams, with schoolboy teams at all levels for boys and girls.[4]

Tennis Clubs

Donnybrook has been home to a number of tennis clubs since the late nineteenth century and it continues to be a popular sport in the area. The origin of tennis goes back to twelfth-century northern France, where a ball was struck with the palm of the hand. King Louis X of France was an active player of *jeu de paume*, which later became real tennis. However, it was not until the sixteenth century that tennis rackets were used and the game changed its name to tennis. A Major Walter Clapton Wingfield is credited with the development of the modern game. Tennis has been described, as 'a simple game affording vigorous exercise for people of all ages and players of both sexes, and it was played at the outset in pleasant social settings'. It was not a difficult game to learn and it very quickly spread to different parts of the world. The oldest tennis

Herbert Park tennis courts in the 1950s. (Courtesy Dublin City Libraries)

tournament in the world is the Wimbledon Championships, which were first played in London in 1877. Lawn tennis became the prerogative of royalty and the aristocracy until the First World War, after which class barriers diminished and this helped to extend the popularity of the game. Today tennis is a truly international sport played by millions of people all over the world.[5]

The history of tennis in Donnybrook goes back to the foundation of the Donnybrook Lawn Tennis Club in 1893. Since then Donnybrook has been home to a number of clubs, some that have disappeared and others that are still with us.

Donnybrook Lawn Tennis Club

The oldest tennis club in Donnybrook is Donnybrook Lawn Tennis Club, situated on Brookfield Road. The first meeting to form this club was held in the schoolhouse on Beaver Row in 1893. (The Erasmus Smith School Hall on Beaver Row became a regular place for Donnybrook Tennis Club to meet until it acquired its own clubhouse.) Initially a provisional Committee met and decided to accept the offer of Mr H. Bantry White for the use of part of a one of his fields at the rear of his house, 'Ballinguile', for a tennis club for three years. Ballinguile was located on Eglinton Road, but it was demolished some years ago and is now the site of a modern development called Eglinton Square. An estimate for laying down three grass courts at a cost of £27 was also accepted. Merrion Lawn Tennis Club offered to sell their pavilion, roller, lawnmower, marker, nets and posts etc. and this offer too was accepted.

The official opening of Donnybrook Lawn Tennis Club took place in June 1893 and by 6 September the same year the club had enrolled 147 members. While from the foundation of the club ladies and gentlemen were allowed to join it was not until 1948 that ladies were included on the club committee. The first 'At Home' was held in 1894 and it became an annual event at which to be seen, often with up to 800 people attending!

The first president of the club was Mr Justice Madden, and the Earl of Pembroke, who was president for nineteen years, succeeded him. Members of Donnybrook Lawn Tennis Club served with the British Army during the two world wars and they were made honorary members of the club for the duration of the wars.

Over the years Donnybrook Lawn Tennis Club has been one of the leading tennis clubs in Dublin. Their teams have won most of the major league and cup matches. Today, Donnybrook Lawn Tennis Club has a long tradition of producing great league tennis players at junior, senior and veteran levels. It has

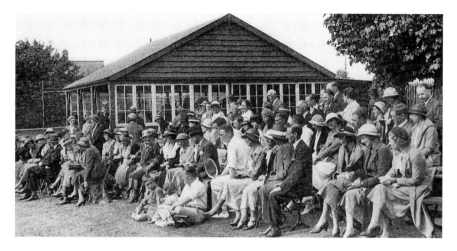

Donnybrook Lawn Tennis Club 'At Home' in 1934. (Courtesy Donnybtook Lawn Tennis Club)

a junior development programme, which is famous for producing players for national and international matches. Among its distinguished members was Miriam Healy (*née* Meehan), who represented Ireland at Junior Wimbledon in the 1940s. Another two members, brothers Frank and Jim McArdle, represented Ireland at international level. During the 1960s and 1970s Bernadette Davy was an Irish international tennis player along with Lesley O'Halloran. Today Lesley is No. 1 in the world rankings in over-45 tennis (both singles and doubles). Leinster players in Donnybrook Lawn Tennis Club included Valerie Clancy (*née* Barry), Paula Ledbetter (*née* Mullen) and Catherine Holohan.[6]

Anglesea Lawn Tennis Club
Anglesea Tennis Club was on Anglesea Road. The tennis facilities at Anglesea were excellent and they included eleven hard courts and six grass courts. It was a very active tennis club in its day, winning many trophies and inter-club competitions. An Irish international tennis player who lived on Anglesea Road and who began her tennis there was the late Betty Lombard. The grounds of Anglesea Lawn Tennis Club were eventually sold to the Licensed Vintners Association as their headquarters.

St Mary's Lawn Tennis Club
Past pupils of St Mary's College in Rathmines founded this club in 1948. In the early years tennis was played in the college sports grounds in Kenilworth Square, Rathmines. From 1952 to 1953 the club was in Harold's Cross, and in

1954 it moved to its present location on Belmont Villas that it bought from Percy Lawn Tennis Club. The grounds here had been in use as a tennis club from 1908.

Over the years St Mary's Lawn Tennis Club has been a very popular Tennis Club and continues to be so to this day. The annual At Home and Marquee Dances were highly entertaining and popular events held by the club for many years. There were many romances and weddings between club members during this period too!

In 2009 the club pavilion was totally upgraded and the tennis courts are now of the highest quality. The Delany brothers, Desmond and Jack, became international players, and Desmond continues to play Veteran's Tennis for Ireland. Another long-standing member of St Mary's Lawn Tennis Club and whose five brothers and sister played here is Ann McKell (*née* Collins). Ann has represented Ireland on both the Leinster and Irish Ladies' Veteran Tennis Teams. Fergus O'Tierney, Christopher Maguire and Gearoid Lynch were all active in the administration of St Mary's Tennis Club for many years.

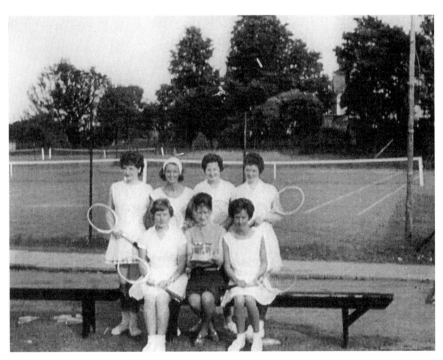

St Mary's Lawn Tennis Club's victorious team in the 1960s. From left to right, back row: Lola Kilmurray, Celeste Loder, Noelle Byrne, Margaret Gough. Front row: Ann Collins, Beatrice Delany, Margaret Buckley. (Courtesy Desmond Delany)

Bective Tennis Club

Another very old tennis club in Donnybrook is Bective Tennis Club. It was founded as part of Bective Rangers Rugby Club but, in 1921, the tennis club became a separate entity. Bective Lawn Tennis Club has seven tennis courts on the banks of the River Dodder. The courts have been resurfaced in recent times due to flooding – most notably Hurricane Charley in 1986. The new all-weather court surface and floodlighting enable the club to play all year round, in contrast to the limited use of grass courts during the summer months only.

Bective hosted the 1986 GOAL annual charity tennis match, featuring tennis legends Mats Wilander and Stefan Edberg amongst others.[7] Bective Tennis Club's Men's and Ladies' Teams are entered in all five DLTC leagues and over the years the club has enjoyed success at all levels. Open Week is an annual fixture and takes place during the summer; it attracts many competitors from numerous clubs in Dublin and beyond.

Bective Tennis Club has produced a number of famous Irish Tennis players, including Joe Hackett and Jim Buckley, both of whom have played at international level and on the Irish Davis Cup Teams. Other distinguished members were Harry Crowe and Denis Crowly, who played on all their Senior Men's Teams over the years.

Elm Park Golf & Sports Club

Elm Park Golf & Sports Club includes a golf club and a tennis club together with other social activities such as a snooker club, a bridge club, a choir, a drama group, an opera interest group, and book clubs. It takes its name from its place of origin, Elm Park House and lands, now the site of St Vincent's University Hospital. In the early days the property was in the ownership of the aristocratic Ffrench family, until purchased by Mr Louis McMullen in 1924, whose dream it was to start a golf club.

In the early years the annual subscription for the golf club was 5 guineas per annum for gentlemen and 3 guineas for ladies. Tennis courts and a badminton hall were built in 1926. In the years following, the club ran into difficulties in relation to the land from its owners. In 1933 a decision was made to buy the land from its owners, but the committee failed to obtain a loan from the bank. In November of the same year, they received notice from the owners to relinquish possession of the land as the house and lands had been sold for development to the Irish Sisters of Charity for a new hospital. In 1933, the gates of Elm Park House closed and the club ceased to exist. Tennis, however, continued on a private basis for some years after that.

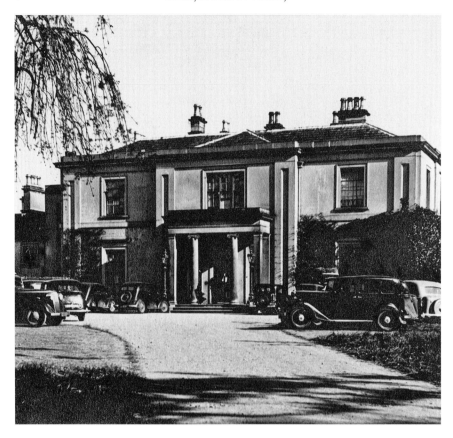

Nutley House, home of Elm Park Golf & Sports Club. (Courtesy Elm Park Golf & Sports Club)

In 1924 some members of the club re-grouped and formed a golfing society that existed until 1936, when the committee managed to acquire a lease on Nutley House, the present clubhouse and lands, from the Irish Sisters of Charity. This led to the re-establishment of the golf club and the tennis club as an integral part of Elm Park Golf & Sports Club. The official opening took place on 13 June 1936. Shortly after this the club ran into problems again with the loss of part of its land to the Irish Sisters of Charity, who were building the new St Vincent's Hospital. The golf course reverted to being a nine-hole course for a number of years. In 1960 an adjoining property called Bloomfield was purchased and the present eighteen-hole golf course opened that year. A modern extension to Nutley House was built in 1975.[8]

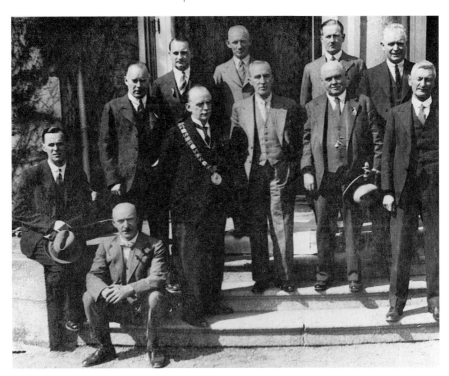

The official opening of Elm Park Golf & Sports Club in 1936. Included is the Lord Mayor of Dublin, Alderman Alfred Byrne. (Courtesy Elm Park Golf & Sports Club)

In 1991 Savannah artificial grass courts replaced some of the old tennis courts, though Elm Park is one of the few tennis clubs that still retains its grass courts during the summer months. The standard of tennis in Elm Park rose in 1960s, so that the Ladies' First Team won the Class 1 Cup in 1965. The men's teams followed with Class 1 wins in 1969, 1972 and 1973. Elm Park Tennis Club continues to be one of the premier tennis clubs in the Dublin Tennis League.

Over the years Elm Park golf and tennis teams have had numerous successes at national and international level. A distinguished member of Elm Park is Ita Butler, the international golfer, who joined Elm Park in 1960. She is a source of pride and honour to the club, with her many outstanding achievements on the golf course, including Championship victories, international appearances, and her selection on the Curtis Cup Team in 1966. She was chosen as captain of the Curtis Cup Team in 1994 and became the first Lady President of Elm Park Golf & Sports Club in 2007.

Ita Butler, captain of the British and Irish Curtis Cup team, 1996. (Courtesy Ita Butler)

Many golfing icons have visited Elm Park in recent years, including Payne Stewart, Mark O'Meara, Scot McCarron, Fred Couples and Darren Clarke. Elm Park has also hosted tennis internationals Mats Wilander, Joachin Nystrom, Sean Sorensen and Matt Doyle.

Elm Park has a number of international tennis players among its members including Breda Claffey, her daughter Jenny, and Michael Wogan, who, along with Breda, plays veteran's tennis for Ireland.

David Lloyd Riverview Sports Club

A more recent addition to sports facilities in Donnybrook is the David Lloyd Riverview Sports Club. The club facilities include tennis, badminton and squash courts, an outdoor poor, indoor pool, sauna and steam room, a gym, a creche, a hair and beauty salon, a bar, a restaurant and function room, an Internet café, and wireless Internet access together with a large sports hall.

A Boxing Match in Donnybrook

On Friday 27 May 1955, there was a European Featherweight title fight held in the CIE Garage at Donnybrook between Ray Famechon of France and Billy Kelly from Derry. Some 10,000 people attended the fight and it lasted for thirteen rounds. When Famechon was declared the victor many of the spectators disagreed with the result and the booing lasted for ten minutes. The poor referee was attacked as he left the ring and had to be given police protection. Many of those attending the fight broke their seats in protest at the result!

A report of the boxing match in the *Irish Independent* by Mitchel V. Cogley stated:

> From the way he fought the last three rounds, I cannot help feeling that Famechon too thought that the verdict must go against him, for he forsook all semblance of boxing and threw all he had into a wild onslaught that seemed inspired by desperation.

Billy Kelly died in 2007 at the age of 78. He is credited with eighty-three fights, winning fifty-six and losing twenty-three, with four draws.[9]

Donnybrook also had its own Olympic boxer, Fred Tiedt (1935-1999), who lived with his family in St Broc's Cottages. Fred was an amateur and professional boxer who won a silver medal for Ireland in the 1956 Olympic Games in Melbourne, Australia.

Donnybrook Boy Scouts

The first unit of the Catholic Boy Scouts in Donnybrook was the 3rd Dublin, which was formed in 1927. Monsignor Daniel Molony, the parish priest of Donnybrook, also founded the 40th and 41st Dublin Troop of Boy Scouts in 1927. At that time the Church of Ireland already had a Boy Scouts Troop attached to St Mary's on Anglesea Road. In 1928, with the assistance of George and Leo Purcell, who were experienced bandsmen, Monsignor Molony formed a pipe band that was in existence up to the 1960s. The Macaoimh Gasra, or Cub Scout Pack, dates from 1934. A red neckerchief was granted to the Donnybrook Boy Scouts in honour of the Sacred Heart and it is still worn by them. The first annual Scout camp was held in Tallaght, and other early camps took place in Dalgan Park, Ballyfin, Thomastown, and Boyle.

The Donnybrook Boy Scouts have camped throughout Ireland since their foundation. They have also gone on pilgrimages to Rome and Lourdes. Annual camps have provided a great opportunity for members of the Donnybrook Scouts to travel abroad, including France, Germany, Luxemburg, Belgium, Austria, Eastern Europe, the United Kingdom and the Isle of Man. The Donnybrook Scouts have taken part in the World Jamborees and have carried out community services in Peru.

The early meetings of the Donnybrook Boy Scouts were held in a number of different places such as the Ancient Order of Hibernians (AOH) hall in the vil-

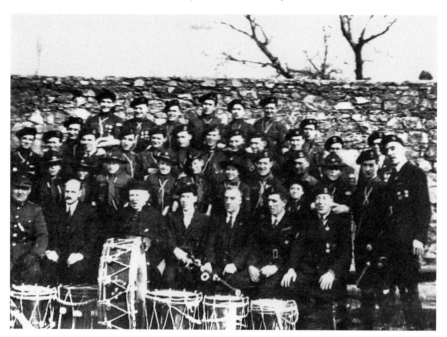

Donnybrook Boy Scouts with Monsignor Molony, in the 1940s. (Courtesy Monsignor Sherry)

lage, the Old Boys School, and the CYMS hall on Morehampton Road, which is now the home of the Donnybrook Credit Union. The Boy Scouts in Donnybrook were very keen to obtain their own Scout Hall so they would not have to rely on the availability of other premises and, in 1952, the Housing Committee of Dublin Corporation agreed to provide a site for a hall. The following year, and after much fundraising, a new Scouts Hall was opened at Brookvale Road in the presence of the parish priest Fr C.P. Crean, and the Deputy Lord Mayor of Dublin, Jimmy O'Connor, who lived in Donnybrook and whose sons and daughter were active in the Donnybrook Scouts over the years. For the next ten years the Donnybrook Scout Show was a popular annual event. It is interesting to note that a number of the stars of stage, radio and television, including Johnny Mc Evoy, Red Hurley, Eamon Morrissey, and Muiris Mc Conghail, have all trodden the boards at the Donnybrook Scout Show.

Since its foundation in 1927, the Donnybrook Boy Scouts have been well served by a number of great Scout leaders, including: John O'Connor, Stanley Byrne, Bernard Burke, Liam and Brendan Maher, Kevin McLoughlin, Derrick Plant, Colin Corcoran, Stephen Bruton, Brendan O'Gorman and Ronan Mason.

In the 1960s, a Donnybrook Company of the Catholic Girl Guides was established. The company met in the Scout Hall and very quickly, under the leadership of Joan Balfe, became another section of the Donnybrook Scouts in everything but name. After much negotiation with the central association, girls were finally admitted. In 2004, the Donnybrook Boy Scouts were also very involved in the merger of the Catholic Boy Scouts of Ireland and the Scout Association of Ireland to create an organisation known as Scouting Ireland.

Well-known members of the Donnybrook Boy Scouts over the years include: Mick Carwood, author of the anthem of the Jack Charlton years 'We are the Boys in Green'; folk singers Johnny McEvoy and Danny Doyle; Ian Mc Garry, a member of Bluesville, the first Irish pop group to have a top ten hit in the USA; Muiris Mc Gonigal, a former government press officer and Controller of Programmes in RTÉ; Professor Patrick Dowling, who became vice chancellor of the University of Surrey; John Graby, now director of the Royal Institute of Architects in Ireland; Joe Dowling, former director of the Abbey Theatre; Abbey actors Paddy Long and Eamonn Morrissey; Olympic wrestler Dermot Dunne; soccer international Ronnie Nolan; and Labour Councillor Dermot Lacey.[10]

Herbert Park

Though Ballsbridge residents may consider Herbert Park to be their territory, everyone who lives in Donnybrook would claim ownership of it too. Located as it is between the two, it is a beautiful recreational area with trees, flowers, a large pond and sports facilities, including football pitches, tennis courts, children's play areas, a bowling green, a croquet lawn and allotments. There are a number of different types of clubs in existence that use the facilities at Herbert Park on a regular basis.

As far back as the thirteenth century the land we know as Herbert Park was part of The Forty Acres. The Fitzwilliam Estate acquired this land in the 1300s. In the late eighteenth and early nineteenth century the Fitzwilliam family were the largest developers south of the River Liffey, beginning about 1750 and continuing for over 100 years. With the Leeson family they also widened and rebuilt Donnybrook Road. The Fitzwilliam Estates passed to the 11th Earl of Pembroke in 1816 and it became part of the Pembroke Estate. The history of the present-day Herbert Park therefore goes back well before

RECORD

—

THE IRISH INTERNATIONAL EXHIBITION
1907.

COMPILED AND EDITED BY

WILLIAM F. DENNEHY.

—

Dublin:
Hely's Limited Dame Street, and Acme Works, Dame Court.
1909.

Record of the Irish International Exhibition, 1907. (Courtesy John Holohan)

1903, when the Earl of Pembroke offered it to the Pembroke Township for a public park to mark the coming of age of his son, the Rt Hon. Sidney Herbert (1810-1861). The park did not become a reality for a number of years after this because it was agreed that the Irish International Exhibition of 1907 could take place in it. The organising committee of the exhibition leased the land for a rent of £1,000 per year for three years (from the Pembroke Urban District) and they also rented land from other landowners in the present area of Brendan, Argyle and Aranmore Roads.

The land for the Irish International Exhibition stretched from Morehampton Road down to Ballsbridge, covering fifty-two acres. The size of the current park is thirty-two acres so it was considerably larger. The exhibition ran from 4 May to 9 November 1907 and was a tremendous success, attracting between 2½ and 3 million visitors. Building the exhibition facilities was supervised by local architects Messrs Parry and Ross (consulting architects). Messrs Humphreys Ltd of London and Dublin (building contractors) were also involved in the construction.

The driving force behind the entire exhibition was William Martin Murphy, the distinguished Irish businessman, who owned both the Dublin United Tramways and the *Irish Independent Newspaper*. Those involved in organising the exhibition wanted to showcase Irish produce and businesses and to

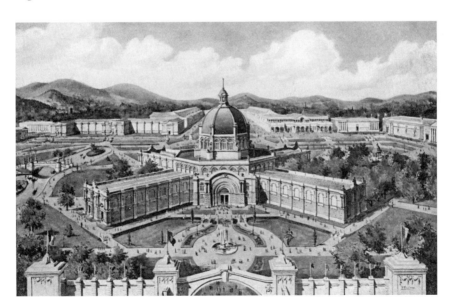

Irish International Exhibition, Herbert Park, 1907. View of the main buildings. (Courtesy Brian Siggins)

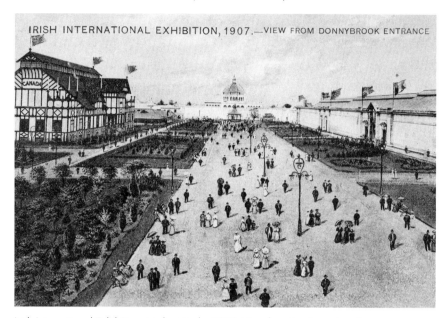

IRISH INTERNATIONAL EXHIBITION, 1907.—VIEW FROM DONNYBROOK ENTRANCE

Irish International Exhibition, Herbert Park, 1907. View from the Donnybrook entrance on Morehampton Road. (Author's collection)

increase the status and international standing of the upper classes of Dublin society. The exhibition area included sections of what are now Aranmore, Argyle and Brendan Roads. The main entrance was on Morehampton Road, opposite the present Donnybrook Fair shop, with another equally fine entrance in Ballsbridge where Roly's Restaurant now stands. Impressive buildings were erected and all the major countries in the British Empire were represented. The writer Bram Stoker turned up to view the exhibition and it was he who coined the phrase 'Great White Fair' that has been used regularly to describe the Irish International Exhibition. Initially the fair attracted the upper classes of Dublin society but later a deliberate attempt was made to encourage the ordinary people of Dublin to visit it and the entrance fee was reduced substantially.

His Excellency, the Lord Lieutenant John Campbell, Earl of Aberdeen, opened the exhibition on Saturday, 4 May 1907. He read out a telegram from King Edward VII, which said: 'Trust that the Exhibition you are to open today may prove a success and demonstrate International progress made by Ireland. Edward R.'

The visit of King Edward VII and Queen Alexandra to the exhibition on 10 July 1907 generated great excitement, with a major fireworks display, during which an outline of the King and Queen could be seen in the sky over the exhi-

The Lake and Fine Art Gallery at the Irish International Exhibition 1907, Herbert Park. (Author's collection)

bition. Their daughter, Princess Victoria, and an entourage accompanied the King and Queen as they toured the exhibition and visited the Home Industries section in particular.

The recreational facilities were magnificent, including a switchback railway, a helter-skelter and the famous Canadian water chute, which was to be found at the Ballsbridge end of the present pond. A ride cost sixpence, and each boat had room for eight people and a steersman. The boat slid down the ramp, hit the water and then skimmed across the surface of the pond, under two bridges, before coming to a stop at the far end of the pond. The entire grounds of the exhibition were beautifully landscaped and maintained for the duration by leading gardening and machinery companies of the day. Particularly popular with the visitors was the Somali village.

All the buildings in the exhibition were temporary, made with iron girder frames covered with wood and plaster and painted white. The principal building was the Grand Central Palace with a large octagonal hall 200ft in diameter with four radial halls 160ft long and 80ft wide that were supposed to represent each Irish province. Concerts and musical entertainment were provided every day by thirty-two bands and orchestras. Besides the Grand Central Palace, there was a Palace of Industries, a Palace of Fine Arts, a Palace of

Irish International Exhibition, Herbert Park, 1907. Visit of King Edward VII and
Queen Alexandra in July 1907. (Courtesy John Holohan)

Mechanical Engineering, and the Canadian Government's pavilion which
encouraged people to emigrate to Canada.[11]

The closing of the exhibition was as fine an occasion as the opening.
Again the Lord Lieutenant John Campbell, the Earl of Aberdeen, con-
ducted it. At the end of the exhibition all the buildings were removed,
despite being offered to the Pembroke Township, who declined to accept
them. All that remains today of the exhibition are the pond, the steps up
to the terrace, the terrace and some of the shelters.[12] With the closure of
the exhibition, work began on the design of the park and it was formally
opened by the Lord Lieutenant John Campbell, the Earl of Aberdeen, on 19
August 1911. Named for the Rt Hon. Sydney Herbert, the son of the Earl
of Pembroke, it was run by the Pembroke Township and Urban Council
until 1932, when an Act of Parliament amalgamated both the Pembroke
and Rathmines Urban Councils with Dublin Corporation.

Today Herbert Park has not changed very much from its original design
and plan. Essentially it is an Edwardian park with fine architectural features,

Children at play
in Herbert Park.
(Courtesy of the
O'Leary family)

beautiful flowerbeds and interesting walkways. Herbert Park is a wonderful recreational facility for the people of Dublin. It has ten different entrances and includes a duck pond, eight tennis courts, a bowling green, three football pitches, a croquet lawn, a synthetic sports pitch and allotments. For many years a double row of Wheatly Elms, planted between 1912 and 1916, graced both sides of the road running through the park. Unfortunately, they died from Dutch elm disease. They were replaced in 1985 by hornbeams (*Carpinus betulus*), and these have matured well in recent years. In 2011 the centenary of Herbert Park was celebrated with a great 'Family Day in the Park'.

The Grove Bird Sanctuary

Very few people in Donnybrook seem to be aware of The Grove, which is a bird sanctuary situated on the corner of Wellington Place and

Entrance to the Bird Sanctuary on the corner of Wellington Place and Morehampton Road. (Author's image)

Morehampton Road. For many years it belonged to Kathleen Goodfellow (1891-1980) who lived at No. 4 Morehampton Road. The Grove was left to An Taisce by Kathleen Goodfellow, who was the daughter of Dublin builder George Goodfellow and his wife Susan. It is approximately half an acre in size and is covered in trees, shrubs and undergrowth.[13] At present it is looked after by volunteers who work with An Taisce in maintaining it and feeding the birds. Visits to it are arranged from time to time via An Taisce.

5

TRAMS AND BUSES

The backbone of any transportation system is of course the roads. Roads developed from prehistoric times from convenient pathways around the country and the remains of some wooden trackways and roads dating from the late Bronze Age have been found in Ireland. There is also some evidence from Munster of an Iron Age stone surface like a road that has been excavated, but this is unusual as most tracks from this period were made of wood. Some of the law tracts from the early medieval period describe different types of road and the early annals mention a network of highways. Some form of organisation was introduced in the 1600s when the land in Ireland was divided into counties. Main roads came into being and Turnpike Trusts controlled these. A turnpike road was a road for which users were required to pay a toll or fee.

The establishment of a General Post Office in Dublin in the 1710s led to the availability of postal services to the main towns in Ireland. Mail coaches were introduced and carried both mail and passengers throughout the country. The mail coaches ran along the main roads and were sometimes met by riders who brought the post to and from towns that were not directly served by the mail coach. Mail coaches were drawn by four horses and had seating for four passengers inside. Eventually additional passengers were allowed to sit outside with the driver. The mail was held in a box to the rear, where a post office guard stood. A letter was said to be posted when it was handed into a Receiving House. Collections took place each day at a specified time and were often heralded by the ringing of a hand bell. There were a number of Receiving Houses in Dublin, including one in Donnybrook.

There were also privately operated stagecoaches in existence that competed with the mail coach service. Of interest in the context of Donnybrook is the early stagecoach service to Wexford. These began in 1785 and left from Duke Street every week on a Thursday. Coaches travelled via Leeson Street to Donnybrook, where they crossed the River Dodder. The old coach road followed what is now the N11 to Wexford.

Jarveys and their sidecars were a common sight in Dublin in the nineteenth century and were a popular mode of transportation to the Donnybrook Fair. The wealthy had their carriages and sedan chairs, or these could be hired as required at stands throughout the city. In 1815 Charles Bianconi introduced his system of stagecoaches, but they were centred in the main on the provinces. Bianconi coaches were the forerunner of the modern Irish transport system.[1] There were other developments with transportation too, for example in 1715 the government began to encourage inland navigation. However, it was not until 1779 that the first twelve miles of the Grand Canal was opened, and the Royal Canal followed this. The canals were used for the transportation of freight in particular, but some of them also carried passengers. Donnybrook was not particularly close to the Grand Canal so it did not have a big impact on the lives of people in Donnybrook.

The Modern Public Transport System

In the eighteenth century an extensive system of roads was built which allowed people to travel throughout the country more freely. These new roads were wide and straight and many of them still form the backbone of the Irish road system today. New roads continued to be built throughout the nineteenth century. The modern Dublin public transport systems go back to the first horse-drawn tram, which operated on the Rathgar/Terenure route in 1872.[2] This led to the development of a substantial network of trams between 1898 and 1900. Two horses pulled the trams and these were changed at intervals during the day. To pull trams up steep hills there were trace horses in the care of trace boys, who were stationed at the bottom of the hills. Horse-drawn trams did not have specific stops but could be hailed by an individual anywhere along the road. Back-up trams were essential parts of the service. At the Donnybrook Garage there was a track maintenance car and this remained in service until after the last tram ran in 1949.

The Donnybrook trams began in March 1873. Each of the horse tram routes had their own distinctively coloured cars. The Donnybrook tram was yellow and the car night-lights were in accordance with their route colours, so that it was easy to identify them from a distance. The Donnybrook route commenced in Sackville Street (now O'Connell Street), continuing on to the village of Donnybrook, with the terminus just beyond Donnybrook church. A depot for the trams was built opposite the Church of the Sacred Heart, where the Donnybrook No. 2 Garage for Dublin Bus now stands.

The development of tramways in the 1870s made suburbs like Rathmines, Pembroke, Glasnevin and Clontarf attractive places to live. Donnybrook was part of the old Pembroke Township and, like the other residential areas with tram services, was a good source of affluent passengers who could afford the tram fares. Horse-drawn trams were very popular but profits were limited by the high costs involved in maintaining the system. The stabling of the horses and the numbers required to operate each service led the Dublin United Tramway Company to seek alternative forms of traction. The alternative was the electric tram, but lobby groups involved with the supply of horses were not in favour of this, and the civic authorities were also concerned about overhead wires and their impact on the streets of Dublin.

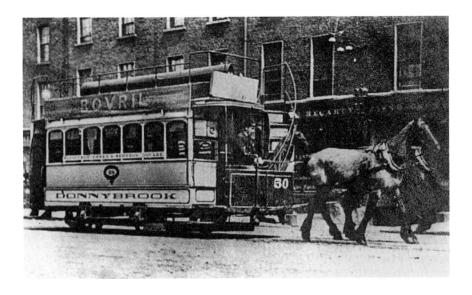

Donnybrook horse-drawn tram in the 1890s. (Courtesy Dr Donal Kelly)

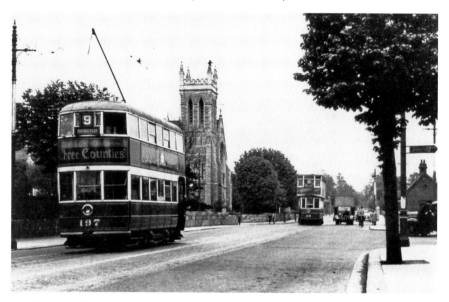

Numbers 9 and 10 trams near Church of the Sacred Heart, Donnybrook. (Courtesy Corcoran Collection/National Transport Museum)

Despite all the objections, the first electric trams began running on 16 May 1896 between Haddington Road and Dalkey and these were run by the Dublin Tramways Company. By the beginning of 1898 there were about ninety electric trams operating in the city. The Dublin United Tramway Company (DUTC) eventually took over the Dublin Tramways Company and the company did everything in its power to increase its revenue, so advertising became popular on the trams and a lucrative parcels service was inaugurated in 1883. This was called the Tramways Parcel Express and it covered the areas served by the trams. The transfer of parcels usually took place at Nelson's Pillar and they could be collected at the local tram depot. A penny fare was introduced in 1883. The Dublin tram system, at its peak, was renowned internationally for being technically advanced and has been described as 'one of the most impressive in the world'. This led to a constant stream of visitors from other countries coming to inspect its electrification and the Power House – built in Ringsend Garage in 1899 and incorporating machinery imported from America. It was the Dublin United Tramway Company that set up the tramcar works at Spa Road in Inchicore, and from that date onwards all of the Dublin trams were built in Inchicore.

Donnybrook trams became electric on 23 January 1899. They joined up with the service to Phoenix Park and this was the beginning of trams run-

ning from Phoenix Park right across the city to Donnybrook. This was the first cross-city tram service; prior to this all tram services radiated from the city centre.

Not all members of society were literate at the time, so the different tram routes were identified by symbols written above the destination scrolls. Donnybrook trams had two blue overlapping diamonds as their symbol. The service to Donnybrook – which went via St Stephen's Green and Lower Baggot Street – had the same symbol but with a horizontal white bar. The destination was painted on the sides of the tram so that no inter-changes of cars were possible. In 1897 interchangeable destination boards were fitted, and in 1903 roller blind destination scrolls came into use. Route numbers were introduced in 1918. By 1918 the Dublin United Tramway Company must have decided that literacy rates had improved, so the use of symbols was discontinued. From this date onwards all trams and, later, the buses, all displayed their route numbers together with their destination on the roller blind scrolls on the front.

All of Dublin United Tramway Company's trams were numbered in a clockwise fashion beginning with Sandymount, so the Donnybrook trams were given routes 9 and 10. The No. 9 was used for trams that travelled via Merrion Square to Phoenix Park, and the No. 10 tram went to Phoenix Park via St Stephen's Green. While Donnybrook people always associate the No. 10 as being the main Donnybrook bus or tram, in the days of the tram it was the No. 9 tram and not the no. 10 tram that was seen as the main service from Donnybrook to Phoenix Park.[3] There appears to have been no class barriers on the No. 9 and 10 trams, though it seems likely that the middle and upper classes of Dublin society were their main users. There was a suggestion at a meeting of the directors of the Dublin United Tramways Company that perhaps there should be a first class on the Donnybrook Trams!

Every individual tramline had its own ticket with the stages printed on it which varied in colour depending on the length of journey and, therefore, the price. There was a penny blue, a twopenny white, the threepenny and fourpenny green ticket and the buff fivepenny ticket that was for Dalkey. Some enterprising city shops such as Hoyte's Chemists in Sackville Street encouraged people from the suburbs to shop in town by giving away three pence worth of free tramway vouchers with every five shillings spent in their shop!

The staff of the Dublin United Tramways Company had a great reputation for being efficient and courteous to their passengers.[4] To distinguish them

from the drivers of horse-drawn trams, the drivers of the electric trams were known as motormen. All were smartly dressed in uniforms and the conductors and inspectors wore straw boater hats during the summer. For some unknown reason, the Dublin United Tramways Company favoured men from the country as drivers and conductors. Cottages were built for staff adjacent to the tram depots, some of which are still in existence beside the Bus Garage in Donnybrook.

The Dublin tram system was central to the Dublin Lockout of 1913, when staff of the DUTC went on strike because the DUTC chairman, William Martin Murphy, refused to allow his workers to join the Irish Transport and General Workers Union.

Michael Corcoran, in his book *Through Streets Broad and Narrow*, has described the decade which preceded the First World War as the 'Golden Age of Dublin's Tramways'.[5] But from the 1920s the DUTC faced heavy competition from buses, which were introduced to Dublin about this time. Buses became popular because they were able to compete with trams in terms of comfort and reliability and were cheaper to run. They did not require dedicated tracks, nor did they need the large numbers of staff who worked in the background on the upkeep of the trams. Buses were also faster and routes could be changed much more easily.

At the beginning of the twentieth century new housing estates were built in areas that did not have a tram services. Adding trams to these areas would involve laying new tracks throughout the city. This was not economically viable, so buses served these new estates.

Originally it was thought that buses and trams would complement one another. However, by the 1930s many tramway systems needed to be renewed.[6] This would have been very costly so the buses were used to replace them. The No. 9 tram from Donnybrook to Phoenix Park via Dawson Street and all of the No. 10 trams ceased on 2 June 1940 after which buses serviced the routes.

Many of the early buses were primitive, with petrol engines and solid tyres, and they generally held about fourteen passengers.[7] A number of different companies competed with one another, but in 1932 legislation was introduced which forced the takeover of many of the private operators by their main competitors. By 1936 the Dublin United Tramway Company had almost a monopoly on bus services. In the late 1930s buses became more comfortable and diesel buses were introduced, with double-decker buses making an appearance from 1937. Around this time too it was decided to close down the

network of trams and the majority were off the road by 1941, though route numbers 6, 7, 8, 14 and 15 survived to the end of the decade and the Hill of Howth tram survived until 1958. It was an open-top tram and unfortunately its potential as a tourist attraction was not realised. However, at the time of writing there is a possibility that it will be restored and reintroduced as a tourist attraction in the near future.

By 1944 the state of public transport throughout Ireland was cause for concern. There were too many companies in existence and a coordinated approach to managing all the public transport in Ireland was required. The government of the day decided to amalgamate the Dublin United Tramways Company and the Great Southern Railways. Coras Iompair Éireann (CIE) therefore came into existence on 1 January 1945.[8] The Dublin United Tramways Company operations, with 113 trams and 364 buses, became part of the Dublin City services of CIE. Today Irish Rail, Bus Éireann and Dublin Bus, which operate the bus and rail services in Ireland, are all part of the CIE group of companies.[9]

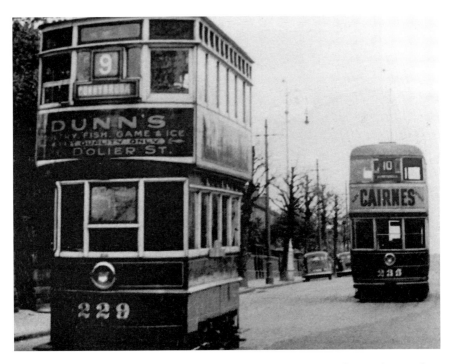

Numbers 9 and 10 Donnybrook trams. (Courtesy Michael Corocan collection/National Transport Museum)

Unfortunately the Donnybrook No. 9 bus has been gone for some time and the No. 10 bus was withdrawn by CIE on 30 October 2010. It is not the first time that route 10 has been cancelled and re-installed and many Donnybrook people hope that we might see a No. 10 bus returned to the route in future years.

Tramway Cottages

The cottages beside Donnybrook Garage were built for the staff of the Dublin United Tramway Company, who rented them for sixpence per week. At the end of the row of cottages there are two-storey houses and these were built for the tram inspectors and cost one shilling per week to rent. For many years these cottages were known as the Tramway Cottages but their name was changed to Simmonscourt Terrace in 1948.

The site of the old Tramways Garage in Donnybrook had been a quarry in earlier times and stones from it were used to build the Dublin to Kingstown (Dun Laoghaire) railway.

Donnybrook Bus Garage, which dates from 1952. It was designed by Michael Scott and Ove Arup, a Danish engineer. It was the first building in the world to be built with a concrete shell roof lit by natural light and is an iconic building. (Courtesy Dublin City Libraries)

Donnybrook Bus Garage

The modern Donnybrook Bus Garage was completed in 1952. It was designed by Michael Scott, the distinguished Irish architect, in association with the Danish engineer Ove Arup (1895-1988). This garage was quite an engineering and architectural feat, and was 'the first building in the world to have a concrete shell roof lit by natural light from one end to the other.'[10] Donnybrook Garage was to have been the first of a series of eight garages to be built to house 100 buses. The other seven garages were never built, possibly due to the fact that the concrete moulds were destroyed after the completion of the first Donnybrook Garage. The old tram garage continues to be used as the No. 2 bus garage.

6

DONNYBROOK SHOPS

Since the 1950s shops in Donnybrook have been located in three main blocks. The first block stretches from Morehampton Road (formerly Donnybrook Road) down to Belmont Avenue. The second block extends from Belmont Avenue to the Ever Ready Garage. And the third block goes from the Spar Supermarket (Woods) to the former Breen's Garage on the Donnybrook Road. There have been great changes in the shops in Donnybrook since the 1950s and '60s and some are no longer with us.

Morehampton Road

On the corner of Marlborough Road, where AIB is now located, was a large family grocery and wine merchant's called Hugh Ward's, where John Kavanagh was the manager. Next door was Furlongs, owned by Mrs Callanan who lived on Carlisle Avenue, and afterwards by her son, Gerry. There was a bad fire in this shop in the late 1940s caused by fireworks, which in those days were permitted to be sold over the counter. John Kavanagh saved Gerry from the fire by climbing on to the roof and smashing the glass of the sky-light to get him out. Unfortunately, it was not possible to rescue a young girl working in the shop and she died. As a result of the fire the government brought in a new law prohibiting the sale of fireworks over shop counters.

Mrs Callanan also owned a shop called Callanan's at the far end of the row of shops, which, like Furlongs, was a popular newsagent and sweet shop. For

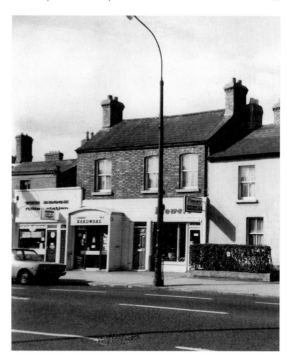

Shops and houses on the Morehampton Road during the 1960s. (Courtesy Philbin family)

many years Gerry Callanan ran both shops along with his sister and his wife Maire. Gerry was a mine of information on anything to do with Donnybrook or its activities and he was greatly missed by all when he decided to retire and devote more of his time to Fitzwilliam Lawn Tennis Club. He died in November of 2009.

Kyle Deevy owned a chemist shop, where Boots chemist is today, and Nylands grocery shop was next door. John Nyland and his wife Marcella opened their shop in 1948. It was a very popular old-fashioned grocery store, where one could catch up on all the Donnybrook news and at Christmas the regular customers were presented with a box of chocolates or fancy biscuits. In later years, John and Marcella's daughter Anne, and her husband Kit Casey, ran the shop until it finally closed its doors in 1990.

Next was Tom Cullen's butcher's shop, now Morehampton Pharmacy, a great source of quality meats and poultry. His son Tom, who had worked in his father's shop, became a very well-known artist in Dublin, and one of his daughters, Pat Boylan, was the leading lady of many of the productions of the Muckross Musical and Dramatic Society.

The longest-serving trader at this end of Donnybrook was Eileen Bastable (*nee* O'Connor), whose hairdressing salon was there for fifty years. Her

daughter, Elaine, ran a gift shop in the same premises for twenty-five years. The story began when Eileen returned to Dublin in 1937, having trained for four years in hairdressing and beauty culture in London. She took over Miss Carter's hairdressing salon on the upper floor of Storey's chemist on the corner of Morehampton Road and Marlborough Road. In 1944, the Munster & Leinster Bank, located at the time at 81 Morehampton Road, wanted to move to the corner site and they offered Eileen Bastable a newly fitted-out salon on the ground floor of No. 81, which she accepted. It was in 1967 that Elaine, Eileen's daughter, opened the Gift Boutique on the ground floor of No. 81 Morehampton Road and Eileen moved her hairdressing business to the upper floors. Eileen retired in 1985 and Elaine took over the running of the hairdressers along with the gift shop. By 1992, with the building in poor repair, Elaine and her husband John decided to rebuild and expand it and share the space with other businesses. When the shop was being rebuilt and the shop front was removed, the original Munster & Leinster Bank sign was exposed. Recognising the lack of a coffee shop in Donnybrook, Elaine decided to open one in the newly designed gift shop. When Elaine retired in 2000 she closed the gift shop and the entire ground floor became a coffee shop. Today Café Java occupies the ground floor and the hairdressing business continues under the independent management of Jean Lynch of Di Milo.[1]

Many recall with pleasure Quinlan's Cake Shop, located next to the post office, and the pub that was originally owned by George Reddan and later by his son, John. This premises has been a public house since 1901 and the date is still inscribed over the entrance.[2] John Reddan also had an off-licence called the Wine Lodge further along the block of shops and he won prizes for his window dressings. Today the pub is run by Brian McCloskey, whose father Barney McCloskey bought it from the Reddan family. Mr Quinlan and his family produced the most wonderful mouth-watering cakes, which

Eileen Bastable, proprietor of Eileen's Hairdressing Salon, Morehampton Road, Donnybrook. (Courtesy Elaine Bastable Cogavin)

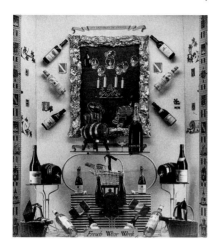

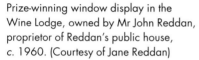

Prize-winning window display in the
Wine Lodge, owned by Mr John Reddan,
proprietor of Reddan's public house,
c. 1960. (Courtesy of Jane Reddan)

Advertisement for Quinlan's Ltd.
(Courtesy Muckross School Archivist,
Deirdre Mac Mahuna)

were always considered a treat. The cakes and bread were made on the premises and the smell of freshly baked bread and cakes greeted the senses as one passed the shop. Subsequently the shop was run by Colm and Fergus Quinlan, the grandsons of old Mrs Quinlan who founded the shop. Everyone was very sad when this shop and bakery closed down.

Next door to Quinlan's was a stationer, newsagent and a sub post office run by Miss Mary Roche at 87a Morehampton Road. Miss Winifred Murray ran a large, popular grocery shop next to this for a number of years called the Donnybrook Fair. Miss Murray had a van on the road driven by Paddy, who delivered groceries regularly to houses in Donnybrook. A Miss Smyth ran a small sweet shop next to Miss Murray's Donnybrook Fair and her brother had a painting and decorating business on the premises. Bells Cleaners and Dyers was also located in this row. Mr Delaney ran another small grocery shop just beside the present Hampton Books and there were a number of private houses nearby. Gilbeys of Ireland, who were wine and spirit merchants, occupied No. 99, Morehampton Road and O'Connor's hardware, next door, was run by Mr Joseph Philbin. This shop was like an Aladdin's cave of everything one could possibly need in the hardware line, and it was a very friendly place to visit. Robinson's owned the Morehampton Garage at 101 Morehampton Road, beside Callanan's the tobacconist and newsagent.

Heading down towards the village there are a number of shops before the
junction with Belmont Avenue. There was a small grocery shop called Bolger's
run by the elderly Mrs Bolger, but this is now closed. This shop sold wonder-
ful brown bread! Le Fanu and Eakins were located next door and described
themselves as motor engineers. This is now Branching Out, a florist. There
was a public house next door which today is O'Connell's restaurant. In the
1940s members of the Hennessy family owned this pub and in the 1950s it
became O'Shea's public house, owned by Patrick O'Shea (1907-1975), who
traded there from 1952 until 1970, when he sold it to Patrick Madigan.[4] Like
many publicans in Dublin, Patrick O'Shea was a Kerry man. He was born in
Ballinaskelligs, a Gaeltacht, and was a native Irish speaker. His wife, Mary
Rafferty, came from Carrickmore, County Tyrone and she too was steeped
in Irish culture and was an Arts graduate of UCD. She became a teacher and
taught Irish at Scoil Brid, Diocesan Girls' School on Adelaide Road, and at
Stratford College in Rathgar. All the O'Shea family could speak Irish. It is
not surprising therefore that O'Shea's pub had an all-Irish-speaking corner
in the Lounge area. Many of the Irish speakers from RTÉ would congregate
here, including the late Eoin O Suilleabhain, who created Irish programmes
for RTÉ. Other Irish speakers, such as those connected with the Teachers' Club
in Parnell Square, also gathered there. There was also a literary corner in
O'Shea's pub; here writers such as Padraig O Siochru, known as An Seabhach
(1883-1964), Myles na gCopaleen, Paddy Kavanagh and Brendan Behan
would congregate.

When pubs closed early on Sundays, fleets of cars would leave O'Shea's
and head out to Cabinteely to the Magic Carpet, a pub outside the city limits.
This pub was a *bona fide* pub meaning that, by law, it could stay open until a
very late hour.

Individual celebrities also called at O'Shea's pub from time to time – on
one occasion Richard Burton and his wife Elizabeth Taylor spent an evening
there, signing autographs! Another well-known person who visited O'Shea's
regularly was Michael Smurfit Senior, the father of successful businessman
Michael Smurfit. When Madigan's took over O'Shea's pub, it became a popu-
lar place for Sunday lunch and for sing-alongs on Sunday nights!

Donnybrook Mall is located where there was a row of houses known as
Whyte's Terrace, owned by the family of the late Ben Whyte, a Dublin auction-
eer who had offices on Morehampton Road. At one stage, in the late 1950s
or early 1960s, one of the cottages was turned into Donnybrook's first coffee
shop – the Coffee Inn.

The present fire station is built on the site of a number of former shops including P.J. D'Arcy's newsagent. Paddy D'Arcy and his daughter Pamela ran this shop with its excellent collection of magazines and sweets. Next door was Prescott's, the dry cleaners and D'Arcy's, the plumbers, beside the AOH hall. Vera McDonald from Eglinton Terrace ran Irish dancing classes for many years in this hall. It was hard to beat the chips from Laura Café run by the Cerassi family for many years. Moran's Garage came next to the Favourite Stores, which was run by Mrs T. Farrell. Her shop was a real treasure trove selling almost everything from a needle to an anchor – fresh bread, single cigarettes, plastic buckets, basins, light bulbs and toys, to name but a few!

Smyth's chemists next to the Favourite Stores began in 1934 when Peggy Morris opened her pharmacy.[4] She was later joined by Joe Smyth, her husband, and they ran a great business until 1979, when a compulsory purchase order (for the building of the fire station) forced them into retirement. There was a butcher's shop next door, owned by a Mr Malone from Eglinton Terrace. This later became a drapery shop called K. & B. Nearby, on the corner of the Crescent, lived Thomas Curry, the local chimney sweep, and his family. The Crescent is a small road running parallel to the main Donnybrook Road. The main entrance to the local Garda station is also in the Crescent. Beside the present Garda station, where Fanagan's are now located, was a large grocery shop called Martin's, which existed on this spot

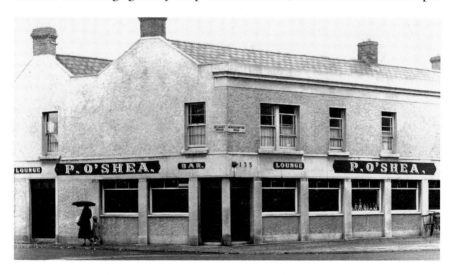

O'Shea's public house, Morehampton Road. (Courtesy Sheila O'Shea)

Poster for Ever Ready Garage on Donnybrook Road. (Courtesy John O'Sullivan)

for a number of years. It was later the home of O'Mara Travel. Kilmartin's betting shop moved here in the 1960s from the bottom of Belmont Avenue.

On the other side of the Garda station (built in 1931) was Cunningham's electrical shop, which Mrs Cunningham continued to run after her husband's death. It is now Mink, a luxurious hand and foot spa. Tierney's butcher's shop, which existed next door to Cunningham's for a number of years, is now Dunn's fish shop. Roy Fox the greengrocer's is a Donnybrook institution and continues to trade to this very day. A Dublin man called Roy Fox established it in the 1930s. Frank Donnelly and Sheila Harbourne ably assisted him. When Roy Fox died from tuberculosis a few years later, Frank and Sheila took over the running of the shop. Frank and Sheila married and they were both involved in the business for many years. In 1968 their son Des took over the shop and he ran it until his untimely death in 2008. Des's daughter, Johanne Donnelly, is now the owner.[5] Stynes had a thriving grocery shop at No. 51 Donnybrook Road, which was established in 1916, and in later years it became an off-license, selling a large selection of high-quality wines before it finally closed in 1979. It is now the Balti Restaurant. Number 55 was the premises of a turf accountant, Joseph Cunningham.

The Ever Ready Garage has long been associated with Donnybrook. Oswald Barton left Chorley, Lancashire, in England, to come to Ireland; within a couple of years he had joined a small motor garage based in Donnybrook called the Ever Ready Garage. The Ever Ready Garage Ltd was

Pembroke Cottages, built in 1912. (Author's image)

founded in 1927 by Johnny Reddy, Billy Dikon and Freddy Smith; Oswald
Barton joined the business in 1928. Initially the Ever Ready Garage was
located beside Pembroke Cottages and behind Vanknockerout's shop, but
later moved to part of the site once occupied by the famous Donnybrook Fair.
This garage sold and serviced Austin, Triumph, Rover, Jaguar, Mercedes,
Citroen, Jensen, Lotus and Daimler, and could supply customers with any
make of car they required. The Ever Ready Garage closed its doors in 1980
after fifty-three years of service, because there was no member of the Barton
family available to take over the business. However, a member of the next
generation of the family, Richard Barton, has opened an Ever Ready Garage
at Cross, County Mayo, specialising in classic cars. The present owner of the
entire site where the Ever Ready Garage was located is John O'Sullivan.

Bective and Old Wesley rugby clubs occupy the area opposite the Ever Ready
Garage. Next to Bective is Woods, now a Spar supermarket, which is one of
the oldest and longest trading shops in Donnybrook. In 1989 the shop cel-
ebrated one hundred continuous years in business at the same address. Five
generations of the family carried on the business from the nineteenth and
early twentieth centuries. During the 1930s and '40s old Mrs Woods ran the
business. Her niece, Elizabeth Kelly, joined her to help run the shop, and she
married a Mr Nicholas Hickey from Tipperary. After the death of Nicholas
Hickey and his wife, their sons, Nicholas and John, continued to run the busi-
ness. When John died, his two sons, Niall and John, continued to run the shop.
In recent years, members of the Hickey family have leased the shop.[6]

Long's public house has always had a large clientele. It was considered an
old-fashioned pub and no attempts were made to modernise it for many years.

The Ever Ready Garage.
(Courtesy John O'Sullivan)

In the middle of the twentieth century Longs belonged to Lawrence Burke and his wife. His nephews, Patrick and Joseph Stapleton, came from Borrisleigh in Tipperary and they worked in the pub with their uncle, Larry Burke. Patrick Stapleton inherited Longs and he ran the pub with his brother Joe for a number of years. Packy Stapleton was a great man for tradition and for years he refused to modernise the pub, making Longs the most old-fashioned pub in Donnybrook. After the death of Patrick Stapleton the pub passed into the hands of his sons. The two Stapleton boys ran a very successful business until recently, when they put Longs up for sale. For a number of years Steele's pork butcher's shop was next door to Longs, but it no longer exists as the premises was acquired by Longs.[7]

Further along the Donnybrook Road we come to the Bank of Ireland, originally the National Bank that has stood in this spot for many years. Next to it Mrs Pope ran a fruit and vegetable shop. Her husband drove a pony and cart to the market several days a week, so one could always be sure of fresh vegetables from Mrs Pope! Next door was a newsagent and Sub Post Office run by Miss Vivien Dunne, whose brother, Kevin, ran a grocery shop (now the Balloon Shop) next door to Keenan's the upmarket drapery store. With no refrigeration in those days it is not surprising to find a number of small dairies like the Homestead Dairy and the Lucan Dairy in Donnybrook. A very popular butcher was Field's, a large butchers shop owned by Mr Raymond Domegan. It had its own slaughterhouse behind the shop in Rampart Lane. Also in Rampart Lane was John Paul & Co., the building contractor, who later moved to Dundrum. Beside Field's was a small draper's shop called Griffins.

Jimmy O'Connor was the owner of a barber's shop at No. 38 Donnybrook Road in the centre of the village, where the AIB Centre now stands. He was also a local Fine Gael Councillor and at times acted as Deputy Lord Mayor. O'Donoghue shoe shop was next door, run by the Freeney family in the late 1950s and '60s. Roche's Chemists occupied 34 Main Street for many years. When the AIB were building their large centre in Donnybrook, having demolished a number of the shops already mentioned, they propped up the side wall of Mr Roche's pharmacy, with beams to support the wall of the shop. One Sunday night the whole wall of the pharmacy collapsed. Above Roche's Chemists was a thriving hairdressing and beauty salon run by Winora, and later by her daughter-in-law, Mary Clarke.

Vanockerout's was famous in Donnybrook for its beautiful cakes that were sold in the cake shop attached to Vanockerout's grocery shop. Madame

Collapse of the wall of Roche's Pharmacy in the 1960s. (Courtesy Nieves Roche Collins)

Vanockerout was well-known in Donnybrook and ran a high-quality grocery shop. An interesting aspect was the lending library to be found at the back of the shop. Vanockerout's was eventually taken over by Mons. & Madame Vanockerout's daughter Odette and her husband Harry Wilka, and it was a thriving business for many years until they retired. O'Brien's Fine Wines then took over the shop, which is located on the corner of Pembroke and St Broc's Cottages.

Shoe-making has been a feature of the corner shop at Pembroke Cottages for a number of years. First of all it was Leman's, the shoemaker, occupied the premises from the early twentieth century and it is now owned by C & D Shoe Repairs. There was also a hall called Leman's Hall behind this shop where Irish dancing classes were held and, at one time, it was also a dogs' beauty parlour. Next to the shoemakers was a small grocery shop called The Nook. This was one of Donnybrook's late-night shops, staying open until 11 p.m. during weekdays.

Kiely's has been a public house since 1739, when it acquired its first licence. Bob Kiely, from Tipperary, founded the modern pub and ran this licensed premise until he retired in 1988. Many of Dublin's literati, such as Brendan

Behan and Myles na gCopaleen, drank here. It is nowadays a well-known Leinster Rugby Supporters pub.

At one stage there was a pet shop along this row with a large bowl of goldfish in the window that was much admired by local children. Facing the fire station, where the Balloon Shop now stands, was a thriving grocery shop run first by Mr and Mrs Kevin Dunne and then solely by Mrs Dunne after her husband's death. Keenan's, next door, was one of the most popular drapery shops on the south side of Dublin. Opened by Mrs Elizabeth Keenan in 1941, it was noted for the high-quality clothes it stocked. It was one of the few shops in Dublin where one could get clothes out on approval for up to two weeks! Many a Donnybrook person was dressed entirely out of Keenan's![8] Mr Keenan also owned a shop called The Keen House in Dunlaoghaire that was run for a time by his daughter Joan. Dargan's chemists occupied the premises next to Keenan's for a number of years, and it later became Niagra, suppliers of aids for arthritis and other disabilities. Nearby was Parkinson's, the electrical shop belonging to the family of Danny Parkinson, the well-known local historian. Jacks was a high-quality fruit and vegetable shop run by the Ronaldson family next door. Donnybrook has long been associated with the automobile industry and Breen's Garage was in existence for a long time until Tom Breen retired a few years ago.

Beaver Row Hat Factory

With the exception of the brewing and distillery industries, some food industries and the textile industry, there was very little large-scale manufacturing in Dublin in the eighteenth and nineteenth centuries. There are, however, a number of small industries associated with Donnybrook, including the Beaver Row Hat Factory.

Fashions change all the time, and at the beginning of the nineteenth century the fashion of wearing wigs or powdering one's hair changed and the wearing of hats became fashionable instead. There was a great demand for beaver hats that very soon became popular with the people of Dublin. At the beginning of the nineteenth century three brothers, James, Joseph and Robert Wright, leased part of the lands of Roebuck, where they built a hat factory. The Wright brothers appear to have been from Golagh, County Monaghan and were descendants of Captain James Wright, a member of Cromwell's army in Ireland.

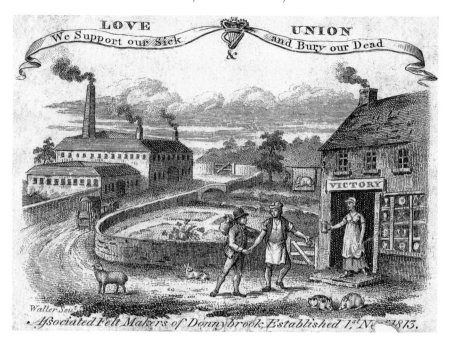

The membership card for the Association of Felt Makers of Donnybrook. (Courtesy of the National Library)

The factory focused on the manufacture of beaver hats. Up to this time, most of the beaver hats were made in France or England but hat factories were soon established in both the north and south of Ireland. Most of the workers, who were often known as felters or hatters as entries in directories and parish registers testify, were originally English Wesleyans, said to have been brought over from Yorkshire to work in the factory. The Wrights built cottages on Beaver Row and provided a school, a hall and a Wesleyan Methodist Church for their employees. The also built a bridge over the Dodder for the convenience of the factory's employees.

It is not clear when the Beaver Hat Factory closed, but it was still in existence in 1826. While there is very little evidence of the activities of the factory in Donnybrook during the mid-nineteenth century, there is evidence of a Joseph Wright, hatter, of 33 Westmorland Street in a book called *The Industries of Dublin*, published in 1887/1888. The nineteenth-century *Thom's Directories* also lists a number of other addresses for the Wrights as hat makers. By 1893, the Donnybrook hat factory was no longer in existence, the chapel was disused, and the felters or hatters seem to have disappeared. Despite research by Glenda Cimino for her thesis on

Beaver Row, she could find no evidence of the existence of the descend-
ants of the original Donnybrook hatters or felters. This supports what the
Donnybrook Parish Magazine of March 1893 had to say: 'We have been
unable to identify by their names any descendants of these worthy felters,
they were very numerous. What has become of them?'

Beaver Row is quite different today from that of the nineteenth century,
when the road ran along the back of the houses. This explains why the
Methodist chapel is to be found in the back garden of No. 9 Beaver Row.
Thanks to Glenda Cimino, this church now has a preservation order on it.[9]

The Donnybrook Bus Garages are located at the entrance to Beaver Row
and include the old tram garage, which housed the early horse-drawn
trams and later the electric trams. This too has been a thriving industry in
Donnybrook, with maintenance work being carried out there over the years.
A quarry existed on this spot prior to the building of the tram garage and
stones from it were used to build the Dublin to Kingstown railway and the
Nine Arches Bridge in Milltown.

Donnybrook was also home to the automobile industry over the years.
The Barton family owned the Ever Ready Garage, as already mentioned,
and other garages included the Morehampton Garage with its petrol

Advertisement for Roebuck Dairy, Beaver Row. (Courtesy Mons. Sherry)

pumps, Cahill's, and, across the road, Breen's, which was the last one to close down.

In the 1970s Browne & Nolan Ltd had their printing works at Richview, on Beaver Row, as did the Richview Press, which was the publishing end of their business. Other businesses here included: Thomas De La Rue & Co. Ltd; Chivers & Sons (Ireland) Ltd, who made jams and jellies between 1953 and 1957; and John Jones Ltd, building contractors, located here in the 1970s.

The Smurfit Paper Mill was on the banks of the Dodder in Clonskeagh for over fifty years, until it closed in 1959. The headquarters of the parent company, the Smurfit Group, was located on Beaver Row until University College Dublin and a group of developers acquired it with plans for student accommodation and apartments. The late Jefferson Smurfit Sr, who was well-known around Donnybrook, founded the company in 1938.

There were at least two dairies on Beaver Row during the twentieth century, one belonged to a family called Keogh, and Larry Keogh was a popular sight delivering milk daily to the houses in Donnybrook. Today there are a number of large business parks on Beaver Row, thus continuing the tradition of its association with industries and businesses.

Hotels

There were originally two hotels in Donnybrook, the Montrose and the Morehampton, not to mention a number of guesthouses. The Montrose Hotel was opened by P.V. Doyle in the 1960s and was one of the most popular hotels in Dublin. It was located on the Stillorgan Road opposite University College Dublin but closed some years ago. The Morehampton Hotel, with its familiar Tam O Shanter Lounge, changed hands in recent years and is now known as the Hampton Hotel.

7

FAMILIAR ROADS AND HISTORIC HOUSES

On leaving Dublin through it's handsomest and most fashionable squares, Merrion and Fitzwilliam, the next excursion at once enters the celebrated village of Donnybrook, situated within the liberties of the city on the river Dodder over which it has a bridge, erected in 1832.

John D'alton, The History of County Dublin *(1838)*

Thom's Directories of the nineteenth and twentieth centuries are a wonderful source of information regarding the major roads and houses in Donnybrook, most of which date from the eighteenth and early nineteenth centuries, a time when the growth of suburban residential areas outside central, commercial and industrial areas of European capital cities was common. Originally the north side of Dublin was the fashionable side of the city in which to live. Mountjoy Square, Rutland Square (now Parnell Square), Henrietta Street and North Great Georges Street were the homes of many leading members of the legal, ecclesiastical and business communities. With the opening of the new Bridge Sackville Bridge in 1791 (now O'Connell Bridge), the fashionable streets on the north side of the Liffey were linked with the broad streets on the south side, and with the new Parliament House and Trinity College Dublin, and they were superseded by the development of Merrion Square. The dissolution of the Irish Parliament with the Act of Union of 1800 led to the decline of Dublin as the capital city.[1] The upper classes left their Georgian houses to be managed by their agents in Ireland, and moved to London. Many of the splendid Georgian

houses in the city were sold to profiteering landlords, who packed them with poor families. This led to the growth of tenements and the centre of the city became the home of some of the most dreadful slums of the nineteenth century.[2]

The nineteenth century saw a big deterioration in Ireland's economic situation, leading to great changes in people's lives in Dublin. The advent of free trade between Ireland and England meant that many of the Irish industries could not compete with the English industries, such as the woollen, cotton, silk, leather, and shipbuilding industries. These industries therefore collapsed in Ireland and this led to massive unemployment in Dublin.

The late nineteenth and early twentieth centuries in Dublin was a period of social migration, when many wealthy inhabitants of the city moved out to the suburbs. As Professor Mary Daly has pointed out in her book *Dublin the Deposed Capital* (1984), the fashion for suburban living was a major trend in Victorian times, not only in Dublin but also in other European cities.[3] Cities were seen as the harbinger of disease (in Dublin, typhoid and tuberculosis were rampant in the city tenements) and the wealthy wanted to live in houses and villas that would reflect their role in society. Such accommodation could not be built within the confines of Dublin city and so suburbs were built, mainly on its southern side. The south side was chosen for a number of reasons, including the fact that a new and substantial bridge over the River Dodder in Donnybrook opened in 1832 and in 1834 the Dublin to Kingstown Railway opened, making the area more accessible. As Professor Daly has pointed out, the fashionable Dublin suburbs were initially focused in the Pembroke and Rathmines areas, which were very convenient to the city centre.[4]

Early movers to the suburbs included lawyers and members of the medical profession. Many of the individual villa-style houses on the south side were laid out on leafy roads and had large gardens. The upper and middle classes were very soon followed to the suburbs by the lower classes, many of whom found work in the large houses and villas in both the Pembroke and Rathmines Townships.

Much of the development of the Dublin suburbs was driven by businessmen and property developers, or by independent landowners like the Earl of Pembroke. It is interesting to note that the people who initially moved from the City of Dublin to the suburbs were overwhelmingly Protestant, which reflects their domination of the upper classes of society in Dublin at this

time. The south side of Dublin was dominated by two main self-governing suburbs: Rathmines (1847) and Pembroke (1863).[5] Each township had its own system of commissioners, their own services and their own rating system. This meant that Dublin Corporation was deprived of rates from the townships, which was a great blow to the corporation in terms of funds as the rates had to pay for the city's workhouse, hospitals and police force. By the end of the nineteenth century more than half of the residents of the Dublin suburbs lived in either the Pembroke or Rathmines Townships, while just over 12 per cent lived in the comparable suburbs of Drumcondra and Clontarf. The Pembroke and Rathmines Townships had much in common in terms of population and social composition; however, there was a big difference in how they were controlled. A benevolent landlord, the Earl of Pembroke, who was also an absentee landlord, controlled the Pembroke Township. Businessmen and developers, on the other hand, controlled the Rathmines Township

The Pembroke Township was governed by a number of Commissioners until 1899, when the Township became an Urban District.[6] The actual areas encompassed by the Pembroke Township began assuming definite forms as far back as the thirteenth century. These areas included farms clustered together for protection, with free tenants who paid rent in money, some who were paid in specific services, and labourers who received small allotments of land instead of wages. From 1863 the Pembroke Township included a number of different districts: Ballsbridge, Donnybrook, Sandymount, Irishtown and Ringsend. These areas were all very different, with Ringsend being an old fishing village, and Irishtown being an industrial area. Ballsbridge and Donnybrook, on the other hand, contained some of the most affluent houses in Dublin.

There were fifteen founding commissioners of the Pembroke Township and of them at least seven were builders or architects, including John Hawkins Askins and Patrick Leahy, who were both builders, and Edward H. Carson, who was an architect/engineer. There was a clause in the original Act that set up the Pembroke Township which stated that the agent for the Pembroke Estate was to be the chairman of the Pembroke Township for life. The property owners elected the remaining fourteen commissioners. Most of the commissioners were Protestant; Catholics were scarcely represented on the Pembroke Council. Of fifteen members at the beginning of the twentieth century only three were nationalists and Catholic. The Records of the Pembroke Township from 1863 to 1930 have survived and are available

for consultation in the Archives Department of Dublin City Libraries in Pearse Street. The area of the Township covered 1,592 acres.

The Earl of Pembroke's agents were the Vernon family, who determined most of the Pembroke Estate policies.[7] The Pembroke Estate was very generous towards the Pembroke Township and provided a site and two thirds of the funding for the Pembroke Town Hall in Ballsbridge, as well as giving a 20 per cent subsidy towards the cost of the main drainage system. The Pembroke Estate also laid out paved roads and sewers that helped reduce the burden on the Pembroke Township rates. The Earl of Pembroke placed great emphasis on controlled development. Only a few houses were built at any one time, and they were required to be of a very high standard. His agents also closely supervised the uses to which they could be used. Typically, plans for housing, including details of the materials that would be used, had to be approved by the Pembroke Estate. The Estate then laid out the necessary roads, infrastructure, paths, water mains, etc. Unfinished buildings were not allowed and the developer was penalised if the house or houses were not finished on time.

Large villas and houses of quality were the hallmark of the Pembroke Township. Terraces of three-storey houses were common with live-in facilities for domestic staff at basement level. Clyde, Elgin, Morehampton and Marlborough Roads were owned by members of the legal and medical professions, colonels and country gentlemen, who had moved to the suburbs for a better quality of life. Pembroke Estate leases were of ninety-nine years, which was shorter than those in the Rathmines Township, and clauses in the leases required that houses should be retained in good repair and were not to be used for commercial purposes. During the nineteenth and twentieth centuries the majority of suburban residents rented their homes. An eight-room house in 1913 could be rented at £75 per annum.

Many of the inhabitants of the townships were Protestant Unionists, and in the Pembroke and Rathmines Townships they were constantly at loggerheads with the mostly Catholic and Nationalist Dublin Corporation. The Pembroke and Rathmines Townships jealously guarded their independence from Dublin Corporation. It seems that they were of the opinion that it was unnecessary for their inhabitants to provide support, in the form of money, for the services provided by Dublin Corporation for the city of Dublin.

The population of the Pembroke Township grew fairly steadily over the years, though at a pace which was much slower than that of Rathmines. The Pembroke Township population rose from 18,256 in 1861, to 25,799

by 1901. The continued independence of the two major Townships left the city of Dublin with less money than it needed to tackle the major problems of housing and the chronic ill-health of the poor. As Jacinta Prunty has pointed out in her book on the Dublin slums in the nineteenth century, the poor lived in extraordinary insanitary accommodation. Conditions were cramped in the tenements in the city, and about one third of the population of the inner city lived in single rooms.

Most of the houses in Donnybrook were built with land leased from the Pembroke Estate. It is interesting to note that many of the senior civil servants and army officers lived in the Pembroke Township, so that may be the reason for the attention the township gave to sanitary problems in contrast to the City Council.

In 1903 the Earl of Pembroke offered land to the Pembroke Township for a park. The committee planning the International Exhibition, which was held in Herbert Park in 1907, then rented this land from the township. The exhibition, which is discussed in chapter 4, was a massive success and it has been suggested that the demand for houses in this area increased significantly as a result.

Pembroke Urban District Council, with additional funding from The Carnegie United Kingdom Trust, also built Pembroke Library on

Pembroke Library, Angelsea Road. The architects were King, Barry, Ross and Hendry and it was built by G. & T. Crampton. (Courtesy David Crampton)

Anglesea Road. The two-storey building was designed by Arnold F. Hendy of Kaye-Parry, Ross & Hendy, architects, Kildare St Dublin, and constructed by G. & T. Crampton between September 1926 and October 1927.

The provision of housing for artisans in the Pembroke Township was spearheaded by the Pembroke Estate. By the beginning of the twentieth century there was an increase in the number of Nationalists on the Board of the Pembroke Township, very different from the Rathmines Township that remained strictly Unionist until 1920. In 1918 there were twelve Nationalists elected to the Pembroke Council. In the same year, a traditional safe Unionist seat of South County Dublin (mostly Pembroke) was won for the first time by Sinn Fein, when Desmond FitzGerald, father of Garret FitzGerald (a former Taoiseach), won the seat.

Artisan Dwellings

Improvements in housing in Dublin during the late nineteenth and early twentieth centuries for the lower classes of society were provided by a few generous and benevolent landlords. In general, the government was very slow to build houses for the working classes, concentrating instead on improving the sanitary conditions in tenements and houses already inhabited by them.

The extension to Ireland of the Artisans and Labourers Dwelling Improvement Act of 1875, known as the Cross Act, was significant. It was the Cross Act that stimulated interest in providing houses for the lower classes. The government's intention appears to have been to sell or lease the land to private companies to develop new housing for the poor of Dublin. There were sizeable working-class populations in the Pembroke Township and the lack of adequate housing was a major problem. Many landowners, like the Earl of Pembroke, took advantage of the low interest rates and in return offered land as security. Within six years the Earl of Pembroke built six estates of cottages in the Pembroke Township, which he leased at low rents to labourers and artisans.[8] One of the main builders of artisan dwellings in the Pembroke Township George O'Connor lived at 3 Morehampton Road. He built houses in Donnybrook, Ballsbridge, Sandymount, Ringsend and Irishtown.

In 1912, eighty-eight artisan dwellings were built in Donnybrook beside Herbert Park. The majority of these houses were in Home Villas, with seventy-seven houses that were of a very high-quality. The houses were two storeys

and had the luxury of a bathroom. A bathroom was a very unusual feature of artisan dwellings at this time, according to Seamus Ó Maitiú in his book *Dublin's Suburban Towns 1834-1930*. The rest of the new houses were St Broc's Cottages, which were one-storey houses. The houses cost almost £24,000 and they were let out to tenants with charges ranging from 4*s* 9*d* to 7*s* per house. The more expensive ones had larger gardens or larger rooms, or their location was better. St Broc's Cottages were part of this development and the accommodation in a single-storey two-bay cottage consisted of a living room, two bedrooms, a store room, kitchen, an outside toilet and a coal shed. The architect was Mr E. Bradbury and the builder was Mr Shorthall. Irish labour was used as far as possible in the construction of the houses.

The early *Thom's Directories* do not provide any great details of tenements in Donnybrook, but according to *Thom's Directory* for 1900, there were a number of tenement houses at Nos 15, 16, 17, 18, 23, 25, 27, 29, 35, 38, 40 and 55 Donnybrook Road. Over the years there may have been re-numbering of the houses as some would have been demolished at the time of road widening in 1931, so it is difficult to actually pinpoint where these tenements were today. There were tenements still in existence in the 1940s, '50s and '60s. Some of the more recent ones were at the rear of a small terrace of cottages that were called Brooklawn, and there were about twelve families housed there. People lived here in very poor conditions, with no gas or electricity, and they shared one cold tap out in the open, together with two lavatories.[9]

Simmonscourt Castle

Donnybrook has a number of significant historic roads and houses.[10] One of the oldest is Simmonscourt Road, where Simmonscourt Castle is located. The name comes from the Smothe family who were major landowners in the fourteenth century. Thomas Smothe built a walled enclosure for the safekeeping of cattle at night and this eventually became a place of recreation, and the green of Smothescourt was popular on festive occasions. Richard Mountney, one of the Barons of the Exchequer, built a second house nearby. The ruins of the old Simmonscourt Castle were in the grounds of the newer Simmonscourt Castle. A bridge across the Dodder in the seventeenth century was known as The Bridge of Simmonscourt. It was in a bad condition in 1640 and Dublin Corporation voted to spend £10 on its restoration. During the 1641 rebel-

lion the lands of Simmonscourt were laid waste but after the Restoration
a member of the Fitzwilliam family, William Fitzwilliam, lived in the castle.
There is evidence that it was a ruin by the seventeenth century. Arthur Forbes,
2nd Earl of Granard, occupied a house that was built at Simmonscourt at the
beginning of the eighteenth century. He lived there until his death in 1734.[11]

University College Dublin Campus in Belfield

The evolution of the Belfield campus actually dates back to the eighteenth
century, with the development of a number of period houses and their associ-
ated lands. In his *Topographical Dictionary of Ireland* (1838), Lewis describes
the area around Roebuck Castle (which includes the area now known as
Belfield campus) as follows:

President Eamon de Valera cutting the sod for the Belfield Campus watched by the president
of UCD, Dr Michael Tierney. (Courtesy E. De Valera and the Irish Press)

This district is chiefly occupied by handsome villas situated in tastefully disposed grounds, many of which command magnificent views of the bay and city of Dublin, the Dublin and Wicklow Mountains, and the beautiful adjacent country.

The University College Dublin (UCD) campus at Belfield is made up from the lands of twelve different suburban estates: Ardmore, Belfield, Belgrove, Merville, Newstead, Roebuck Castle, Roebuck Grove, Roebuck House, Richview, Rosemont, Thornfield and Woodview. Unfortunately not all of the houses are still in existence, but seven of them are still standing. Not all of the houses in Belfield could be classified as being in Donnybrook as some are in the Clonskeagh and Roebuck end of the campus, so the following discussion is limited to the ones that have a Donnybrook address.[12]

Ardmore House
This house was built around 1800 and is a good example of a nineteenth-century villa in Dublin. In the late 1800s a Corinthian porch was added, together with bow ends to the house, and an extension was built that incorporated a balustrade. The house is two storeys over a basement and once contained ten bedrooms and two fine reception rooms. Ardmore House is currently in use as research laboratories. The house has been partially restored and UCD has a programme in place for the restoration of all the historic houses on its Belfield campus.

Belfield House
Belfield House dates from 1801 and was built by Ambrose Moore, a member of the La Touche banking family. The original house was two storeys over a basement, with a parapet at roof level. It also had a distinctive central bow bay to the northeast, which overlooked Dublin Bay. There is an impressive entrance hall and oval room, which was a feature of many great Irish houses at that time. In 1934, Belfield House and grounds were purchased by UCD to provide a sports centre and playing fields for the students. Today, Belfield House is the home of the William Jefferson Clinton Institute for American Studies. The building itself is a protected structure and it has been beautifully restored by UCD.

Belgrove House
This house no longer exists but for many years it was the home of the Overseas Archive founded in 1954 by Professor Patrick McBride of the

Belgrove House. Former home of the Irish and Overseas Archive, on the UCD Belfield Campus now demolished due to the widening of the Stillorgan Road. (Courtesy Karen Cronin)

Department of Spanish and Italian. It aimed to document the history of the Irish in Europe and to make this material readily available to Irish research-ers. The Overseas Archives contains 250,000 documents on the Irish abroad, collected from archives in Spain, France, Austria, Italy and Belgium. Dr Micheline Kearney Walsh (1919-1997) became deputy director and overseas archivist to UCD from the foundation of the Overseas Archives until she retired in 1987. The Ó Fiaich Library in Armagh has partnered with UCD to ensure the further development of the collection. It is now known as the Micheline Kearney Walsh Overseas Archive. Belgrove House was a mock Tudor building that was demolished in 1973 to make way for the new Stillorgan dual carriageway.

Merville House

Located near the Foster's Avenue end of the UCD campus, Merville House was built in mid-1700 for the Right Honourable Anthony Foster, Chief Baron of the Irish Exchequer. The gardens are said to have extended to four acres with running streams. In 1778 the house passed to his son, Sir John Foster, who was the last Speaker of the Irish House of Commons. In the 1820s William Downes, the Lord Chief Justice, lived there. In the latter part of the nineteenth century a Lieutenant General Henry Hall occupied

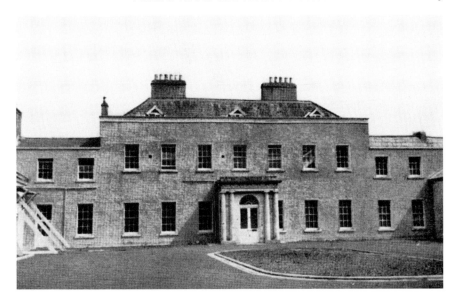

Merville House in the grounds of University College in Belfield. (Author's image)

the house. The Hume Dudgeon family took over Merville in 1890 and in 1938 Merville House was established as a riding school under the direction of Colonel Joseph Hume Dudgeon. The Riding School continued until the 1950s, when the estate was acquired by UCD. Today Merville hosts the UCD innovation and technology transfer centre called Nova.

University Lodge

The early history of University Lodge, the home of the president of UCD, is uncertain. The Lodge has held various names since it was built, including Roebuck Grove, Whiteoaks and the present title of University Lodge. The land was originally part of a larger estate dating from the Middle Ages and owned by a family called Barnewell. The head of this family was created Baron Trimlestown in 1461, and the family itself was important in Dublin during the sixteenth and seventeenth centuries. In the late 1700s the 14th Baron Trimlestown, Nicholas Barnewell (1726-1812), began to dispose of land in the area. In 1812, Captain Solomon A. Richards, a landowner from County Wexford, acquired the land on which University Lodge is located. Captain Richards leased twelve acres, in 1853, to Robert Queale, who built Roebuck Grove. Queale was a leather and bark merchant, and he soon sold the lease on to Richard Seymour Guinness in 1862. The house changed hands a number of times until it was purchased

in 1949 by UCD. It then became the official residence of the president of UCD. University Lodge is now a listed building, with strict legal restrictions on how it may be refurbished.

Across the road from the UCD Belfield campus lies the home of the National Broadcasting Corporation (RTÉ) and in its grounds are two significant historic houses, Montrose and Mount Errol.

Montrose House

The grounds and the house itself covered twenty-three acres along the Stillorgan Road. Montrose House was built in 1836 for James Jameson, a member of the well-known distillery family.[13] He was a great fan of Sir Walter Scott so he named his house Montrose, after a novel by Scott called *A Legend of Montrose*, published in 1819. Annie Jameson, a daughter of the family, studied music at the Conservatoire in Bologna and, in 1864, married widower Giuseppe Marconi. Their son, Guglielmo Marconi (of radio fame), was also the founder of the Marconi Marine Communications Company. Between 1897 and 1905 Sir Malcolm and Lady Ingis occupied Montrose House.

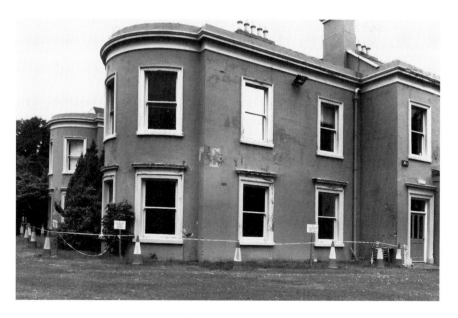

Montrose House in the grounds of RTÉ. (Author's image)

In 1909, a Major Vincent J. Kelly bought Montrose House. Major Kelly had served with the Royal Irish Rifles in the Boer War and also with the Munster Fusiliers. The family of T. & C. Martin, a well-known Dublin firm, also lived in Montrose for a short period at the beginning of the twentieth century. A member of this family was Mother Mary Martin, the founder of the Medical Missionaries of Mary.

Montrose was bought by UCD in 1947, with a view of moving the University from Earlsfort Terrace to a new greenfield site. About the same time, the Office of Public Works had acquired Ardmore House and grounds, with a view to the development of the national broadcasting facilities. Ardmore was adjacent to two other properties owned by UCD, and an arrangement was entered into between the two, so that a direct swap took place and Ardmore became the property of UCD and RTÉ acquired Montrose. With the acquisition of Ardmore House and grounds, UCD consolidated its property on the western side of the Stillorgan Road and Montrose became the headquarters of RTÉ.

Mount Errol

This Palladian-style house is now in the grounds of RTÉ at Montrose. It was very difficult to find any information about it except through *Thom's Directories*. Sir Richard Baker lived in Mount Errol in 1835. In 1882 a Mr Fred Sims inhabited it and he was still living here in 1900. He had a business address at 51 Dawson, Street Dublin. In 1925 a Mrs Cantwell lived in Mount Errol and a Mr J.A. Gargan lived in it in 1934, remaining there until 1952. In 1957 the occupant was a Mr W.L. Freeman and he remained there until 1971, when a Mrs Gargan moved in. It was eventually purchased by RTÉ and is currently used as a training centre.

Nutley House

Nutley House is a late neo-classical Georgian mansion built around 1820. Today it is the home of Elm Park Golf & Sports Club.[14] It may have been designed and built by Richard Morrison, a distinguished Irish architect. The house originally had sixty-five acres of land and its entrance was through an ornate gateway. Until the turn of the nineteenth century,

the house was occupied by Alderman George Roe, of Roe's Distillery, twice Lord Mayor of Dublin, who employed Ninian Niven, a noted botanist and director of the Botanic Gardens, to design a garden, park, lake and tall belvedere at Nutley.

At the beginning of the nineteenth century, Nutley House became the property of a High Court judge and vice chancellor of Trinity College, the Right Honourable Dodgson Hamilton Madden, who was also a Shakespearean scholar, and who died in 1917. In 1927, the owners, Lillis and Thompson, sold thirteen acres of the land and houses were built in what is now Nutley Park, with further houses on the Stillorgan Road. Later, part of the land was acquired by the Irish Sisters of Charity for St Vincent's University Hospital.

Donnybrook Castle

The site of Donnybrook Castle, built by the Ussher family, is now the location of the Irish Sisters of Charity and the Magdalene Home.[15] One of the earliest occupants of Donnybrook Castle was Thomas Twigge, a member of the legal profession. The next owner was Sir Francis Soyte, a former Lord Mayor of Dublin, who receives honourable mention in Swift's *Journal to Stella*. In 1726 the house was sold to Sir Robert Jocelyn, MP for Granard, who went on to become Lord Chancellor. Before Sir Robert Jocelyn acquired Donnybrook Castle, Isaac Dobson, son of a leading bookseller and publisher, lived here for a period of time, as did Warden Flood, Lord Chief Justice, who was the first native Irishman to be appointed a judge. He was the father of the celebrated orator and statesman Henry Flood. Donnybrook Castle was in a state of rapid decay when Sir Robert Jocelyn abandoned it for a beautiful new residence on the River Dodder, which he called Ballinguile. He moved there in 1725 and Donnybrook Castle was finally demolished in 1759. In 1789 a new house was built on the site that later became a boys' school called the Castle School.

In the early days the grounds of Donnybrook Castle covered five statute acres and included a large garden, which became the present-day cemetery for the Irish Sisters of Charity. Mother Mary Aikenhead, founder of the Irish Sisters of Charity, is buried there.

Beech Hill House

Beech Hill House was located at the foot of the present Beech Hill Estate, but it is no longer in existence. It was built for the Wright brothers, who owned the hat factory on Beaver Row.[16] In more recent times the house was also known as The Manse. The last occupants of the house were the family of Byrne's the butcher, who had a shop in Chatham Street in the city. There was also a lodge at the entrance to Beech Hill house and a family named Ennis was the last family to live in this lodge. During the Second World War, a knitting factory operated in Beech Hill house. The present Beech Hill flats are now built on the site of this house.

Other Important Residences

Lewis's *Topographical Dictionary* of 1837 lists a number of important residences in Donnybrook, together with the name of the occupants: Anne Field, the residence of R. Percival Esq. MD; Mount Errol of Sir R. Baker, Knt; Montrose of J. Jameson, Esq.; Swanbrook of Alderman F. Darley; Gayfield of T.P. Luscombe, Esq., Commissary-General; Priest House of J. Robinson, Esq.; Stonehouse of J. Barton, Esq; Woodview of E.J. Nolan, Esq; Nutley of G. Roe, Esq.; Thornfield of W. Potts, Esq.; Airfield of C. Hogan, Esq.; Simmonscourt Hall of G. Howell, Esq.; Belville of Alderman Morrison; Flora Ville of M. FitzGerald, Esq.; Donnybrook Cottage of Abraham Colles, FRCSI; Simmons Court of P. Madden, Esq.; and Glenville of J. O'Dwyer, Esq. Many of these houses have now disappeared but several roads named after them still remain.[17]

Nutley Lane

During the nineteenth century Nutley Lane had deep muddy ruts, made by carts heading for the farm that belonged to Blackrock College. The farm extended from Nutley Lane to Ailesbury Road and is now built on, except for the sports fields of St Michael's College. On the opposite side of Nutley Lane were fields that belonged to a house called Elm Park House on the Merrion Road, and during the First World War its land was used as a practice range for bombs and grenades. At the Merrion Road end of Nutley Lane were

the nurseries of the Walsh brothers (Harry and Herbert) who provided garden
and house plants for the people of Donnybrook.

Shrewsbury Road

Two of the most outstanding roads in Donnybrook are Ailesbury Road
and Shrewsbury Road.[19] Today and in the past, Shrewsbury Road and
Ailesbury Road contain some of the most expensive houses in Dublin. In the
Irish version of the board game Monopoly, Shrewsbury and Ailesbury are the
most expensive roads!

Shrewsbury Road was named for the Marquis of Shrewsbury. It contains
a great number of beautiful Edwardian houses, set in spacious and mature
grounds. Over the years, it became the home of many of Dublin's leading
medical and legal families, but today one is more likely to find property devel-
opers and Celtic Tiger millionaires living here. There are twenty-six houses
on Shrewsbury Road and most of them date from the end of the nineteenth
century or the beginning of the twentieth century. Many of the houses have
beautiful mahogany staircases and are decorated with teak and wood panelling.
The majority of these houses have at least six bedrooms; large reception rooms,
domestic staff accommodation and some even have swimming pools.

Shrewsbury Road still looks much as it would have looked in the early
1900s. Some of the houses have added extensions but these have been done
discreetly and more or less blend in with the road's environment. What has
been described as one of the most beautiful houses on Shrewsbury Road
is Runnymede. This house dates from the late 1890s and was designed
by Richard Caulfield Orpen. It is built of brick and half-timber, with a dis-
tinguished arts and crafts interior. Another house, Walford, came into
prominence when it was sold for a reported €58 million in 2005, making it
the most expensive house ever sold in Ireland at the time. Walford dates from
1900 and it has extensive grounds attached to it, which made it very desir-
able for future development. It belonged to Patrick Duggan, a former director
of the Bank of Ireland and chairman of Hibernian Insurance. Walford came
back on the market again in 2008 at a price of €75 million, but it remained
unsold. In 2011 the house was on the market again at €15 million, but
again it remained unsold.

For many years the Pharmaceutical Society of Ireland had their headquar-
ters in a large Edwardian house on this road. The house dates from 1903 and

was designed by a Cornish architect, Silvanus Trevail. It was originally known as Woodside. This house was acquired by the Pharmaceutical Society of Ireland from a Church of Ireland Archbishop of Dublin, Revd Arthur Barton, DD. The house was owned by the Department of Health from the 1950s and it was rented to Trinity College for a long period until 1998. From 1999 the Irish Pharmaceutical Society were based here and it was finally sold in 2011.

The Chester Beatty Library

Shrewsbury Road was home for many years to the Chester Beatty Library. It is now located in the grounds of Dublin Castle. Sir Alfred Chester Beatty left the library to the Irish nation. He was an American multimillionaire mining engineer, who collected around 5,000 rare books, 10,000 manuscripts and artefacts of Oriental Art. He bought most of his magnificent collection between the two world wars. All the material in the Chester Beatty collection is of the highest quality. He first visited Dublin regularly in the 1930s. In 1948 his son bought an estate in County Kildare and his father was a frequent visitor to Ireland. When he was 75 years old, Sir Alfred Chester Beatty bought

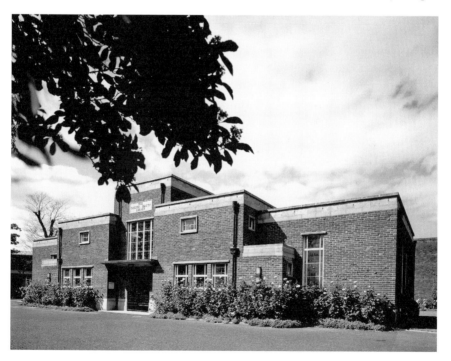

Chester Beatty Library, Shrewsbury Road, before it moved to the grounds of Dublin Castle. (Courtesy © The Trustees of the Chester Beatty Library, Dublin)

No. 10 Ailesbury Road as he had decided to settle in this country. He brought with him about 35 tons of art treasures, and presented some 100 nineteenth-century French paintings to the National Gallery of Ireland. The Chester Beatty Library opened its door in 1954 and in 1958 an additional gallery was built to enable more of the collection to be displayed. A new and enlarged gallery was opened in 1975. Regular exhibitions of the magnificent artefacts of the collection are held in the Chester Beatty Library, now located in the grounds of Dublin Castle.

Ailesbury Road

Ailesbury Road was named for the Marquis of Ailesbury, who married a daughter of Lord Pembroke, the ground's owner. The original design and plans for Ailesbury Road can be seen in houses 1 to 51 on the south-east side of the road. These houses are all of redbrick and granite, with a flight of granite steps leading to the hall door, and iron railings delimiting the front gardens. Ailesbury Road is considered to be the longest straight road in Dublin and has often been called the golden mile – it extends for one mile from the Church of the Sacred Heart to the railway station at Sydney Parade. Sir Thomas Manly Deane was responsible for the design of a number of houses on Ailesbury Road, Ailesbury Park, Merrion Road and Sydney Parade. He moved into No. 2 Ailesbury Road in about 1912 and altered the original design by adding curved bow windows to the house.

Michael Meade was one of the major builders who leased plots from the Pembroke Estate to build many houses around the south side of the city of Dublin. Numbers 1-27 Ailesbury Road were built by him and circular granite pillars at the entrance gate mark the houses he built. Michael Meade's building firm was first established in Westland Row in the 1850s, and later moved to 153-159 Pearse Street. The firm was contemporaneous with a number of the other Dublin builders of the nineteenth century such as Moyers, Cockburn and Bolton. Meade had a very good reputation as a builder of quality houses and his company was well known for the quality of their workmanship, and for the high-class materials they used in building. He was an active builder between the late 1840s and the 1880s. He also owned sawing, planning and moulding mills on Great Brunswick Street, in Dublin. The firm of Michael Meade also built a number of churches in Dublin, including the Church of the Sacred Heart Donnybrook, and churches in Bray, Monkstown

and Harrington Street. They also built the Gaiety Theatre and Dun Laoire Town Hall. A fellow builder to Meade on Ailesbury Road around 1870 was a man called Baird, who provided square pillars for his houses as opposed to Meade's circular pillars. Another builder was William Wardrop, who built the houses at the corner of Ailesbury Road and Seaview Terrace in 1879. Seaview Terrace had been built prior to this in the 1830s.

Michael Meade built the present St Michael's School as his own private residence in 1860. It was modelled on Queen Victoria's holiday residence at Osborne on the Isle of Wight and is an excellent example of a nineteenth-century house with a lovely balcony, a lofty tower and marble pillars.[19] His son Joseph succeeded him, and he built houses on Northumberland Road. Some of them still bear the monogram MM on the centre of the pediment on each block of four of the houses on Northumberland Road. As well as being a successful businessman, Joseph Meade became High Sheriff in 1889, was a member of Dublin Corporation, and was appointed Lord Mayor of Dublin in 1891. He had a reputation as a strong Nationalist. After his sudden death on 14 July 1900 the business went into a decline.

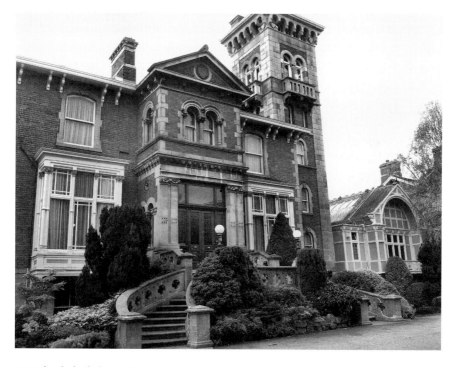

St Michael's built, by Michael Meade as his family home. (Courtsey Fr Seamus Galvin)

The next owner of St Michael's was Sir Ernest Cochrane, whose firm Cantrell & Cochrane were well-known mineral water manufacturers. Cochrane added the billiard room and the oak panelling in the entrance hall and dining room of St Michael's. He also redecorated the ceilings of the ballroom and reception rooms in the Adams style, and installed two beautiful Bossi fireplaces. Cochrane was also interested in gardening, and had a rectangular lily pond installed and a glasshouse with a variety of tropical plants.

The next occupant of St Michael's was G.N. Jacob, a son of the founder of the firm Messers Jacob & Co., the biscuit manufacturers, followed by the Holy Ghost Fathers, Blackrock College, who acquired St Michael's towards the end of 1943.

Originally it was planned that all the houses on Ailesbury Road would be of similar design, but about the turn of the twentieth century the Pembroke Estate, which owned the ground, seemed to lose interest, and ground rents were sold and permission given for two-storey houses, which can now be seen on both sides of the road. These more modern houses at the Donnybrook end of Ailesbury Road are post Second World War.

The 1901 and 1911 census indicates that Ailesbury Road was inhabited, in the main, by the professional classes. Included were several barristers, solic-

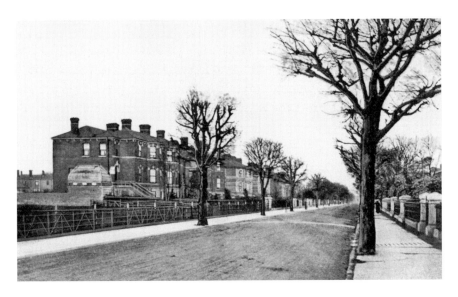

Ailesbury Road from the Donnybrook end. (Author's image)

itors, mechanical and civil engineers, a vet, a doctor, a ship owner, a brewer, an accountant and a building contactor. There were also several merchants, stockbrokers and one or two former senior military men. Evidence from the 1901 and 1911 census suggests that families living on Ailesbury and Shrewsbury Roads often employed a number of servants such as a chauffeur, gardener, coachman, groom, cook, housemaid, nanny, and a governess to look after their children. Servants could earn very different wages depending on their post in a household. A butler, for example, could earn between £40 and £50 per annum. A footman might earn £25 per annum but female servants could only earn between £10 and £14 per annum. A cook could earn more – from £25 to £30 per annum. A governess, on the other hand, could earn up to £30 per annum.

Danesfield

Seaview Terrace dates from the early 1800s. Danesfield is the residence of the German Ambassador on Seaview Terrace and it was built about 1879. When excavations were taking place for the building of the house, a burial mound containing the remains of around 700 people, including children, that had remained hidden for centuries, were unearthed. Archaeologists, anthropologists and doctors studied the evidence from this Viking burial in detail, and the remains were finally buried in Donnybrook Graveyard.[20] Dr William Frazer, in his paper in the *Proceedings of the Royal Irish Academy*, published in 1879, suggests that this was the scene of a cold-blooded massacre and that the people were fleeing from the Vikings but were unable to cross the River Dodder and so perished at the hands of the raiders. Buried apart from the victims lay the leader of the Viking raiders, and at his feet were the skeletons of two young people buried with him.

Among the grave goods described by Dr Frazer was a broken broad-bladed iron sword, the handle of which was inlaid with gold and silver. This sword disappeared sometime after 1879 but reappeared in 1936, when it was sold by Glendining's auction house in the United Kingdom. It found a home in the Castle Museum in Nottingham and was part of a donation from W.J. Thompson in the mid-1950s to Nottingham Corporation. It was identified by R.A. Hall and his findings were published in *Medieval Archaeology* in 1978.[21] The sword is similar to others produced

Seaview Terrace, which was built in the 1830s. (Courtesy of Adrian Le Harival)

in Scandinavia and found in Viking colonies in the British Isles and also
in mainland Europe. Dr Betty O'Brien published a re-assessment of the
Viking burial at Donnybrook in *Medieval Archaeology* in 1992. She has
reinterpreted the site as a native Irish cemetery of the early Christian
period into which a Viking burial has been inserted. Dr O'Brien points out
that Dr Frazer's description of the burial practice in this grave is that of
normal burial practice in Ireland from about the fourth century AD. There
is evidence too for kitchen middens on the surface of the graves that would
indicate the presence of habitation nearby. Dr O'Brien suggests that since
this material covered the burials this would indicate that this cemetery
had ceased to function during the period of habitation and that this was
possibly as early as the ninth century, based on the evidence of some of
the grave goods. Dr O'Brien is confident from her re-assessment of the
Viking burial in Donnybrook that the cemetery can now be recognised
as a secular or familial cemetery of the Early Christian period and that a
single Viking burial was deposited there. There is evidence from elsewhere
in Ireland, the Isle of Man and Britain of the practice of the depositing of
pagan Viking burials in Christian cemeteries.[22]

French Ambassador's Residence and Offices

Number 53 Ailesbury Road, now the residence of the French Ambassador, was formerly known as Mytilene. This house is one of the finest houses on Ailesbury Road with beautiful gardens. The architect of this house was Alfred Gresham Jones and it was designed in 1885. The white bricks for the house were said to have been specially made, and each one cost two and a half pence. It is said that the original house contained forty rooms of various shapes and sizes. The house is built of creamy bricks with a porcelain finish with inset designs in black. There is a wonderful story attached to this house.

A young boy selling newspapers at Donnybrook Fair found a wallet containing a large sum of money and the boy left no stone unturned until he found the owner of the purse. The owner was most impressed with the boy's honesty and gave him a generous reward. The young boy then bought a ticket to Australia, where he made a fortune as a builder and developer. But he always planned to return to Dublin to retire and build a large house near the Donnybrook Fair. Unfortunately he did not live to do this, but in his will he requested his son and daughters to do so for him, which they did. Exact details and plans for the house were provided by him. The son married and moved to Northern Ireland, so it was his three sisters who lived in the house after it was completed. The eldest of the sisters died shortly afterwards, and the two surviving sisters lived a secluded life there until the late 1920s. On their father's instructions the dining room table was always laid for the four children, whether present or not, and this practice continued until only one of the sisters remained. She eventually moved to a smaller house on Brendan Road, and her fortune passed to her niece and nephew on her death. In 1930 it was sold to the French government

Number 36 Ailesbury Road, now the offices of the French Embassy, was built in 1920 by Batt O'Connor, the well-known Dublin builder, for Limerick woman Nell Humphreys. Her brother, Commandant O'Rahilly, was one of the founders of the Irish Volunteers and he was killed in 1916. The house contained a secret room and many Irishmen on the run often stayed in it and the house was used as an IRA safe house throughout the War of Independence. It was visited by many of the Irish leaders of the period such as Eamon de Valera, Arthur Griffith and Michael Collins for meetings of the Dail, the Cabinet, staff of GHQ and even Republican Courts. During the Civil War, Free State forces became aware of the secret room and in November 1922

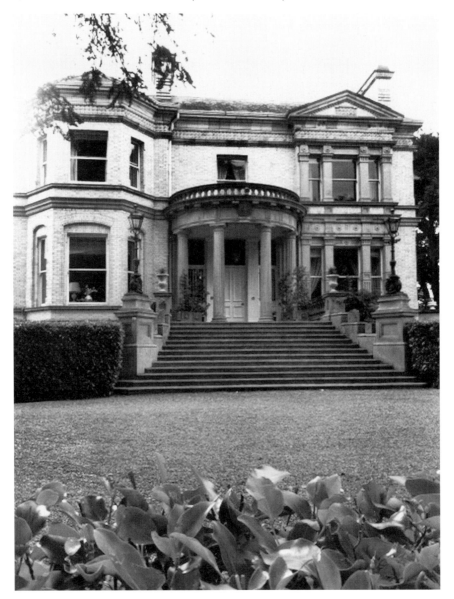

Residence of the French Ambassador (formerly Myelene). The architect was Alfred Gresham Jones (1824-1913). (Author's Collection)

they raided the house. The daughter of the house, Sheila Humphreys, who was active in Cumann na mBan, together with her mother and aunt, were arrested in the aftermath of the raid and they remained in prison for the remainder of the Civil War.

Number 36 Ailesbury Road, built by Batt O'Connor for the Humphreys family and now the offices of the French Embassy. (Courtesy Dublin City Libraries)

Airfield House, Stillorgan Road

Airfield is a fine detached two-storey garden level house of over 9,500 square feet. It has an interesting history. At the turn of the twentieth century it was the home of the Lord Chief Justice of Ireland, Peter O'Brien. He was formerly the Attorney General, and became Lord Chief Justice in 1884. After his death the house was converted into flats and an illustrious resident of the top flat, which was rented at £120 per annum, was the former Minister of External Affairs, Desmond FitzGerald. His son Garret went on to become Taoiseach and he got married from this house. Over the years the grounds of Airfield House were sold off for building and a number of modern houses are close by.

Anglesea Road

Anglesea Road is an interesting road with a number of Edwardian and Victorian-style residences. Cherry Tree Cottage at No. 26 was the home for a number of years of Sean T. O'Kelly, former President of Ireland, and his wife. Another resident of Anglesea Road was the well-known journalists Cathal

O'Shannon. Perhaps one of the most interesting houses is the one now known as Blakeney Cottage. Long before the 1850s, when most of the houses were built along Anglesea Road, it is thought to have been a tollhouse. In the 1940s it was described as 'the premises at the rear of 95 Anglesea Road'. Other redbrick terrace houses on the road date from 1903. In the lease of another house on Anglesea Road was a proviso that it was not to be let to Papists!

It is important to recall that there was a large working-class population living almost cheek by jowl with the upper and middle classes in Donnybrook. Many of them found employment in the houses and gardens of the large houses and villas. In the twentieth century many people also worked in the mills in Donnybrook and Ballsbridge, as well as in the Irish Glass Bottle Company in Ringsend and the Irish Hospital Sweepstake in Ballsbridge. The majority would have lived in the artisan dwellings and the tenements in Donnybrook.

Morehampton Road and Marlborough Road

In the nineteenth century most of Upper Leeson Street to Donnybrook village changed its name from Donnybrook Road to a more fashionable name – Morehampton Road. Most of the houses on Morehampton Road date from 1860 onwards. The houses are redbrick with granite undercourses and many have cast-iron railings.

One of the most significant events that took place during the War of Independence became known as Bloody Sunday. The IRA plan was to assassinate the Cairo Gang, a team of undercover British agents who worked and lived in Dublin during the 1920s. Twelve of this gang were British Army officers, one was a member of the Royal Irish Constabulary (RIC) and the other was a civilian informant. On the morning of 21 November 1920, the IRA operation commenced. Most of the assassinations took place within a small middle-class area of south Dublin, with the exception of one shooting at the Gresham Hotel on O'Connell Street. One of the shootings took place in Donnybrook, at 117 Morehampton Road, which was owned by a Mr Thomas H. Smith. Six IRA men burst into this house killing the owner, Thomas Herbert Smith, along with Lieutenant Donald Lewis MacLean. MacLean's brother-in-law, John Caldow, survived the attack.

Other well-known builders in Dublin during the nineteenth century included Patrick Cranny and Patrick Plunkett. Patrick Cranny married Miss

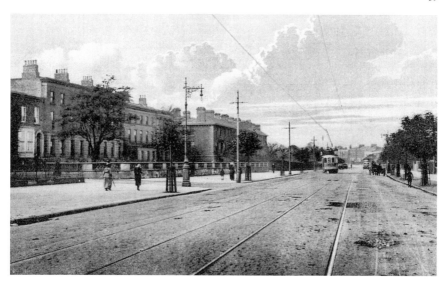

Morehampton Road in the early 1900s. (Courtesy Dr Donal Kelly)

Maria Keane, the daughter of a prosperous Tralee merchant. When the Cranny's left Tralee they set up a shoe shop in South Great George's Street next to Pims, a well-known department store. The Crannys' cousins, the Plunketts, had a similar shop nearby. The Crannys made quite a fortune in the bespoke trade and then Mrs Cranny persuaded her husband to sell the business in South Great George's Street and set himself up as a builder.

The Cranny houses were solid Victorian buildings, and were very well built. In 1856, Patrick Cranny was building houses on Wellington Road, Clyde Road, Raglan Road and Elgin Road. He also built a number of houses on Marlborough Road. The development of Marlborough Road took place over a number of years, with the earliest houses on the road dating from the 1820s. In general, the houses were built in short, separate terraces with their own individual names, for example Muckross Terrace, Thornberry Terrace, Carlisle Terrace, George's Terrace, but eventually the terraces were absorbed into the overall name for the road as happened on Belmont Avenue.

Numbers 13 to 39, Marlborough Road were built by Patrick Cranny. In 1865 Patrick Cranny built No. 56A Muckross Park as his own family home. This was the same year in which the foundation stone for the Church of the Sacred Heart in Donnybrook was laid, and while the building was in progress, the Crannys offered one of their large stucco rooms to the residents of Donnybrook as the venue for Sunday Mass.

The Cranny children grew up in Muckross Park and four of them survived to maturity – John became a doctor; Gerald followed in his father's footsteps and built many houses on Marlborough Road; Frank emigrated to Australia; and their sister Josephine married Count Plunkett. Count and Countess Plunkett received a terrace of houses in Rathmines and another on Marlborough Road as part of their marriage settlement. Their son, Joseph Mary Plunkett, was one of the signatures on the 1916 Proclamation, and was executed in Kilmainham Gaol.

Patrick Plunkett came from County Meath and, like Patrick Cranny, he set up a shoe shop in George's Street in Dublin before eventually becoming a builder. He had two building yards in Dublin by 1847, and at that time he began buying building plots in Rathmines. In 1854 he bought sites on Belgrave Road and he built three fine three-storey houses before going on to develop Palmerston, Ormond, Windsor, Cowper and Killeen Roads.[23]

Off Marlborough Road is Bushfield Terrace where No. 2 was home to the well-known Dublin architect and developer Edward Carson, the father of Sir Edward Carson. Carson (senior) designed a number of public buildings and substantial houses in Dublin including some on Marlborough Road, and he built a sewer along the length of Marlborough Road in Donnybrook at his

Muckross Park in 1900, the year Mrs Cranny sold it to the Dominican Sisters.
(Courtesy Honor O'Brolochain)

Sweet
Heart of
Jesus,
be Thou
my love.
300 *days.*

Jesus,
in the
Blessed
Sacrament,
have
mercy
on us.
300 *days.*

Pray for the Repose of the Soul of
JOSEPH MARY PLUNKETT,
(Born on November 21st, 1887)
who was shot at Kilmainham Prison on
May 4th, 1916
after he and the other leaders of the Insurrection had
surrendered to save the lives of the citizens of Dublin.

" But I, like my brethren, offer up my life and my
body for the laws of our fathers : calling upon God to
be speedily merciful to our nation."—II. *Machabees,*
vii. 37.
" Blessed are they that hunger and thirst after
justice : for they shall have their fill."—*St. Matthew*, v. 6.
" Deliver me and rescue me out of the hand of
strange children, whose mouth hath spoken vanity :
and their right hand is the right hand of iniquity."
—*Psalm* cxliii. 11.
" Blessed is he who hath the God of Jacob for his
helper, whose hope is in the Lord his God.
" Who keepeth truth for ever: who executeth
judgment for them that suffer wrong : who giveth food
to the hungry.
" The Lord looseth them that are fettered: the
Lord enlighteneth the blind."—*Psalm* cxlv. 5, 7-8.

ᵹo n▽éiṁ▽ ▽iᴀ cᵹóċᴀiᵹe ᴀᵹ ᴀ ᴀnᴀm.

Memorial Card for Joseph
Mary Plunkett, son of Count and
Countess Plunkett, who was one
of the leaders of the 1916 Rising.
(Courtesy Maeve O'Leary)

own expense. Edward Carson was vice president of the Royal Institute of Irish
Architects. He was also an entrepreneurial businessman and a commissioner
of Pembroke Township from 1864 until 1880 as well as being a member of
Dublin Corporation in 1877 and 1878.

Off Bushfield Terrace is a lovely row of whitewashed cottages, known as
Smith's Cottages, which were built in the middle of the nineteenth century.
At the back of Nos 101-109 Malborough Road was a piggery, and in the
1970s Dublin Corporation endeavoured to obtain this land from the owners
as it was causing a public nuisance. The Corporation architect at the time,
Mr John Menage, stated that 'it would be difficult to find alternative feeding
arrangement for 300 to 400 pigs if the piggery had to be moved from the
area'. However, Dublin Corporation did succeed in getting the land!

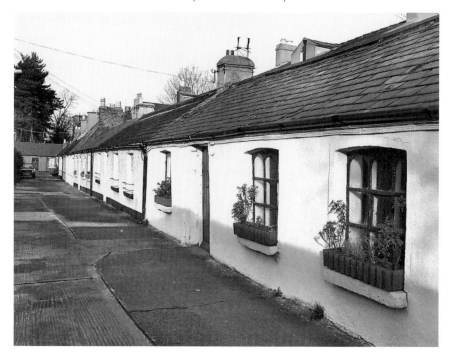

Smith's Cottages, Bushfield Terrace, Marlborough Road. (Courtesy Pat Langan)

Crampton Houses

G. & T. Crampton, the well-known Dublin builders, acquired land from the Pembroke Estate, about 1908, and commenced building high-quality houses on Herbert Park, Aranmore Road, Brendan Road and Argyle Road. Herbert Park Road appears to have been in existence prior to the building of the houses by G. & T. Crampton.[24] The architect for some of these houses was Charles Ashworth (1862-1926). In 1909, advertisements in *The Irish Times* described the houses on Herbert Park as 'semi-detached villas with three reception rooms and eight bedrooms'. Samuel Beckett's grandfather lived in 38 Herbert Park. He too was a builder and contractor – the Beckett family were well-known Dublin builders. According to Ruth McManus in her book *Crampton Built*, it was customary that in addition to building their own houses, G. & T. Crampton made sites on the Herbert Park Estate available to other builders for construction purposes. Among the builders who obtained sites from Crampton's were Batt O'Connor and Patrick J. Tracy.

One of the most interesting houses built by G. & T. Crampton is No. 32 Herbert Park and it was built for T.A. (Alfred) Fannin who was the managing director of Fannin's & Co. Medical and Surgical Suppliers. Detailed specifications for materials to be used in the house and instructions regarding the quality of the workmanship required extended to ten pages. In 1983, this house was sold for around £180,000. In April 2000 the same house was bought for €5.3 million.

Argyle and Aranmore Roads

Housing on nearby Argyle Road developed more slowly than those on Herbert Park. Again the main builder was G. & T. Crampton and the architects for some were Fuller & Jermyn. According to the census of 1911 there were only four houses on Argyle Road. Members of the Crampton family lived in a house known as Argyle House for a number of years from 1913. No development took place on Argyle Road between 1915 and the middle of the 1920s and by this time there was a severe shortage of housing in Dublin, as Ruth MacManus has pointed out in her book *Dublin 1910-1940: Shaping the City and Suburbs.*[25]

Houses on Aranmore Road were more or less contemporaneous with those on Argyle Road and part of Herbert Park. Again the builders were G. & T. Crampton. The earliest house appears to date from 1914, when Nos 2 and 4 were built. For a period there was no building on this road and it only resumed in 1927 according to Ruth MacManus.

Brendan Road

Batt O'Connor came from Kerry and he wanted to call the road where he built a number of houses after St Brendan, but he was not allowed to use a saint's name so he called it Brendan Road. He did not sell all the houses he built on this road but retained a number which he let out to tenants. Batt O'Connor was a great friend of Michael Collins and his family home was No. 1 Brendan Road. Later in life, Batt O'Connor became chairman of the Pembroke Urban District Council and went on to became a TD in 1924, serving in the Dail for nine years. Michael Collins often stayed with the O'Connors at No. 1 Brendan Road.[26] O'Connor was an expert at hiding

Number 1 Brendan Road, home of Batt O'Connor and used as a safe
house by Michael Collins. (Courtesy irishvolunteers.com)

people on the run, and built a secret room in his house to hide the fugitives.
Sean McDermott, for example, stayed there after he had been in hospital
in 1916. Austin Stack also spent six months in the secret room in 1918.

According to Batt O'Connor's memoir *With Michael Collins in the Fight for
Irish Independence*, Collins, as Minister for Finance, asked O'Connor to hide
gold under his house. After Collins died, the Irish Accountant General asked
O'Connor for the gold and it was dug up – some £20,000-worth in gold bars
and coins which had been hidden in a baby's coffin and steel boxes – and
handed over to the Accountant General.

There are interconnecting doors in some of the houses on Brendan Road so
that if a raid was taking place a man on the run could just move into the house
next door.

Number 6 Brendan Road was owned by the Dail; at No. 23 lived Sinead Mason, who was secretary to Michael Collins, and Batt O'Connor owned No. 9. All three houses were frequented by Michael Collins.

In 1907, during the International Irish Exhibition held in Herbert Park, Irish architects were invited to submit designs which would be suitable for twentieth-century housing. Houses on the left-hand side of Brendan Road represent some of these designs. Similar houses were later built in a number of the UK garden cities.

The Woods family lived at 131 Morehampton Road. Members of the family were great admirers of Patrick Pearse – hence their home was called St Enda's and it still bears this name. The Woods were a Republican family and during the 1916 rising, the War of Independence and the Civil War, their house was a hive of activity with meetings of the various leaders taking place in it. The family was a well-known Donnybrook family with a

Houses on Brendan Road, built by G. & T. Crampton in 1926. (Courtesy David Crampton)

dairy and building business. They also owned several houses on Eglinton Terrace and Morehampton Road. A James Woods built eleven of the houses on Eglinton Terrace and some of the family lived there for a number of years. He was also the owner of the land where the Every Ready Garage stands. From the next generation, Andrew Woods was married Mollie Flannery, who was a very active member of Cumann na mBan and friend of Michael Collins, Cathal Brugha, and Liam Mellowes. She was also close friends with Countess Markievicz, Maud Gonne McBride and Charlotte Despard. The son of Andrew and Mollie was Andrew Woods who was an aviator and a member of the Irish Aero Club. In 1931 he became the first Irish civil aviator to make the journey to and from London on a solo flight. It took him three and a half hours to fly from Baldonnel to Hendon aerodrome in London. The entire Woods family was very active in the fight for Irish freedom. The eldest son, Tony, was imprisoned in Kilmainham when he was only sixteen. The younger members of the family, including the two girls, were all part of what was commonly known as the Woods Brigade of the Irish Republican Army.

When the split occurred, Mrs Woods was opposed to the Treaty so her house was no longer used as a refuge. Instead she gained a reputation for moving guns and driving IRA men around the city. She also carried dispatches and acted as a centre for communication. According to her testimony for the *Bureau of Military History 1913-1921*, St Enda's was

St Enda's, Morehampton Road, home of the Woods family for many years. It was a safe house used by IRA members on the run. (Author's image)

home to leaders and men involved in the fight for Irish freedom, and it was the headquarters of Liam Mellows, a prominent republican and TD of the first Dail. Mrs Woods was also involved with Ireland-India relationships, and was a founding member of the Ireland-India League. When Mahatma Ghandi visited London it was hoped he would come to Dublin, where it was proposed that Mrs Woods would host him. Full military honours were accorded to Mrs Woods in 1954 at her funeral from the Church of the Sacred Heart, Donnybrook to Glencullen cemetery.

There is a terrace of Regency-style houses of four storeys on Morehampton Road that is now the Hampton Hotel, and dates from the 1830s or 1840s. This was modelled on regency terraces in Brighton and Hove. A site on Bloomfield Avenue belonging to the Quakers included Bloomfield House, Swanbrook House, New Lodge, and Westfield. At one stage, part of the land belonging to the Quakers was purchased by the Irish Government to relocate the National Library of Ireland. However, this idea was never pursued and our National Library is still in Kildare Street, where it expanded and took over the old College of Art buildings.

Eglinton Road

Eglinton Road has a number of fine houses dating from the nineteenth century. A house called Lisateer (now No. 51) is a redbrick villa dating from around 1875 and was designed by James Franklin Fuller (1835-1924), the well-known Dublin architect, as his family home. He was born in Kerry but studied in London, where he worked for some major architectural practices. He applied for and was appointed a District Architect under the Irish Ecclesiastical Commissioners in 1862 and returned to Dublin. There were ninety-seven applicants for the post and he was the successful one! He eventually set up his own large architectural practice in Dublin, at 170 Great Brunswick Street. He designed a number of churches throughout Ireland, including those in Arthurstown, County Wexford; Killadrone, County Fermanagh; Durrow, County Offaly; and Rathclare, County Laois. He was also the architect for the Old Coombe Hospital, Ashford Castle, Parknasilla Hotel, Kylemore Abbey, Tinakilly House, and alterations to Farmleigh in Phoenix Park. Despite running a very busy practice, he had an interest in genealogy, heraldry and antiquarian subjects. He wrote regularly for journals such as *Building News*. He also wrote novels, including *John Orlebar*, *The Chronicles of Westerly*,

Culmshire Folk and *Billy*. His autobiography, published in 1916, was called *Omniana: The Autobiography of an Irish Octogenarian*.

Ballinguile House

Located on what is now Eglinton Road, this house dated back to 1725 and was built for Sir Robert Jocelyn. It had a number of interesting occupants including John Fitzgibbon, father of Lord Chancellor Clare, who opposed the Act of Union. The next occupant was a Mrs Margaret Ashworth and subsequently the first Lord Bloomfield occupied it. In 1818 Ballinguile was vested in the Bower family and became known as Bowerville. In the nineteenth century, Dr Wright, a member of the influential Wright family who owned substantial property in Donnybrook, purchased the house and he re-named it Ballinguile House. It was later acquired by a Mr Bantry White, who bought it from a Mr Henderson, who owned sawmills in Donnybrook. A feature of Ballinguile House and its extensive grounds was the avenue of stately elm trees. The kitchen garden too was extensive, and is presently occupied by a number of motor accessories garages. One of the last occupants of Ballinguile was Dr Thomas Ottiwell Graham MD, FRCSI, who moved to a house on the Merrion Road in 1957. Ballinguile was finally demolished in the 1970s.

Laburnum Cottage (San Mario)

Initially called San Mario, this house is located off Eglinton Road and was built in 1710. It is one of the oldest houses in Donnybrook. It was originally a farmhouse surrounded by open fields and countryside. Entrance to this house is from Harmony Avenue. It has a delightful cottage garden surrounded by high stone walls and a patio garden. There is also a small studio at the end of the garden. For many years this was the home of the writer Carey Harrison Lambe (the son of Rex Harrison and Lilli Palmer) and his artist wife Claire Harrison Lambe. It was also the home of Lydia Prescott, a White Russian princess who escaped from Russia in 1917 by marrying Captain Prescott, who brought her to Ireland. She later married an Irish doctor. In a book called *Mariga and her Friends* by Carola Peck two of Mariga Guinness's friends describe a picnic in this house given by Mariga in honour

of her friend Leda Prescott's (as she preferred to be known) birthday. Leda was elderly by 1979, when this picnic took place, but she was seated in a place of honour by Mariga.

Belmont Avenue

Belmont Avenue was called Coldblow Lane since 1766 but changed to Belmont Avenue in the 1840s. During the eighteenth century there was an estate at the top of Belmont Avenue owned by a Colonel Coldblow, which is now the location of Milltown Park, owned by the Jesuit Fathers. Coldblow Lane originally led up to Coldblow House. In the 1780s it was the home of Sir William Fortick and later it was owned by the Hon. Denis George. Coldblow was also the home of members of the Roberts family (whose descendant was Captain Lewis Riall, of Old Conna, who built houses on Mount Eden Road). Some of the Roberts family are buried in Donnybrook Graveyard.

One of the oldest houses on Belmont Avenue is Belmont House, which is located at the Sandford Road end of the road. It is a three-bay, two-storey detached house, with pitched, slated, hipped roofs, and it dates to around 1760. The ground floor has two bay windows, a central hallway and a lime-

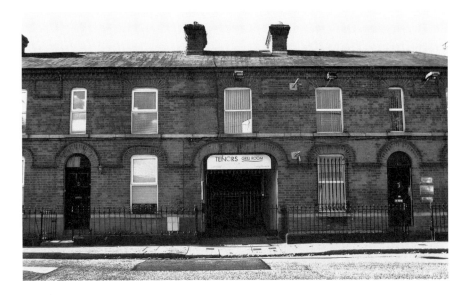

Belmont Avenue showing the site of an early police station in Donnybrook. (Author's image)

rendered façade. The main room to the rear is bay-windowed at both levels. Most of the houses on Belmont Avenue are later than Belmont House and date from the 1860s and 1870s. Some of the redbrick terraces date from the 1880s but there are later redbricked houses on the road, which date from the 1900s. In her article on Mount Eden Road in the *Dublin Historical Record* (2010), Patricia McKenna is of the opinion that some of the houses at the bottom of Belmont Avenue were built by Captain Riall (who developed Mount Eden Road). Another terrace of houses on Belmont Avenue was built by Mr John D'Arcy, a car man who had lived on Belmont Avenue for forty years. The site of O'Connell's Restaurant at the bottom of Belmont Avenue was formerly occupied by Mr D'Arcy's coach houses. His terrace of houses adjoined those built by John Newport, a grocer from Morehampton Road who built a terrace of four houses at the Morehampton Road end of Belmont Avenue. These were known as Newport Terrace, and they still exist today, as does the terrace of D'Arcy houses. Newport Terrace incorporates an arched entrance into what was once a police station, as shown on early maps of the area. Later, the census for 1901 and 1911 reveals that there were seven dwellings in this area, which came to be known as Belmont Court.

Further up on the same side of the road is Aberdeen Terrace, which was named in honour of the Lord Lieutenant, the Earl of Aberdeen.

Sylvan House is another distinguished house on Belmont Avenue and is currently the home of the chairman of the Ballsbridge, Donnybrook and Sandymount Historical Society, Mr John Holohan, and his wife Jacqueline. It dates back to the 1830s.

Mount Eden Road

Fifty houses on Mount Eden Road were built between 1884 and 1904, on land which belonged to Captain Lewis Riall of Old Conna, County Wicklow. Building began on a small scale, and leases were given to people to build terraces of four houses at a time. Well-known Dublin architect James Franklin Fuller was involved in the design of at least two of the terraces, and in the design of the new road which linked Morehampton Road and Belmont Avenue. Another architect who was responsible for two other houses on Mount Eden Road was Francis Curran Caldbeck (1869-1956), who was also a civil engineer. Patricia McKenna has suggested that Captain Riall appears to have used the Caldbeck's design for the two Mount Eden Road

houses to the remaining four houses on Morehampton Road (Nos 119, 121, 123 and 125). Captain Riall was involved in the development of ten houses on Morehampton Road in total. Most of the houses built by Riall were sold, but he held on to two semi-detached houses.[27] In 1901 Captain Riall sold a field on the borders of Muckross Park to the Dominican Sisters from Sion Hill for £2,000. This field allowed the nuns to have an entrance to Muckross from Mount Eden Road.

Donnybrook Garda Station

The year 1931 saw the opening of the new Metropolitan Garda Station in Donnybrook, which replaced an old three-storey masonry building which was removed by Pembroke Urban District Council when carrying out a scheme of street widening. The old station belonged to the Dublin Metropolitan Police, the police force of Dublin from 1836 to 1925, when it became part of An Garda Siochana. The old police station occupied the former site of the Glebe House for St Mary's Church of Ireland. It was later the site of the Rose Tavern owned by Mathias Carigan. The old police station was decreed to be not suitable for purpose and a new building was built on

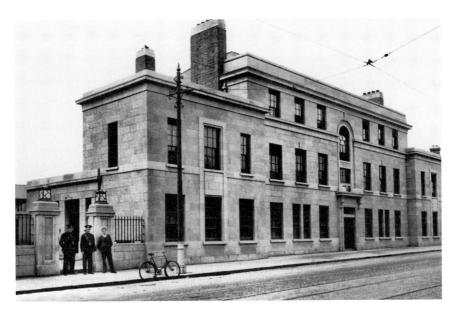

Donnybrook Garda Station built in 1931 by G. & T. Crampton. (Courtesy of David Crampton)

the site of the old one to service the needs of a modern police force. The new Garda Station is a stone-faced structure with a seven-bay central block and three-bay wings. The general contractors for the police station were G. & T. Crampton and the architect was T.J. Byrne ARIBA, FRIAI, Chief Architect to the Board of Works.

Morrison Obelisk

At the junction of Anglesea and Ailesbury Roads stands a granite obelisk on an island adjacent to Donnybrook Church. The inscription is as follows:

> MDCCCXXVIII
> Erected to the memory of the late Alderman Arthur Morrison. As Lord Mayor of the City of Dublin he was respected and esteemed. He was a sincere friend, charitable, kind, generous. As a Christian and citizen they're few to equal, none to surpass him.

Arthur Morrison's home was Belville, built in 1835 on the Stillorgan Road. Before moving to Belville, Arthur lived in a house called Lilliput (now Riversdale House) at the top of Anglesea Road. Belville, the distinct pink house next to

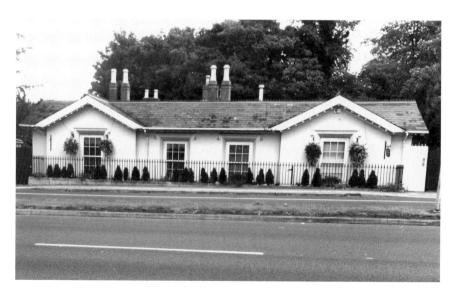

Belville, Stillorgan Road, built for Alderman Arthur Morrison. (Author's image)

Donnybrook Church, is still in existence today. Originally the gardens of Belville included a croquet lawn and tennis court on different levels, together with a glass fernery. Besides being a Lord Mayor of Dublin (1835-1836), Arthur was the owner of Morrison's Hotel at the bottom of Dawson Street. George Moore set his novel *Nobby Clarks* in Morrison's Hotel and it provides a vivid picture of the atmosphere in the hotel. Charles Stewart Parnell is reputed to have stayed in this hotel on his regular visits to Dublin. The poet Gerald Manley Hopkins stayed at Belville whenever he visited Dublin. Later it became the parish priest's house for the Church of the Sacred Heart, Donnybrook. In 1982, Cosgrave brothers, the well-known Dublin builders, purchased the house and divided it in two. Their mother lived in one half for many years.

Beaver Row

Beaver Row, situated on the banks of the River Dodder, is more than 250 years old according to Glenda Cimino, who has written a thesis on Beaver Row. At one time it was known as Sudsy Row because a number of women had a washing and mangling business there. There is also some twentieth-century history attached to one of the houses on Beaver Row in that the cellar at No. 9 was often used by Eamon de Valera to drill his troops prior to the 1916 Rising.

Alongside the Dodder in Beaver Row there was an Iron Works called Clonskeagh Iron Works and the Smurfit Paper Mill occupied the left bank of the Dodder; it was one of a number of mills and factories which, over the years, used water power from the River Dodder. An earlier mill in the same location in existence in the nineteenth century was Portis's iron mill.

The waterfall on the Dodder at Beaver Row is a rock waterfall composed of a large outcrop of limestone. According to Christopher Moriarty, an authority on the River Dodder, sea trout and salmon have been known to come up as far as this waterfall. Originally there was a waterworks associated with the Dodder here, but all that remains today is a green-painted sluice, the gate of which can be seen on the left bank of the river. From the eighteenth century there were also a number of mills on the Dodder, including paper mills, cloth mills, iron mills, corn mills, flour mills and bleach mills. Further down the river, towards Anglesea Bridge, Hugh McGuirk had a large sawmill in the nineteenth century adjacent to the old Fair Green. There is even evidence, too, for a windmill on old maps, where Eglinton Terrace is now located.

When the Wright brothers built their hat factory they also built eighteen cottages for their employees, a Wesleyan Methodist Chapel, a school for employees' children, and two houses, Floraville, and Beech Hill House. They also built Harmony Cottages. Floraville was on the site of Eglinton Park, and the only evidence of its existence is the old pillar from the entrance gate that stands at the entrance to Eglinton Park. At the rear of No. 9 the Wesleyan Methodist Church still stands. The owner of this house (Glenda Cimino) has recently ensured that there is a Preservation Order on this church. The famous Methodist preacher Gideon Ousely was a frequent guest at Beech Hill House, and he occasionally preached on Donnybrook Green.

It is of interest to note that the Horticultural Society of Ireland, which had been formed at the Rose Tavern in Donnybrook, held their first show in the newly built Erasmus Smith School on Beaver Row. The Wright brothers also built a hall for their workers on Beaver Row and tradition has it that Eamon de Valera trained with other members of the Donnybrook Brigade of the IRA in this hall.

Joseph Wright (d. 1877), his wife Mary (d. 1828) and their eldest daughter (d. 1869) are buried in Donnybrook Graveyard. There were some distinguished descendants of the Wright family of Donnybrook. For example, Dr Edward Wright's eldest son, Dr E. Perceval Wright, became Professor of Botany at Trinity College Dublin and his second son, the Revd Dr Charles H. Wright, was a minister at the Bethesda Church Dublin, between 1885 and 1891. Charles' second son, Sir Almroth Wright, is famous for developing an anti-typhoid inoculation. He also recognised early on that antibiotics could create resistant bacteria and was a strong advocate for preventive medicine.

The metal footbridge across the River Dodder replaced a wooden bridge originally built by the Wright brothers for the convenience of their factory workers. The metal bridge was built in the 1890s at a cost of £90, paid for by Ashton of Clonskeagh.

Beaver Row, as we know it today, is quite different from that of the nineteenth century when the road ran along the back of the houses. This can explain why the Methodist Chapel is to be found in the back garden of No. 9 Beaver Row. There were a number of dairy farms on Beaver Row and Larry Keogh was a well-known figure delivering milk to the people of Donnybrook.

Beaver Row continues to be a busy thoroughfare between Donnybrook and Clonskeagh. In 1996, a CIE bus travelling along Beaver Row crashed through some railings and fell 15 to 20 feet down an embankment and into the River Dodder. Fortunately the driver of the bus – the only person aboard

A bus in the River Dodder at Beaver Row, Donnybrook. (Courtesy of Lensmen
Photographic Archive)

– was unhurt. The accident occurred at about 7.30 a.m. when the driver
was bringing a No. 11 bus back to the bus garage.

The *Donnybrook Review* was a local newspaper produced by Dermot Lacey,
the local Labour councillor, and former Lord Mayor of Dublin in the 1970s
and 1980s. The following extract, entitled 'Old Place Names Remembered',
appeared in the February 1987 edition of the paper and makes
interesting reading:

> The Sanner was the Sandford Cinema in Ranelagh.
> Plunkett's field was the field beside the Dodder on Brookvale Road where
> an unsightly office block now stands near Anglesea Bridge.
> An open space where the Ever Ready Garage is built was once known as
> The Triangle.
> Barrack Yard, so called because there was an army and then a police bar-
> racks built there, was situated at the end of Belmont Avenue.
> Belmont Avenue was originally called Coldblow Lane. It is reputed to be
> the first named street outside the city walls of Dublin.
> The Crescent was originally called Church Lane.

Perhaps no other area of Dublin has such a variety of historic houses and
roads as are to be found in Donnybrook.

8

WELL-KNOWN RESIDENTS

Over the years there have been a large number of distinguished residents of Donnybrook, including politicians, writers, academics, artists, lawyers, doctors and businessmen, and one can still find people from these professions in Donnybrook today.

Politicians

Quite a number of politicians have made their home in Donnybrook over the years. The Pearse family, for example, lived in 39 Marlborough Road when Patrick and Willie Pearse were children. Eamon de Valera, first President of Ireland and Taoiseach, lived in Donnybrook with his wife Sinead, at No. 33 Morehampton Terrace.[1] Michael Collins, the well-known politician, used a number of safe houses in Donnybrook over the years, but especially Batt O'Connor's home at No. 1 Brendan Road. Eoin McNeill, Commander-in-Chief of the Irish Volunteers in 1916, lived at 19 Herbert Park. Herbert Park was also home to The O'Rahilly (1875-1916) who lived at 40 Herbert Park. He was instrumental in founding the Irish Volunteers. During the War of Independence a meeting was held in this house in 1921, to finalise plans for the taking of the Custom House, which was attended by Piaras Béaslaí, Cathal Brugha, Michael Collins, Eamon de Valera, Sean McMahon, Liam Mellows, Richard Mulcahy, J.J. (Ginger) O'Connell, Eoin O'Duffy, Diarmuid O'Hegarty, Gearóid O'Sullivan, Séan Russell, Austin Stack and Oscar Traynor.

Eamon de Valera who lived at 33
Morehampton Terrace after his
marriage to Sinead Flanagan.
(Courtesy National Library of
Ireland)

1st Communion Day at Muckross – Eithne de Valera with her parents, Professor Ruairi de Valera
and Mrs de Valera, and her grandparents, President Eamon de Valera and Mrs Sinead de Valera,
on the steps of Muckross Park. (Courtesy of Deirdre Mac Mahuna, School Archivist)

John A. Costello, leader of Fine Gael and a former Taoiseach, lived at 20 Herbert Park. He was Taoiseach of the Inter-Party Governments from 1948 to 1951. It was he who made the Declaration of the Republic in 1948 in Canada and made the decision for Ireland to remain outside NATO.[2] Garret FitzGerald, Fine Gael leader and former Taoiseach, also lived in Donnybrook at different periods of his life. As a young boy he lived at No. 15 Marlborough Road. The family also lived in Airfield House and he was married from there. Afterwards he lived with his wife Joan and their family at 75 Eglinton Road, and it was from here that Garret FitzGerald launched his political career.[3] Many national and international political figures visited this house during the FitzGerald's time there. He had purchased this house from Count Eduardo Tomacella, who was the Irish leader of the Italian fascists during the war. The last Governor General of Ireland, Domhnall Ua Buachalla (1866-1963), who was in office from November 1932 to December 1936, lived at No. 4 Eglinton Road from his retirement until his death.

A number of civil servants also made their homes in Donnybrook, including Dr T.K. Whitaker, who lived in 148 Stillorgan Road for many years. T.K. Whitaker was voted Irishman of the twentieth century in 2002 and also

Garret FitzGerald, a former Taoiseach, who lived with his wife Joan on Eglinton Road. (Courtesy Mary FitzGerald)

the Greatest Living Irish Person. Dr Whitaker has many achievements to his credit, having been an outstanding civil servant all his life. He was involved with the government in the promotion of an agenda that brought groundbreaking economic change to Ireland. He was also involved in the Northern Ireland peace process and has been a great supporter of artistic and cultural life in Ireland. Another well-known civil servant was President de Valera's secretary, Mairtin O Flatharta, who lived with his family on Mount Eden Road.

A number of Dublin's Lord Mayors also resided in Donnybrook. An early Lord Mayor of Dublin (1835-1836) was Arthur Morrison,

who lived on the Stillorgan Road in a house called Belville.[4] He owned Morrison's Hotel at the bottom of Dawson Street, where Charles Stewart Parnell is reputed to have stayed when he visited Dublin. An obelisk was erected in his memory at the junction of Anglesea and Ailesbury Roads. Another Lord Mayor of Dublin (1842-1843) who lived in Nutley House, now Elm Park Golf & Sports Club, was George Roe of Roe's Distillery. Joseph Michael Meade was also a Lord Mayor of Dublin (1891-1892). He was the son of Michael Meade, who built many houses on Ailesbury Road, and he lived at St Michael's Ailesbury Road.

Other politicians who lived in Donnybrook include Sean Moore, a Fianna Fail TD for Dublin South East, who was also Lord Mayor of Dublin (1963-1964). He will be remembered as the Lord Mayor at the time of President Kennedy's visit to Ireland. Councillor Robert Ellis was a Fianna Fail representative on Dublin Corporation and he lived on Victoria Avenue. Councillor Robert Briscoe too was a Fianna Fail member of Dublin Corporation, and he became Lord Mayor of Dublin on two different occasions in 1956-1957 and again in 1961-1962. He lived at 12 Herbert Park. Another resident, who lived in Eglinton Terrace, was Councillor Jimmy O'Connor of Fine Gael, who owned a barber's shop in Donnybrook. Joe Doyle was also very well known in Donnybrook, initially as the Sacristan of the Catholic Church (1998-1999) and later as a City Councillor and TD.

Albert Reynolds, a former Taoiseach, has lived for a number of years in Donnybrook. Now a retired politician, he was twice Taoiseach, serving from February 1992 to January 1993 and again from January 1993 to December 1994. Albert Reynolds played a very important part in the Peace Process of Northern Ireland.[5] A wonderful lady and a committed member of the Fianna Fail Party was Mrs Maud Long, who lived at No. 93a

Robert Ellis, Fianna Fail County Councillor, c. 1955. (Courtesy Deirdre Ellis-King)

Morehampton Road. She was a great fan of Charlie Haughey, and had a large collection of political memorabilia. Mrs Long worked closely with the de Valera's over the years, and had a long-standing association with another member of the Fianna Fail Party, Sean Moore. Another former Lord Mayor of Dublin living in Donnybrook today is the Labour Councillor Dermot Lacey, who lives in Beech Hill.

Writers

There have been a number of distinguished writers living in Donnybrook over the years. The novelist Anthony Trollope (1815-1882) lived at 6 Seaview Terrace for five years in the 1840s, when he was employed by the Post Office, and was involved in the development of the nationwide postal service in Ireland. He loved the lifestyle in Ireland and hunting became his passion. It was in Ireland that he wrote his first Irish novels, *The McDermott's of Ballycloran* (1847) and *The Kellys and the O'Kellys* (1848). While in Ireland he also began to write the *Barchester Chronicles* for which he is so well known.

The home of Anthony Trollope on Seaview Terrace. (Author's image)

Patrick Kavanagh (1905-1967), the poet and novelist, lived with his brother Peter at 122 Morehampton Road. His works include the novel *Tarry Flynn* and the poems 'The Great Hunger' and 'Raglan Road'.[6] An Seabhach, Padraig Ó Siochfhradh (1883-1964), lived on Morehampton Road too – his most famous book is *Jimín Mháire Thaidhg* (1919), which is semi-auto-biographical. Brian O'Nolan (1911-1966), the journalist and author, lived at No. 10 Belmont Avenue. He wrote under the pen names of Flann O'Brien and Myles na gCopaleen. O'Nolan became a senior civil servant and died in Dublin in 1966. His novels include *At Swim-Two-Birds*, *The Dalkey Archive*, *The Third Policeman*, *The Hard Life* and *The Poor Mouth* (originally published in Irish as *An Beal Bocht*).[7]

Another writer who lived at 2 Belmont Avenue was Padraic Colum (1881-1972). He also lived in Bushfield Villas, on Bushfield Terrace off Marlborough Road. Colum was a poet, novelist, dramatist, biographer and playwright. He was also one of the leading members of the Irish Literary Revival. He and his wife, Mary Maguire, held a regular Tuesday literary salon in their house in Donnybrook.

Benedict Kiely (1919-2007) lived on Morehampton Road for a number of years, where his wife Frances continues to live.[8] Born in Dromore,

Benedict Kiely (1919-2007), who lived at 119 Morehampton Road. (Courtesy Frances Kiely)

County Tyrone he moved to Omagh and was still at school when he had his first piece of writing published. He spent time with the Jesuits and became a student at UCD in 1940. He worked as a journalist with the *Irish Independent* for a number of years and was a visiting professor at Hollins College, Virginia. He was also a popular contributor to *Sunday Miscellany* on RTÉ Radio. Every year in September the Benedict Kiely Weekend is held in Omagh to commemorate the writer.

Denis Johnson (1901-1984) was one of Ireland's great playwrights, theatre director and man of letters.[9] He was married to Shelah Richards, a well-known Abbey Theatre actress, and they lived for some time in Greenfield Manor on the Stillorgan Road, since demolished. Their daughter is Jennifer Johnson, the brilliant novelist and playwright, who was educated at Park House School on Morehampton Road. Although she was born in Dublin, Jennifer has lived most of her life in the north of Ireland.

Brendan Behan (1923-1964) lived at No. 5 Anglesea Road with his wife Beatrice, whom he married in 1955. Beatrice Salkeld was an artist and daughter of the painter Cecil ffrench Salkeld. Well known as a poet, short-story writer, novelist and playwright, Brendan Behan wrote in both the Irish and English languages. Born into a Republican family, he became a member of the IRA. As a result, he spent time in a Borstal Youth Prison in England and in an Irish prison. Being in prison had a huge influence on his writing. His first play, *The Quare Fellow*, was produced in Dublin in 1954 to much acclaim. His next play was in the Irish language and was called *An Giall*. This was later translated into English as *The Hostage*, and it became a great success internationally. Unfortunately Behan had major health problems, which led to him developing diabetes, and an early death.[10]

Frank O'Connor (1903–1966) was the first Librarian of Pembroke Library on Anglesea Road. He also lived on Anglesea Road for a period of time and it was here he wrote his novel *The Saint and Mary Kate*. Born Michael Francis O'Donovan, Frank O'Connor was a pen name. He wrote over 150 works, but he is best known for his short stories and memoirs. His work as a literary critic, essayist, travel writer, translator and biographer was also significant.[11] The Munster Literature Centre Cork, where Frank O'Connor was born, runs a Frank O'Connor Literary Festival dedicated to the short story in O'Connor's memory.

Another Donnybrook resident was Bertie Smylie, a former editor of *The Irish Times* (1934-1954) who lived on Pembroke Park. A former editor of the same paper, Geraldine Kennedy lives on Mount Eden Road.

Terence de Vere White (1912-1944) was born in 61 Marlborough Road and Dr John Cowell, who wrote *Where they Lived in Dublin*, also lived in the same house. Thomas William Lyster (1855-1922) was a former Director of the National Library and he lived in No. 89 Marlborough Road. He was imortalised by James Joyce as the Quaker Librarian in *Ulysses*. Another Director of the National Library also resided in Donnybrook – in Eglinton Park – and that was Patrick Henchy, who was the director from 1967 to 1976.

Judges

Several judges have lived in Donnybrook including the late Mr Justice J.C. Conroy (1906-1985), president of the Circuit Criminal Court who was also president of the Irish Rugby Football Union. Other judges who were Chief Justices lived in Donnybrook, including: Mr Justice Hugh Kennedy, who held office from 1924 to 1936; Mr Justice Timothy Sullivan (in office from 1936 to 1946), who lived in a house called 'Shamrock Hill' on Stillorgan Road; Mr Justice Conor Maguire (in office from 1946 to 1961); and Mr Justice Ronan Keane (in office from 2000 to 2004).

Inventors, Collectors and Explorers

John Boyd Dunlop (1840-1921), the inventor of the pneumatic tyre, lived at No. 46 Ailesbury Road until he died. Another resident was Sir Alfred Chester Beatty (1875-1968), who bequeathed the Chester Beatty Library to the nation. He lived at 10 Ailesbury Road.[12]

Sir Ernest Shackleton (1874-1922), the famous Antarctic explorer, lived at 35 Marlborough Road. He travelled in the *Discovery* in 1902 with Scott of the Antarctic, and in 1907 he led the British Antarctic Expedition further south than anyone before him. Captain Laurence Oates (1880-1912) lived for a period on Mount Eden Road. He was an English Antarctic explorer famous for the manner of his death during the *Terra Nova* expedition, when he left the tent and walked into a blizzard and a temperature of -40 degrees Celsius to his certain death. He left his companions' with the words, 'I am just going outside and may be some time.' Oates Land, part of the Antarctic coastline discovered by the *Terra Nova* in February 1911, was named in his honour.

Sir Alfred Chester Beatty (1875-1968). He lived at 10 Ailesbury Road.
(Courtesy © The Trustees of the Chester Beatty Library Dublin)

Radio and Television

Guglielmo Marconi (1874-1937), whose mother was from the Jameson family,
is associated with Montrose, now the location of RTÉ, on the Stillorgan Road.
He was the founder of the Marconi Marine Communications Company.

Lorna Madigan, a well-known member of the RTÉ staff, grew up on Mount
Eden Road. Lorna was educated in Donnybrook at Muckross and at University
College Dublin. She joined RTÉ Radio in 1964 as an announcer and presenter
of programmes. Her last radio programme was *Nocturne*, a popular classical
music programme which was aired every Sunday night for many years. Lorna
became head of Radio Presentation in the early 1970s and was responsible for
the recruitment and training of all radio announcers. She became manager of
Radio Administration in the late 1990s.

Another well-known broadcaster who lived in Donnybrook (off Eglinton
Road) was the late Frankie Byrne, whose programme *Dear Frankie* was broad-
cast on Radió Éireann from 1963 to 1985. Frankie had her own PR company

Lorna Madigan, broadcaster and head of RTÉ Radio Presentation who grew up on Mount Eden Road. (Courtesy Stills Library RTÉ)

and she became one of the first Agony Aunts in Ireland. She was a big fan of Frank Sinatra and his records were always played on her programme. She facilitated open discussions on matters of a personal nature such as relationships within and without marriage, loneliness, etc.

Film and Theatre

Another resident of Donnybrook was Brendan Smith of the Brendan Smith Academy of Dramatic Art. Brendan ran the Olympia Theatre, the Brendan Smith Academy of Acting, and also founded the Dublin Theatre Festival in 1957. He lived with his wife Beryl at 77a Marlborough Road, a house that was built in the 1930s in the long front garden of a cottage.

Colm O Laoghaire was a nephew of Joe Plunkett and Geraldine Plunkett Dillon, and a grandson of Count and Countess Plunkett. He lived in No. 60 Marlborough Road and his wife Nora and son continue to live there. A pioneer

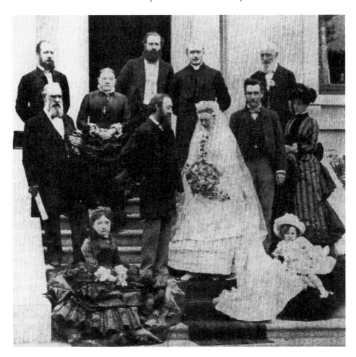

The wedding of Count and Countess Plunkett with their family on the steps of Muckross Park, the Cranny home. (Courtesy Honor O'Brolochain)

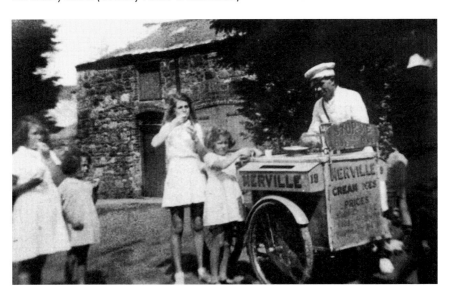

Clara Dumbleton (third from left) and friends with the Merville ice-cream man, in the 1930s. Courtesy Clara Dumbleton)

filmmaker in the 1950s, Colm received the St Finbar Award at the Cork Film Festival. He was also responsible for the production of the Gael Linn films over the years.

Another long-standing resident of Donnybrook is Miss Clara Dumbleton who has lived on Anglesea Road most of her life. For many years she ran the Scouts attached to St Mary's Church of Ireland on Anglesea Road and is a former president of the Donnybrook Active Retired Group based at the Church of the Sacred Heart.

Academics

A number of UCD academics lived in Donnybrook, including Professor Robin Dudley Edwards, who lived on Brendan Road, and Professor Patrick Meenan, who lived on Greenfield Crescent. Professor Ronan Fanning continues to live on Brendan Road. The presidents of UCD were also residents of Donnybrook in that they live at University Lodge at the top of Greenfield Crescent.

Rudolf Maximilian Butler was born in Dublin in 1872 and lived at 73 Ailesbury Road. His first big success as an architect was winning the prize for the design of University College Dublin in 1912. He became examiner in

Thomas Murphy, President of University College Dublin, who lived in University Lodge, Donnybrook pictured with Professor R. Dudley Edwards, who lived on Brendan Road. (Courtesy of Irish Press and E. de Valera)

architecture to the National University of Ireland in 1923 and UCD's Professor
of Architecture in 1924. In 1899, he became editor of the *Irish Builder* and
remained in this capacity until 1935. He was largely engaged in Irish eccle-
siastical work throughout his life. On his death his son, John Butler, and his
daughter, Eleanor Butler, carried on the practice. Eleanor married the 8th Earl
of Wicklow, William Howard, in 1959. As Lady Wicklow Eleanor Butler was
a member of the Labour Party. She became a senator in 1948 and served in
Seanad Éireann until 1951.

Painters

The well-known Irish painter Jack Yeats (1871-1957) lived for a number of
years at 61 Marlborough Road.[13] Many of his early pictures depict the West
of Ireland, especially his boyhood home in Sligo. He began as a graphic artist
and cartoonist and only began working in oils in 1906. Yeats painted popular
subjects such as the Irish landscape, horses, the circus and travelling players.
One of his most famous paintings is 'The Liffey Swim' (1923).

 Estella Solomons (1882–1968), who lived at No. 2 Morehampton Road,
was one of the most distinguished artists of her generation.[14] She studied at
the Royal Hibernian Academy School and then in London and Paris. She was
a talented landscape painter and also an excellent portrait painter with one
of her outstanding portraits being of her brother, Edwin Solomons. She was
married to the poet and publisher Seamus O'Sullivan (1879–1958), editor of
the *Dublin Review*, and they lived next door to their friend Kathleen Goodfellow
at No. 2 Morehampton Road. She worked tirelessly behind the scenes with
Estella Solomons on the production of the *Dublin Review* and contributed
many articles to the magazine. She also provided financial backing to the
magazine and the two ladies worked hard to bring in advertising for the *Dublin
Review*, thus ensuring its survival for many years.

 The painter Cecil ffrench Salkeld ARHA (1904–1969) was also a poet and
playwright and the owner of the Gayfield Press. He has been described as
'almost a Renaissance character in the multiplicity of his gifts and interests'.
He was born in India but after his father's death his mother brought him
back to Ireland and they settled in Morehampton Road. He studied art in
Dublin and on the continent and was involved in the avant-garde art and
literature movement in twentieth-century Ireland. He was the father-in-law
of Brendan Behan, who married his daughter Beatrice, also an artist.

The Starkie Family

Melfort, a house on Shrewsbury Road, was for a number of years the home to an interesting literary and musical family. The Right Honourable William Joseph Myles Starkie (1860-1920) lived there with his wife May and their children, who mixed with leading musicians, writers and artists in Dublin during the late nineteenth and early twentieth centuries. All of the Starkie children were talented musicians and were prize-winners at the Dublin Feis Ceol. William was a graduate and fellow of Trinity College Dublin, and president of University College Galway from 1897 to 1899. An academic and classicist all his life, he published a number of studies on Irish education and the classics. He was a member of the Academic Council of Trinity College and a past president of the Classical Association of Ireland. Dr Starkie was a prominent member of the Royal Commission on University Education in Ireland from 1901 to 1902 and became chairman of the Board of Intermediate Education in 1911. He was the last Resident High Commissioner of National Education under British rule. He died in 1920 in Cushendun, County Antrim.

William Joseph Myles Starkie (1860-1920), Greek scholar and former President of Queen's College Galway (1897-1899) and last Resident Commissioner of National Education for Ireland under British rule. (Courtesy Gillian Leonard)

Four of the Starkie children: Walter, Enid, Chou Chou and Muriel. (Courtesy of Gillian Leonard)

Walter (1894-1976), his son, was the Professor of Spanish at Trinity College Dublin. In 1927, he became a director of the Abbey Theatre at the invitation of W.B. Yeats. Later he was a member of the Board of the Gate Theatre. In the 1940s Walter Starkie became a British Cultural Representative, founder and the first Director of the British Institute in Madrid (1940-1954). He also became a visiting Professor at a number of American universities. His autobiography, *Scholars and Gypsies*, describes life in Dublin, England and Spain during the early twentieth century.[15]

Walter's sister, Enid (1897-1970) was a distinguished academic at Somerville College, Oxford, where she spent most of her life. A French scholar, she wrote books on Rimbault (1947), Baudelaire (1957), and Flaubert (1967). In her autobiography, *A Lady's Child* (1941), she provides an interesting account of growing up in Dublin during the early part of the twentieth century.[16]

The third sister, Ida Starkie O'Reilly, who was known as Chou Chou (1903-1987), studied cello in London, and was principal cellist with a number of leading conductors, including Sir Adrian Boult. She became a Senior Professor of Cello at the Royal Irish Academy of Music. One of Ireland's lead-

ing cellists, she was a frequent soloist at Symphony Concerts. She moved to live in Waterford with her family and was very active in Waterford's Music Club. This led ultimately to the establishment of the Waterford School of Music. The other sisters, Muriel (1899-1993) and Nancy (1910-1983), lived in England where they married. Walter Starkie's daughter, Alma Starkie Herrero, lives in Madrid. There is only one member of the Starkie family living in Dublin today, and that is Chou Chou's daughter, Gillian Leonard.

Musicians

The distinguished Irish composer and arranger Frederick May (1911-1985) lived at 38 Marlborough Road. He had a lifelong hearing problem which hampered his work as a composer. Despite this handicap, he composed a number of major works including the Scherzo for Orchestra, written during his time in London as a student. His only chamber music was the String Quartet in C Minor. He was a regular contributor to *The Bell*, a monthly journal devoted to the arts. His contributions were on various aspects of music. Frederick May was also one of the founding members of the Music Association of Ireland (now known as Friends of Classical Music).[17]

Number 58 Marlborough Road was the home of Achille Simonetti (1857-1928), composer and Professor of Music at the Royal Irish Academy of Music. Another composer Eamon O Gallachoir also lived on Marlborough Road – his home was No. 82. The conductor of the No.1 Army Band after the foundation of the State, Colonel Sauerzweig, also lived on Marlborough Road – his house was No. 104.

Over the years many ordinary people worked locally in the factories and shops in Donnybrook and Ballsbridge, particularly in places such as Johnson Mooney and O'Brien's bakery, the Irish Hospitals Sweepstakes and with the Irish Glass Bottle Company. In the nineteenth and early twentieth centuries others worked as domestic servants, grooms and gardeners in the houses of the wealthy classes of society on the leafy roads of Donnybrook. While the owners of the large houses and villas were mostly Protestant, the servants were normally Catholic.

CONCLUSION

This book is an overview and a contribution to the history of Donnybrook over the centuries. It began with the early history of the area together with the origins of some of the institutions based there. A short chapter is devoted to the Donnybrook Fair that has been described in much greater detail in Seamus Ó Maitiú's book *The Humours of Donnybrook* and by Professor Fergus D'Arcy in his comprehensive article 'The decline and fall of Donnybrook Fair: moral reform and social control in nineteenth-century Dublin'.

The various schools and colleges in Donnybrook are described together with their history. Donnybrook has always been a great centre for sports and leisure, and details of the various different types of sports and their facilities are included. The story of transport in Donnybrook has been outlined with details of the services provided in the nineteenth and twentieth centuries.

During the twentieth-century Donnybrook people were served by shop-keepers or their assistants, who would locate items required for their customers. There was no question of walking around supermarket shelves! Goods could also be delivered to the homes of regular customers, as was done for many years by the Donnybrook Fair on Morehampton Road. The service provided by shops was most important and that offered by Keenan's in Donnybrook – where one could take goods out on approval for up to two weeks – was significant. Today, Donnybrook has a selection of supermarkets and the idea of being served by a shopkeeper has long since passed! Growing up in Donnybrook during the 1950s and '60s enabled me to list the major shops and businesses during this period in the village and I received great assistance from family members of those who owned shops and businesses in the Donnybrook.

The growth of Donnybrook as a suburb of Dublin commenced in the nine-
teenth century. The important roles played by the Earls of Pembroke and the
Pembroke Estate in its development cannot be over emphasised. The Pembroke
Township dates from 1863. Governed by a Board of Commissioners until
1899, when it became an Urban District, it was finally absorbed in 1930
into Dublin Corporation. Land was acquired from the Pembroke Estate and
the township by major builders such as the Plunketts, the Crannys, Michael
Meade, G. & T. Crampton and Batt O'Connor, among others, who built new
roads, beautiful villas and homes of distinction designed by some of the great
architects of the day. Most of these houses are still in existence and an attempt
has been made to list and describe them.

Donnybrook is located conveniently to the city of Dublin, so it is hardly sur-
prising that so many of the professional classes and civil servants choose to
make their homes here. Initially, the majority of the residents of the Pembroke
Township were upper middle class and Protestant. They were very soon fol-
lowed to the suburbs by the lower classes that were mostly Catholics and
they found employment as servants and gardeners in the large houses in
Donnybrook. A selection of the well-known residents of Donnybrook over the
years, including writers, poets, musicians and artists has been identified in the
final chapter of the book, together with the addresses at which these distin-
guished people lived.

Researching and writing this book has given me a great deal of pleasure,
and it has been a labour of love. I hope it proves interesting and enjoyable for
those who read it and that it brings back many happy memories of this, my
native place.

NOTES

1. Early History and Institutions

1. O'Croinin, D., *Early Medieval Ireland, 400-1200* (London; Longmans, 1995)
2. Frazer, W., 'Description of a Great Sepulchral Mound', *Proceedings of the Royal Irish Academy*, 2nd series, 2(2) (1880), pp. 29-55
3. O'Clery, M., *The Martyrology of Donegal*, translated by J. O'Donovan (Dublin; Irish Archaeological and Celtic Society, 1864)
4. St John Brooks, E., 'The de Ridelesfords', J*ournal of the Royal Society of Antiquaries of Ireland*, 81(2) (1951), pp. 115-38
5. Ó Maitiú, S., *The Humours of Donnybrook* (Dublin; Irish Academic Press, 1995)
6. Gorevan M., 'Donnybrook', *Dublin Historical Record*, 17(3) (1962), pp. 106-21
7. Ball, F.E., *The Vacinity of the International Exhibition, Dublin: An Historical Sketch of the Pembroke Township* (Dublin; Alex Thom, 1907)
8. Ball, F.E., *A History of the County of Dublin* (Dublin; Gill & Macmillan, 1979) (Reprint)
9. Barrow, L., 'Riding the Franchises', *Dublin Historical Record*, 33(4) (1980), pp. 135-80
10. Milne, K., *A Short History of the Church of Ireland* (Dublin; Columba Press, 2003)
11. Beaver Blacker, Revd H., *Brief Sketches of the Parishes of Booterstown and Donnybrook in the County of Dublin* (Dublin; Herbert, 1861)
12. Donnelly Revd N., *History of Donnybrook Parish* (Dublin; Catholic Truth Society, 1912)
13. Costello, P., *Dublin Churches* (Dublin; Gill & Macmillan, 1989)
14. Crean, C.P., *Parish of the Sacred Heart Donnybrook* (Dublin; Church of the Sacred Heart, 1966)
15. McGreevy, T., 'Healy Window' in *Parish of the Sacred Heart Donnybrook* (C.P. Crean), pp. 133-4
16. Parkinson, D., *Donnybrook Graveyard* (Dublin; Family History Society, 1993)

17. Igoe, V., *Dublin Burial Grounds and Graveyards* (Dublin; Wolfhound Press, 2001)

18. Teamworkers Donnybrook Trust, *Donnybrook: A Riotous Occasion* (Dublin; Donnybrook Trust, 1988)

19. O'Broin, L., 'The Search for Madden's Grave', *Studies,* 50(197) (1961), pp. 88-91

20. Craig, M., 'The Quest for Sir Edward Lovett Pearce', *Irish Arts Review Yearbook,* 12 (1996), pp. 27-34

21. O'Brien, C., *The Story of the Poor Clares* (Limerick; Franciscan Friary, 1992)

22. de Buitléir, E., 'Mary Aikenhead: Foundress of the Congregation of the Irish Sisters of Charity', *Irish Monthly,* 53(622) (1925), pp. 188-92

23. *St Mary's Gayfield: Centenary Record of St Mary's Gayfield 1875-1975* (Dublin; Carmelite Fathers Gayfield, 1975)

24. Burke, H., *The Royal Hospital Donnybrook* (Dublin; Royal Hospital and UCD Social Science Research Centre, 1993)

25. Douglas, G. *et al.*, *Bloomfield: A History 1812-2012* (Dublin; Ashfield Press, 2012)

26. Pine, R., *2RN and the Origins of Irish Radio* (Dublin; Four Courts Press, 2002)

27. Bowman, J., *Window and Mirror: RTÉ Television 1961-2011* (Cork; Collins Press, 2011)

28. Moriarty, C., *Down the Dodder* (Dublin; Wolfhound Press, 1991)

29. Sweeney, C., *The Rivers of Dublin* (Dublin; Dublin Corporation, 1991)

2. The Donnybrook Fair

1. Ó Maitiú, S., *The Humours of Donnybrook* (Dublin; Academic Press, 1995)

2. Gilligan, J. *et al.*, *Irish Fairs and Markets* (Dublin; Four Courts Press, 2000)

3. D'Arcy, F., 'The Decline and Fall of Donnybrook Fair', *Saothar,* 13 (1988), pp. 7-21

4. O'Dea, L., 'The Fair of Donnybrook', *Dublin Historical Record,* vol. 15 (1958-59), pp. 11-20

5. Anon, 'Donnybrook Fair: Was It All That Bad?', *Dublin Historical Record,* 34(3) (1981), pp. 103-9

6. Hall, S.C. and A.M. Hall, *Ireland its Scenery and Character* (London; Hall, Virtue & Co., 1840)

3. Schools and Colleges

1. Coolahan, J., *Irish Education: Its History and Structure* (Dublin; Institute of Public Administration, 1981)

2. McIlvanney, L. and R. Ryan, *Ireland and Scotland* (Dublin; Four Courts Press, 2005)

3. Hanson, W.G., *The Early Monastic Schools of Ireland* (New York; Franklin 1972)

4. Dowling, P., *A History of Irish Education* (Cork; Mercier Press, 1971)

5. Akenson, D.H., *The Irish Education Experiment* (London; Routledge & K. Paul, 1970)
6. Dowling, P., *The Hedge Schools of Ireland* (Cork; Mercier Press, 1968)
7. Holland, M. *Clonskeagh* (Dublin; Linden Publishing Services, 2007)
8. Redmond, J., 'The Schools of Donnybrook' in *Parish of the Sacred Heart Donnybrook* by C.P. Crean
9. Crean, C.P. 'The Boys Club' in *Parish of the Sacred Heart Donnybrook*
10. Benevenuta, Sr. M., 'St Mary's University College', *University Review*, 3(4) (1964), pp. 33-47
11. Litton, H., *A Century of Memories* (Dublin; Muckross, 2000)
12. Cox, V. ed., *Muckross Park Past Pupils Union: A Century of Memories 1912-2012* (Dublin; Muckross Past Pupils Union, 2012)
13. Purcell, M., *The Sower and the Seed: Padre Proveda and the Teresians* (Dublin; Browne & Nolan, 1964)
14. Raftery, D. and Parkes, S., *Female Education in Ireland 1700-1900* (Dublin; Irish Academic Press, 2007)
15. Fitzpatrick, G., *St Andrew's College 1894-1994* (Dublin; St Andrew's College, 1994)
16. St Conleth's, *St Conleth's College: Memories of 50 Years* (Dublin; St Conleth's, 1989)
17. McGlynn, P., *History of St Michael's College, Ailesbury Road 1944-2007* (Dublin; St Michael's, 2007)
18. McCartney, D., *UCD: A National Idea* (Dublin; Gill & Macmillan, 1999)

4. Sports and Leisure

1. Bective Rangers RFC, *Bective Rangers Football Club 75th Anniversary 1881-1956* (Dublin; Mount Salus Press, 1957)
2. Van Esbeck E., *Ten of our Fifty: A Chronicle of Old Belvedere Rugby Football Club 1930-1980* (Dublin; Old Belvedere RFC, 1980)
3. Van Esbeck, E., *Old Wesley Rugby Football Club 1891-1991* (Dublin; Old Wesley RFC, 1991)
4. Little, A. and Parkinson, D., *Merrion: A History of the Cricket Club 1892-2010* (Dublin; Saltwater Publishing, 2011)
5. Higgins, T., *The History of Irish Tennis* (Sligo; Sligo Tennis Club, 2006)
6. Maguire, A., *Donnybrook Lawn Tennis Club, 1893-1993: A Centenary Commemoration* (Dublin; Donnybrook Lawn Tennis Club, 1993)
7. *Bective LTC: Goal Challenge 17th and 18th June 1986* (Dublin; Bective LTC, 1986)
8. Tighe, B.J., *Elm Park 1925-1993* (Dublin; Elm Park Golf & Sports Club, 1993)
9. Flynn, B., *Legends of Irish Boxing* (Belfast; Appletree Press, 2007)
10. Lacey, D., *History of Donnybrook Scouts* (unpublished manuscript, 2012)
11. Siggins, B., *The Great White Fair* (Dublin; The History Press, 2007)

12. Finlay, K., *The Biggest Show in Town* (Dublin; Nonsuch, 2007)
13. Lattimore, R., *The Real Donnybrook* (Dublin; Kamac Publications, 1998)

5. Trams and Buses

1. Bianconi, M. O'C & Watson, S.J., *Bianconi: King of the Irish Roads* (Dublin; Figgis, 1962)
2. Murphy, F.J., 'Dublin Trams 1872-1959', *Dublin Historical Record*, 33(1) (1979), pp. 2-9
3. Johnston, D., 'The Dublin Trams', *Dublin Historical Record*, 12(4) (1951), pp. 99-113
4. McCamley, B., *Dublin Tram Workers, 1872-1945* (Dublin; Labour History Society, 2008)
5. Corcoran M., *Through Streets Broad and Narrow* (Dublin; City Public Libraries and Archive, 2008)
6. Scannell, J., *From Horse Drawn Trams to Luas* (Dublin Knocklyon History Society, 2004)
7. Flanagan, P. and C. Mac An tSaoir, *Dublin's Buses* (Dublin; Transport Research Associates, 1968)
8. Corcoran, M. and G. Manahan, *Winged Wheel: A History of CIE Buses 1945-1987* (Dublin; National Transport Museum)
9. Molloy, I. *et al.*, *Dublin Bus: Changing with the City* (Surrey; Hersham, 2007)
10. www.archiseek.com

6. Donnybrook Shops

1. Information provided by Elaine Bastable, daughter of Eileen Bastable of Eileen's Hair salon
2. Information on Reddan's Licensed Premises provided by Jane and George Reddan
3. Information on O'Shea's Licensed Premise provided by Sheila O'Shea daughter of Patrick and Mary O'Shea
4. Information on Smyth's chemist shop provided by Mary Dee daughter of Joe and Peggy Smyth
5. Information on Roy Fox's provided by Joanne Donnelly, the present owner
6. Information on Wood's shop provided by Peggy Curran (*née* Hickey), daughter of Nicholas Hickey and aunt of the present owners
7. Information on Long's public house provided by the Stapleton family
8. Information on Keenan's drapery shop provided by Joan Keenan and Mary Atkinson (*née* Keenan)
9. Cimino, G., 'The Wesleyans and Hatters of Donnybrook' (unpublished thesis, National University of Ireland, Maynooth)

7. Familiar Roads and Historic Houses

1. Maxwell, C., *Dublin Under the Georges 1714-1830* (Dublin; Harrap, 1936)

2. Prunty, J., *Dublin Slums 1800-1925* (Dublin; Irish Academic Press, 1998)

3. Daly, M., *Dublin the Deposed Capital* (Cork; Cork University Press, 1984)

4. Kennedy, T. (ed.), *Victorian Dublin* (Dublin; Kennedy & Dublin Arts Festival, 1980)

5. Ó Maitiú, S., *Dublin's Suburban Towns 1834-1930* (Dublin; Four Courts Press, 2003)

6. *City of Dublin Education Committee: The Old Township of Pembroke 1863-1930* (Dublin; VEC, 1993)

7. Ball, F.E., *The Vacinity of the International Exhibition, Dublin: An Historical Sketch of the Pembroke Township* (Dublin; Alex Thom, 1907)

8. Kirk, I., 'The Artisan Dwellings of the Pembroke Estate' (unpublished MA thesis, University College Dublin,2001)

9. Kearns, K.C., *Dublin Tenement Life* (Dublin; Gill & Macmillan, 1994)

10. Bennett, D., *The Encyclopaedia of Dublin* (Dublin; Gill & Macmillan, 1991)

11. Wakeman, W.F., *Old Dublin* (Dublin; Evening Telegraph, 1937)

12. McCartney, D., *UCD: A National Idea* (Dublin; Gill & Macmillan, 1999)

13. Warren, S., 'Montrose House and the Jameson Family in Dublin and Wexford', *The Past: The Organ of the Uí Cinsealaigh Historical Society*, 28 (2007), pp. 87-97

14. Tighe, B.J., *Elm Park 1925-1993* (Dublin; Elm Park Golf & Sports Club, 1993)

15. Crean, C.P., *Parish of the Sacred Heart Donnybrook* (Dublin; Church of the Sacred Heart, 1966)

16. Cimino, G., 'The Wesleyans and Hatters of Donnybrook: Some Insights into the History of Beaver Row' (unpublished thesis, National University of Ireland, Maynooth)

17. Lewis, S., *A Topographical Dictionary of Ireland* (London; 1837)

18. Bennett, D., *Encyclopaedia of Dublin* (Dublin; Gill and Macmillan, 1991)

19. McGlynn, P., *History of St Michael's College* (Dublin; St Michael's College, 2007)

20. Frazer, W., 'Description of a Great Sepulchral Mound', *Proceedings of the Royal Irish Academy*, 2nd series, (2)2, (1880), pp. 29-55

21. Hall, R.A., *A Viking-age Grave at Donnybrook, Co Dublin Medieval Archaeology*, 22 (1978), pp. 64-83.

22. O'Brien, E., 'A Re-Assessment of the "Great Sepulchral Mound" Containing a Viking Burial at Donnybrook, Dublin', *Medieval Archaeology*, 36 (1992), pp. 170-3.

23. Plunkett Dillon, G., *All in the Blood*, edited by H. O'Brolchain (Dublin; Farmer, 2006)

24. McManus, R., *Crampton Built* (Dublin; G. & T. Crampton, 2008)

25. McManus, R., *Dublin 1910-1940: Shaping the City and Suburbs* (Dublin; Four Courts Press, 2002)

26. O'Connor, B., *With Michael Collins in the Fight for Irish Independence* (London; Davies, 1929)

27. McKenna, P., 'Development on the Riall Estate in Donnybrook West, 1884-1904', *Dublin Historical Record*, 63(2) (2010), pp. 173-96

28. Craig, M., *Dublin 1660-1860: A Social and Architectural History* (Dublin; Figgis, 1969)

8. Well-Known Residents

1. O'Carroll, J.P. & Murphy, J.A., *de Valera and his Times* (Cork; Cork University Press, 1983)

2. McCullagh, D., *The Reluctant Taoiseach* (Dublin; Gill and Macmillan, 2011)

3. FitzGerald, G., *All in a Life* (Dublin; Gill & Macmillan, 1991)

4. Parkinson, D., 'Arthur Morrisson, 1765-1837, Lord Mayor of Dublin 1835', *Dublin Historical Record*, 47(2) (1994), pp. 183-6

5. Reynolds, A. & Arlon, J., *Albert Reynolds: My Autobiography* (London Transworld Ireland, 2009)

6. Kavanagh, P., *The Green Fool* (London; Penguin Books, 1975)

7. O'Keeffe, T., *Myles: Portraits of Brian O'Nolan* (London; Martin Brian & O'Keeffe, 1973)

8. Kiely, B., *The Waves Behind Us: Further Memoirs* (London; Methuen, 2000)

9. Boylan, H., *A Dictionary of Irish Biography* (New York; Barnes & Noble, 1978)

10. O'Connor, U., *Brendan Behan* (London; Hamilton, 1970)

11. O'Connor F., *An Only Child* (New York; Knopf, 1961)

12. Horton, C., *Sir Alfred Chester Beatty* (Dublin; Town House, 2003)

13. Arnold. B., *Jack Yeats* (New Haven, CT; Yale University Press, 1998)

14. Pyle, H., *Portraits of Patriots: With a Biography of the Artist Estella Solomons* (Dublin; Figgis, 1966)

15. Starkie, W., *Scholars and Gypsies* (Berkely; University of California Press, 1963)

16. Starkie, E., *A Lady's Child* (London; Faber & Faber, 1941)

17. Grimes, J., *Irish Composers* (Dublin; Contemporary Music Centre, 2004)

SELECT BIBLIOGRAPHY

Aalen F. & Whelan, K. (eds), *Dublin City and County from Prehistory to the Present* (Dublin; Geography Publications, 1992)

Adams, B., *Denis Johnson* (Dublin; Lilliput, 2002)

Anon, 'Donnybrook Fair', *Dublin Penny Journal* 72(2) (1833)

Anon, *Parish of St Mary's Donnybrook: A Brief Sketch of the History of the Parish Church* (Dublin; St Mary's, 1946)

Anon, *The Industries of Dublin* (London; Blackett, *c.* 1887)

Archives of the Pembroke Township (Dublin; Dublin City Library and Archives)

Ball, F.E., *A History of the County Dublin* (Dublin; Alex Thom, 1903)

Ball, F.E., *Historical Sketch of Pembroke Township* (Dublin; Alex Thom, 1907)

Bennett, D., *Encyclopaedia of Dublin* (Dublin; Gill & Macmillan, 1991)

Blacker, Revd Beaver H., *Brief Sketches of the Parishes of Booterstown and Donnybrook in the county of Dublin* (Dublin; George Herbert, 1874)

Bowman, J., *Window and Mirror: RTÉ Television 1961-2011* (Cork; Collins Press, 2012)

Boyd, G., *Dublin 1745-1922* (Dublin; Four Courts Press, 2006)

Boylan, H., *Dictionary of Irish Biography* (New York; Barnes & Noble, 1998)

Bradley J. *et al.*, *Dublin in the Medieval World: Studies in Honour of Howard B. Clarke* (Dublin; Four Courts Press, 2009)

Brady, J. & Simms, A., *Dublin: Through Space and Time* (Dublin; Four Courts Press, 2007)

Burke, Helen, *The Royal Hospital Donnybrook* (Dublin; Royal Hospital Donnybrook & Social Science Research Centre, University College Dublin, 1993)

Byrne, P.F., 'Anthony Trollope in Ireland', *Dublin Historical Record*, 4(2) (1992), pp. 126-8

Caprani, V., *Discovering Donnybrook* (Dublin; Superquin, 1986)

Casey, C. (ed.), *The Eighteenth-Century Dublin Town House* (Dublin; Four Courts Press, 2010)

Cimino, G., 'Beaver Row in Donnybrook 1996' (unpublished thesis, National University of Ireland, Maynooth)

City of Dublin VEC, *The Old Township of Pembroke* (Dublin; VEC, 2011)

Clarke, D., *Dublin* (London; Batsford, 1977)

Clarke, H.B., *Medieval Dublin, the Making of a Metropolis* (Dublin; Irish Academic
 Press, 1990)
Connell, J., *Where's Where in Dublin* (Dublin Four Courts Press, 2006)
Cooke J., 'John Boyd Dunlop 1840-1921', *Dublin Historical Record*, 49(1) (1996),
 pp. 16-31
Cosgrove, A., *Dublin Through the Ages* (Dublin; College Press, 1988)
Costello, P., *Dublin Churches* (Dublin; Gill & Macmillan, 1989)
Cowell, J., *Where They Lived in Dublin* (Dublin; O'Brien Press, 1980)
Craig, M., *Dublin 1660-1860* (Dublin; Hodges Figgis, 1952)
Crean, C.P., *Parish of the Sacred Heart of Donnybrook* (Dublin; Drought, 1966)
Crone, J., *Concise Dictionary of Irish Biography* (Dublin; Talbot Press, 1937)
Cronin, D. *et al.* (eds), *Irish Fairs and Markets* (Dublin; Four Courts Press, 2001)
Curtis, J., *Times, Chimes and Charms of Dublin* (Dublin; Verge Books, 1992)
Curtis, J., *Mount Merrion* (Dublin; The History Press Ireland, 2011)
Curtis, M., *Rathmines* (Dublin; The History Press Ireland, 2011)
Curtis, M., *The Liberties* (Dublin; The History Press Ireland, 2013)
D'Alton, J., *The History of County Dublin* (Dublin; Hodges & Smith, 1838)
D'Arcy, F., 'The Decline and Fall of Donnybrook Fair', *Saothar*, 13 (1988), pp. 7-21
Dennehy, W. ed., *Record: The Irish International Exhibition 1907* (Dublin; Hely's, 1909)
Donnelly, Revd N., *A Short History of Some Dublin Parishes, Donnybrook* (Dublin; 1907)
Donnybrook Parish Magazine, 1 March 1893, Vol.4 (39)
Duffy, S. *et al.*, *Medieval Ireland: An Encyclopaedia* (New York; Routledge, 2005)
Edwards, R.D., *Reformation to Restoration Ireland 1534-1660* (1987)
Fagan, P., *Dublin: The Second City* (Dublin; Branar, 1986)
Finlay, K., *Dublin Day by Day* (Dublin Nonsuch Publications, 2005)
Finlay, K., *Dublin 4* (Donaghadee; Cottage Publications, 2006)
Finlay, K., *The Biggest Show in Town* (Dublin; Nonsuch Publications, 2007)
Frazer, W., 'Description of a Great Sepulchral Mound', *Proceedings of the Royal Irish
 Academy*, 2nd series, (2)2 (1880), pp. 29-55
Gilbert, Sir J.T., *A History of the City of Dublin* (Dublin; James McGlashan, 1854)
Gorevan, M., 'Donnybrook', *Dublin Historical Record*, 17 (3) 1962, 106-121
Graby, J. & O'Connor D. (eds), *Phaidon Architecture Guide* (Dublin. London: Phaidon
 Press, 1993)
Hall, R.A. 'A Viking-age Grave at Donnybrook, County Dublin', *Medieval Archaeology*,
 22, 1978, 64-83
Harrison, S. & O Floinn R., *Viking Graves and Grave-Goods in Ireland* (Dublin: National
 Museum of Ireland; in press)
Hogan, A., *The Priory of Llanthony Prima and Secunda in Ireland, 1172 to 1541*
 (Dublin; Four Courts Press, 2008)
Holland, M., *Clonskeagh: A Place in History* (Dublin; Linden Publishing Services, 2007)
Hone, J. *et al.*, *The New Neighbourhood of Dublin* (Dublin; A & A Farmar, 2002)
Igoe, V., *A Literary Guide to Dublin* (London; Methuen, 1994)
Igoe, V., *Dublin Burial Grounds & Graveyards* (Dublin; Wolfhound Press, 2001)
Joyce, W. St John, *The Neighbourhood of Dublin* (Gill & Son, 1939)

Kelly, D., *Four Roads to Dublin* (Dublin; O'Brien Press, 1995)

Kelly, R.J., 'Donnybrook', *Royal Society Antiquaries of Ireland*, 9 (1919), pp. 136-48.

Kilfeather, S., *Dublin: A Cultural and Literary History* (Dublin; Liffey Press, 2005)

Lattimore, R., *The Real Donnybrook* (Dublin: Karmac Publications, 1998)

Lennan, L.J., *Donnybrook 1910-1930*, memoirs transcribed by his son

Lensmen Photographic Archive, *The 1950s, Ireland in Pictures* (Dublin; O'Brien Press, 2012)

Lensmen Photographic Archive, *The 1960s, Ireland in Pictures* (Dublin; O'Brien Press, 2012)

Lewis, S., *A Topographical Dictionary of Ireland* (Dublin, 1837)

Liddy, P., *Dublin: A Celebration from the 1st to the 21st Century* (Dublin; Dublin Corporation, 200)

Little, A. & Parkinson, D., *Merrion: History of the Cricket Club (1892-2010)* (Dublin; Saltwater, 2011)

Logan, P., *Fair Day: The Story of Irish Fairs and Markets* (Belfast; Appletree Press, 1986)

Lynch, B., *Prodigals and Geniuses* (Dublin; Liffey Press, 2011)

MacDonald, F., *The Destruction of Dublin* (Dublin; Gill & Macmillan, 1985)

Maguire, J.I. and J. Quinn (eds), *Dictionary of Irish Biography* (Cambridge U.P. and RIA, 2009)

McCullough, N., *Dublin: An Urban History* (Dublin; Anne Street Press, 2007)

McManus, A., *The Irish Hedge Schools and its Books 1695-1831* (Dublin; Four Courts Press, 2004)

McManus, R., *Dublin 1910-1940: Shaping the City and Suburbs* (Dublin; Four Courts Press, 2002)

McManus, R., *Crampton Built* (Dublin; G. & T. Crampton, 2008)

Maguire, A., *Donnybrook Lawn Tennis Club, 1893-1993* (Dublin; Donnybrook Lawn Tennis Club, 1993)

Maxwell, C., *Dublin Under the Georges* (London; G. Harrap, 1946)

Mitchell, F., *Vanishing Dublin* (Dublin; Allen Figgis, 1966)

Murphy, M. & Poterton, M., *The Dublin Region in the Middle Ages* (Dublin; Four Courts Press, 2010)

O'Brien, E., 'A Re-assessment of the "Great Sepulchral Mound" containing a Viking Burial at Donnybrook, Dublin', *Medieval Archaeology*, 36 (1992), pp. 170-3

O'Brien, G. & O'Kane, F. (eds), *Georgian Dublin* (Dublin; Four Courts Press, 2008)

O'Brien, G. & O'Kane, F. (eds), *Portraits of the City* (Dublin; Four Courts Press, 2012)

O'Dea, L., 'The Fair of Donnybrook', *Dublin Historical Record*, 15 (1958-9), pp. 11-20

O'Donnell, E., *Farther Browne's Dublin photographs 1925-1950* (Dublin; Wolfhound Press, 1993)

O'Dwyer, F., *Lost Dublin* (Dublin; Gill & Macmillan, 1981)

Ó Maitiú, S., *The Humours of Donnybrook, Dublin's Famous Fair and Its Suppression* (Dublin; Irish Academic Press, 1995)

Ó Maitiú, S., *Dublin's Suburban Towns 1834-1930* (Dublin; Four Courts Press, 2003)

Ó Maitiú, S., 'Donnybrook Fair: Carnival versus Lent', *History Ireland*, 4(1) (1996), pp. 21-6

Oram, H., *Dublin: The Complete Guide* (Dublin; Appletree Press, 1995)

O'Regan, P., *Archbishop William King 1650-1729 and the constitution in Church and State* (Dublin; Four Courts Press, 2000)

O'Riain, P., *A Dictionary of Irish Saints* (Dublin; Four Courts Press, 2011)

Parkinson, D., *Donnybrook Graveyard c.800-1993* (Dublin; Family History Society, 1988)

Pearson, P., *Dun Laoghaire* (Dublin; O'Brien Press, 1981)

Pearson, P., *The Heart of Dublin* (Dublin; O'Brien Press, 2000)

Pearson, P. & Broad, I., *Peter Pearson's Decorative Dublin* (Dublin; O'Brien Press, 2002)

Pine, R., *2RN and the Origins of Irish Radio* (Dublin; Four Courts Press, 2001)

Pyle, H & Solomons, E., *Portraits of Patriots* (Dublin; Allen Figgis, 1966)

Refausse, R. & Clark M., *A Catalogue of the Maps of the Estates of the Archbishops of Dublin, 1654-1850* (Dublin; Four Courts Press, 2000)

Shaw, H., *Dublin Pictorial Guide and Directory, 1850* (Belfast; Friars Bush Press, 1988)

Siggins, B., *The Great White Fair* (Dublin; Nonsuch Press, 2007)

Somerville Large, P., *Dublin* (Dublin; Hamilton, 1979)

Stanley, D., *Images of Ireland South Dublin from the Liffey to Greystones* (Gill & Macmillan, 2000)

Starkie, E., *A Lady's Child* (London; Faber & Faber, 1941)

Starkie, W., *Scholars and Gypsies* (Berkeley; University California Press, 1963)

Sweeney, A. 'The Victorian Expansion of Dublin's South Suburbs – A Case History: St Michael's College' (unpublished MA thesis, University College Dublin)

Thom's Directory of Ireland: Dublin City and County (Dublin; Alex Thom)

Van Esbeck, E., *Ten Out of Fifty: Chronicle of Old Belvedere RFC 1930-1980* (Dublin; Old Belvedere RFC, 1980)

Van Esbeck, E., *Old Wesley Rugby Football Club 1891-1991* (Dublin; Old Wesley RFC, 1991)

Williams, J., *A Companion Guide to Architecture in Ireland 1837-1921* (Dublin; Irish Academic Press, 1994)

White, B., 'An Old House at Donnybrook', *Proceedings of the Royal Society Antiquaries*, 9 (1919), pp. 149-52.

Wright, G., *An Historical Guide to the City of Dublin* (London; Baldwin, Cradock & Joy, 1825)

Newspapers

Dublin Builder
Dublin Penny Journal
Freeman's Journal
Irish Builder
Irish Independent
Irish Newspaper Archive
Irish Press
Irish Times Digital Archive (1859-2010)
Irish Times online

Journals

Archaeology Ireland
History Ireland
Irish Historical Studies
Journal of Medieval Archaeology
Journal of the Royal Society of Antiquaries of Ireland
Local History Review
Proceedings of the Royal Irish Academy
Saothar

Websites

Bureau of Military History, www.bureauofmilitaryhistory.ie/about.html
Dublin Forums, www.dublinforums.ie
Irish Volunteers, http://irishvolunteers.org/2012/01/michael-collins-haunts-
 around-dublin-and-elsewhere/
National Archives, www.nationalarchives.ie/
National Library of Ireland, www.nli.ie
Sources (Database for Irish Research), http://sources.nli.ie/

ABOUT THE AUTHOR

Dr Beatrice Doran grew up in Donnybrook and she still lives there. She was educated at Muckross and University College Dublin. A librarian by profession, Beatrice has worked in a number of libraries, including the Royal Dublin Society, the University of Ulster, the University College Cork and the Royal College of Surgeons in Ireland where she was Library Director. She is a former president of the Library Association of Ireland. Beatrice has a BA, a Diploma in Librarianship, an MBA and a PhD from University College Dublin. Local history and archaeology are particular interests of hers, and she was active in the Cork Historical & Archaeological Society as vice-president, council member and honorary organiser. Today she is a member of the Ballsbridge, Donnybrook and Sandymount Historical Society, the Irish Georgian Society, the Royal Society of Antiquaries and the Royal Dublin Society.

INDEX